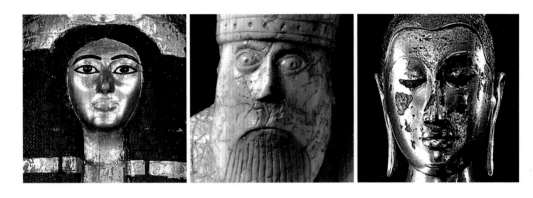

MASTERPIECES
OF THE BRITISH MUSEUM

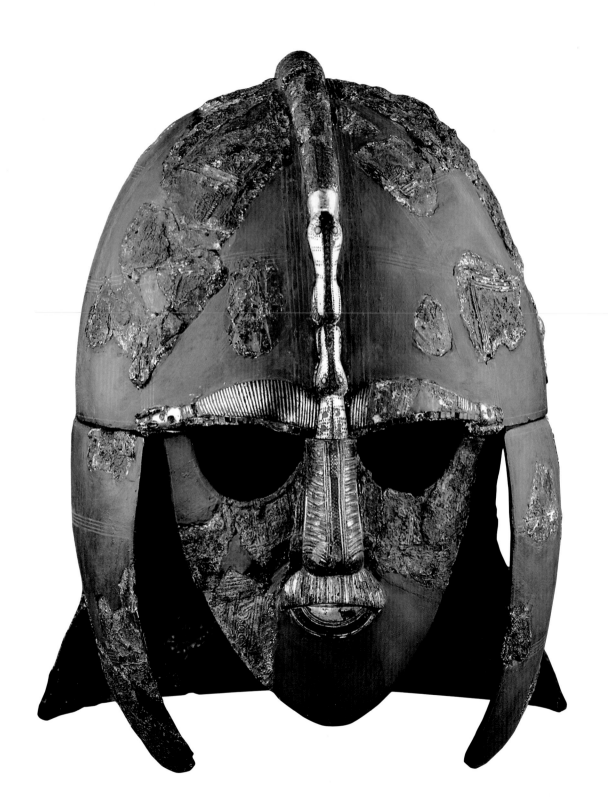

MASTERPIECES
OF THE BRITISH MUSEUM
Edited by J.D. Hill

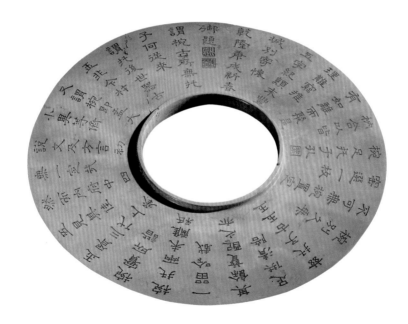

THE BRITISH MUSEUM PRESS

First published in 2009 by The British Museum Press
A division of The British Museum Company Ltd
38 Russell Square, London WC1B 3QQ
britishmuseum.org/publishing

Reprinted 2010 (twice), 2011, 2012 (twice)

A catalogue record for this book is available from the British Library

ISBN 978-0-7141-5068-0

Photography by the British Museum Department of Photography
and Imaging
Designed and typeset in Minion by John Hawkins Design
Printed and bound in Singapore by CS Graphics

HALF-TITLE PAGE *left to right*: mummy coffin (see p. 144);
Lewis chessman (see p. 90); Tara (see p. 39)
FRONTISPIECE: Sutton Hoo helmet (see p. 95)
TITLE PAGE: Jade *bi* (see p. 264)
OPPOSITE: Assistant to a Judge of Hell (see p. 153)

Explore the British Museum's collections online at
britishmuseum.org

Contents

Director's Introduction

WHAT IS A MASTERPIECE? This book illustrates 250 objects chosen from the vast collection of the British Museum. Some of these are famous pieces such as the Rosetta Stone, images of Egyptian pharaohs and the Sutton Hoo helmet, which are well known across the world and among the objects most visitors to the Museum come to see. Included are works of art by famous artists such as Picasso, Leonardo da Vinci and Michelangelo, Greek and Roman statues and works of Chinese and Indian art. But this selection of masterpieces contains many other objects that you may be surprised, even perhaps shocked, to see. Is a fist-sized lump of grey rock really a masterpiece? To explain why this book begins with a grey rock is also to explore the purpose of the British Museum.

For 250 years the British Museum has been open free of charge to all, to enable everybody to explore the histories of the world through things made by peoples from every part of the world, from the beginnings of human culture to the twenty-first century. These range from well-known works of art through to cooking pots and everyday tools. They can allow the visitor to explore the artistic history of a particular culture or period, or its social and political history, or the practicalities of its everyday life. In this sense, though the masterpieces shown here do include objects of great artistic merit, and many are made of precious materials and have taken skill and time to create, others are master pieces of evidence with which to explore our past.

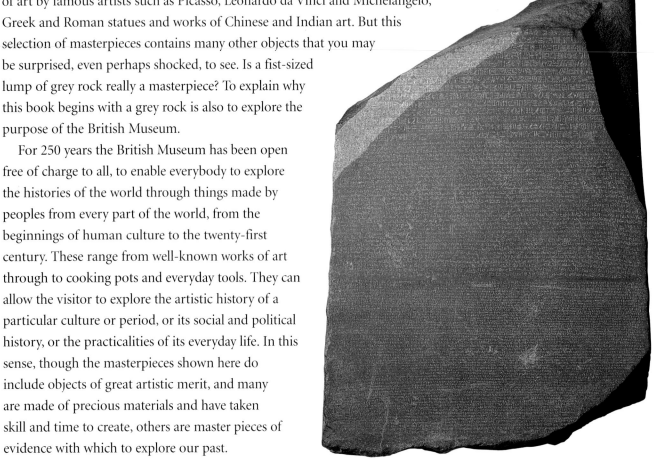

The Rosetta Stone

For this book, 250 objects had to be selected from the tens of thousands that our five million annual visitors can see in our galleries. The Museum is primarily a museum for and about the world, so it is important that people outside London have opportunities to see objects from the Museum's collections. This means there are usually some masterpieces away on loan to exhibitions in other museums across Britain and throughout the world. Others may have been taken off display so that they can be cared for and studied. The Museum exists to increase our understanding of human cultures, and preserving the objects in the Museum and researching them involves about 150 skilled conservators and curators. Ten thousand additional researchers, scholars and students come to study objects in the Museum each year, while the Museum's staff also work with others to carry out expeditions and excavations throughout the world. Some of the Museum's most fragile objects are only ever on display for limited periods, above all to protect them from the damaging effects of light. Fortunately images and information are always available free of charge to all those with access to the internet (www.britishmuseum.org).

By bringing objects together from across the world and from different periods of history, the Museum allows us to explore what divides and unites peoples. This book could have been arranged into predictable chapters such as Egypt, China, India or Europe, for instance. Instead we have chosen to let objects from different times and places speak to each other in ways that demonstrate the range of the Museum's collections and encourage us to think, disagree, occasionally frown and perhaps even laugh. We have chosen to group the objects to illuminate big common themes that resonate across human history, whether it is the use of objects to depict the gods or to legitimize political authority. Other chapters bring together objects associated with

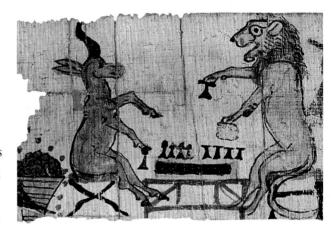

Ancient Egyptian satire, over 3000 years old

ordinary activities such as eating and drinking, and images that show how the same animal, real or mythical, has been viewed in either similar or very different ways in the past. It is by pointing out the contrasts and similarities between objects, whether made thousands of years apart or at the same time but in different cultures, that the Museum can spark debate and demonstrate again and again not just the enduring connectedness of the world, but above all, our common humanity.

Stone chopping tool

THIS CHOPPING TOOL, and others like it, are the oldest objects in the British Museum. Made nearly two million years ago, such stone tools are the oldest surviving objects made by our human ancestors. They are evidence for the beginnings of technology and the use of what makes us human. They are testimony not just that the human species comes from Africa, but that human culture comes from Africa.

This stone tool comes from the site of an early human campsite found by Louis Leakey at Olduvai Gorge, Tanzania. Using another hard stone as a hammer, the maker has knocked flakes off both sides of a basalt (volcanic lava) pebble to make a sharp edge. The edge is formed by a deliberate sequence of skilfully placed blows of more or less uniform force, showing that this is a deliberately made artefact and not an accidental shape. The tool could be used for many activities such as to chop branches from trees, cut meat from large animals or smash bones for marrow fat – an essential part of the early human diet.

From Olduvai Gorge, Tanzania
Lower Palaeolithic, about 1.8 million years old
Ht 8.7 cm

El Anatsui (*b.* 1944), *Bottle-top Textile*

THIS SCULPTURE IS ONE OF the most recently made objects in the British Museum. Visitors are often surprised that the Museum collects objects from our own time, as well as from the past, and collects contemporary works of art. This is a large artwork made from recycled metal bottle tops by the sculptor El Anatsui, who was born in Ghana. He uses modern methods and materials to create traditional objects which then become a powerful medium for conveying social messages. The people of Ghana have for centuries been producing *kente* cloth, textiles made of interwoven cotton or silk strips patterned with designs that represent the status of the wearer.

This sculpture takes the form of the traditional *kente* cloth worn by Ghanaian men but uses bottle tops to comment on how modern consumerism has threatened the survival of these long-established traditions.

From Ghana, AD 2002
Ht 297 cm

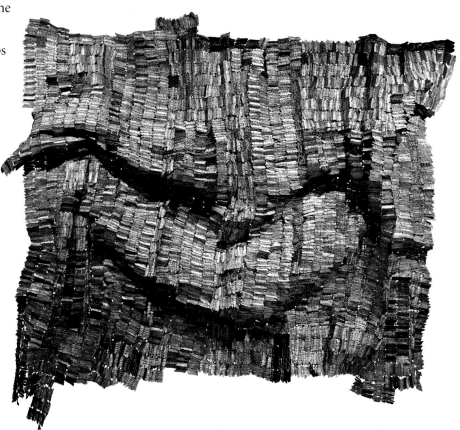

Albrecht Dürer (1471–1528), *The Rhinoceros*

BOTH THIS RHINOCEROS and the elephants on the next page were created by artists who had never seen the living animals. The creator of the rhino woodcut, Albrecht Dürer, is well known. We do not know who made the elephants. This celebrated woodcut records the arrival in Lisbon of an Indian rhinoceros on 20 May 1515 as a gift to the king of Portugal.

A description of the rhinoceros soon reached Dürer in Nuremberg, presumably with sketches, from which Dürer prepared this woodcut. It is not an accurate picture of the actual animal, but his fanciful creation proved so convincing that for the next 300 years European illustrators borrowed from his woodcut, even after they had seen living rhinoceroses without plates and scales. It became the image of what people expected a rhinoceros to look like, partly because of Dürer's fame and renown as an artist. This print is one of the most famous of over a million prints and drawings from across the world currently held in the British Museum.

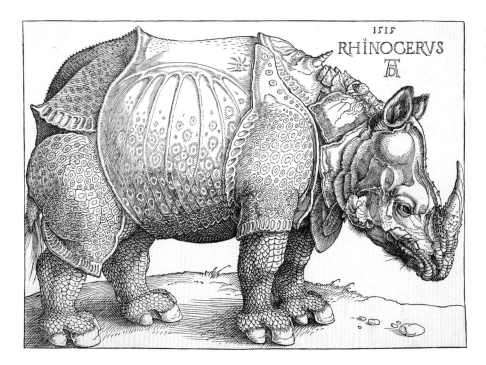

From Germany, AD 1515
Ht 24.8 cm
Gift of William Mitchell

Pair of porcelain model elephants

THESE PORCELAIN ELEPHANTS were made by craftsmen in Japan for display on the mantelpieces of European houses half a world a way. Like many objects in the British Museum, these exotic elephants are part of a story of the complex links between different parts of the world that over the centuries have led to the movement of ideas, objects and people. Made over 300 years ago, when actual elephants would not have been seen in Japan, these may have been inspired by pictures of Indian processional elephants.

Many such models of animals, including dogs, cats, deer, boars and horses, were made in Japan to be sold in Europe as ornaments. These elephants are decorated in overglaze enamels in the Kakiemon style, in which an opaque white glaze is applied over the clay to give an exquisite milky-white ground (*nigoshide*) that displays the coloured enamel designs to great effect. Reds, greens, blues and yellows were commonly used.

From Japan, Edo period, late 17th century AD
Ht 35.5 cm
Garner Collection

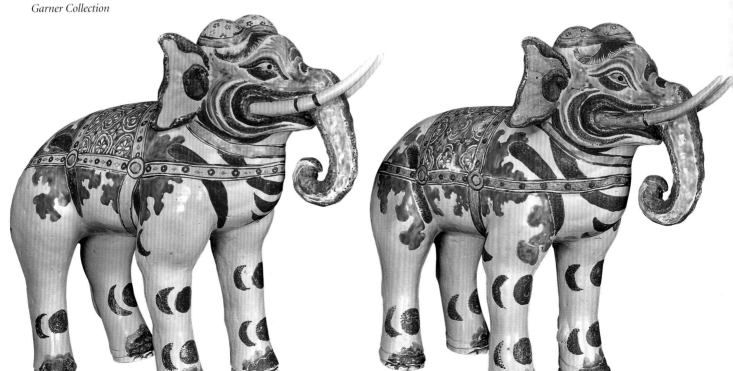

Hans Holbein the Younger (1497/8–1543), *Portrait of an English Woman*

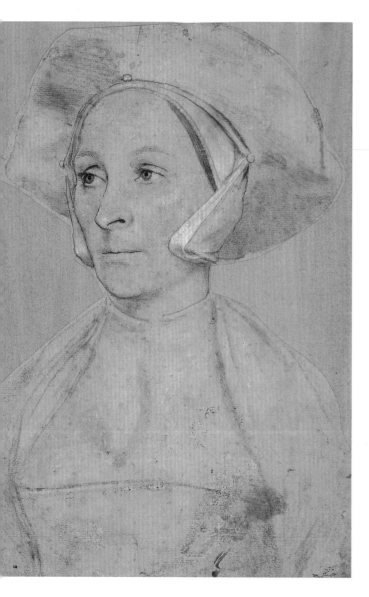

THE BRITISH MUSEUM contains thousands of images of people from a huge variety of cultures and periods of history. Few however are actual portraits that attempt to show what a person really looked like. The identity of this woman drawn by the artist Hans Holbein is no longer known, but she was probably a lady from the court of the English king Henry VIII (reigned 1509–47). She is drawn in red and black chalk, with touches of bodycolour to highlight her features. Holbein used black ink on the point of a brush to reinforce the edge of her cap and facial features. Her eyebrows and eyelashes are particularly delicate. The original paper was prepared with a soft pink ground, which suggests her flesh tones. At some stage, however, the drawing was cut out from its original paper and laid down on another sheet, so that the figure is now silhouetted.

From England, mid 1530s AD
Ht 27.6 cm
Bequeathed by George Salting

Gilded mummy mask

ANCIENT EGYPTIANS used mummy masks to protect the face of the deceased and act as a substitute for the mummified head, should it be damaged or lost. Egyptians believed that the spirit (*ba*) survived death and could leave the tomb but needed to recognize its host in order to return. It is perhaps odd therefore that mummy masks are rarely realistic portraits but usually have idealized features, such as on this example.

The mask was created from layers of linen with a thin outer coating of plaster (cartonnage) which could then be painted or gilded. The use of gold was connected to the belief that the sun god Re, with whom the mummy hoped to be united, had flesh of pure gold. The headband on this example is inscribed with a funerary text and the top of the mask is decorated with a winged scarab beetle to associate it with the sun god.

From Egypt, late 1st century BC*–early 1st century* AD
Ht 44 cm

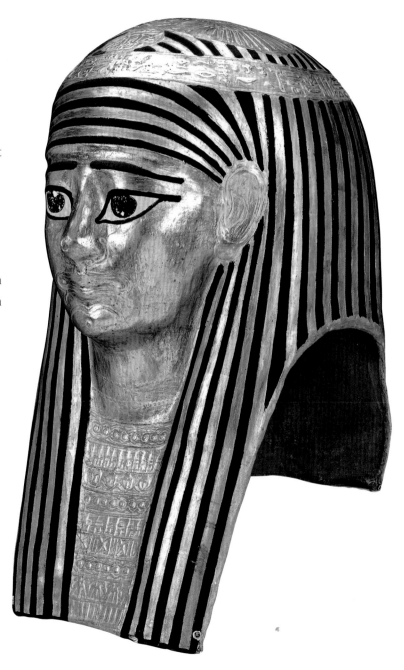

Navigation chart (*mattang*)

THIS FRAME OF STICKS and seashells is a map to help sailors navigate part of the Pacific Ocean. It was used by the Marshall Islanders of Micronesia, whose islands are spread across several hundred miles of the Pacific Ocean. A detailed knowledge of winds, tides, currents, wave patterns and swells was vital to their successful navigation. The map would not have been taken on a voyage but was made to help train people selected to become navigators and could be used as a memory aid before setting out.

Made from sticks tied together and popularly known as 'stick charts', they depict the location of islands and their surrounding swell movements and wave patterns. The horizontal and vertical sticks form a framework upon which diagonal and curved sticks represent wave swells and small shells represent the positions of the islands.

From the Marshall Islands, Micronesia, probably 19th or early 20th century AD
L. 75.5 cm
Gift of Mrs H.G. Beasley

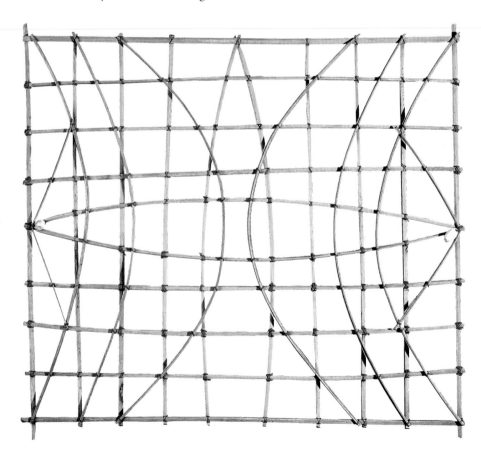

Sloane astrolabe

THIS BEAUTIFUL AND COMPLEX object is an astrolabe. It could be used for navigating a ship by calculating latitude, but it could also be used for time-keeping (both day and night) and for surveying and casting horoscopes. Astrolabes came to Europe from the Islamic world in the Middle Ages.

This particular astrolabe could also be used to calculate the dates of the movable Christian feasts. Three of the saints' days that could be calculated have particular connections with England: Dunstan (celebrated on 19 May), Augustine of Canterbury (26 May), and Edmund (20 November). These saints, and the fact that London is the only place mentioned on the latitude plates, suggests that this astrolabe was made in England. It is one of three astrolabes that belonged to Sir Hans Sloane, whose collections formed the foundation of the British Museum.

From England, c. AD 1300
D. 46 cm
Bequeathed by Sir Hans Sloane

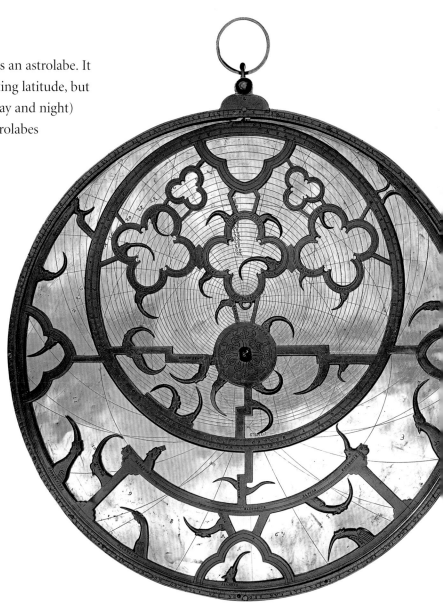

John Constable (1776–1837), *Stonehenge*

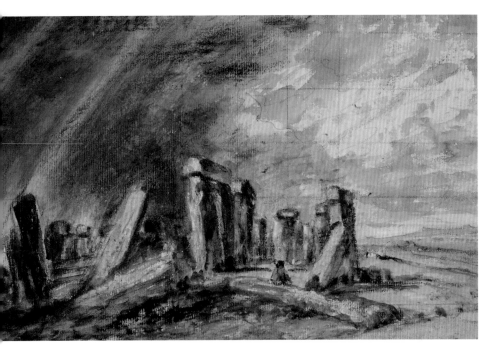

HOW A PARTICULAR PLACE has been depicted by different artists can reveal as much about the time and culture the artist lived in as it does the place being depicted. The great prehistoric British monument of Stonehenge is no exception. These two images of Stonehenge were made by two famous artists, one English and one Japanese.

John Constable visited Stonehenge in 1820, where he made a sketch that he eventually worked up into a large watercolour. This watercolour over black chalk represents a middle stage in the process and is squared for transfer to a larger sheet. The finished work (now in the Victoria and Albert Museum, London) was captioned: 'the mysterious monument ... standing remote on a bare and boundless heath, as much unconnected with the events of the past as it is with the uses of the present, carries you back beyond all historical records into the obscurity of a totally unknown period'.

From Wiltshire, England, AD 1820–35
Ht 16.8 cm
Gift of Miss Isabel Constable

Urushibara Mokuchu (Yoshijiro) (1888–1953), *Stonehenge, Moonlight*

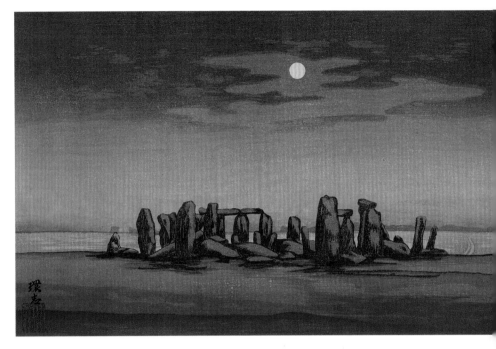

THIS VIEW OF STONEHENGE was made by the Japanese artist Urushibara. A woodblock print artist, he came to London from Tokyo as part of an exhibition of Japanese print-making. He remained in England teaching colour woodblock printing techniques and became a major influence on the works of many European artists.

Urushibara's own designs were usually still lifes (*kacho-e*), particularly of flowers, though he did produce landscapes of English and Italian scenes. This colour woodblock print of Stonehenge in moonlight was one of a pair (the other shows Stonehenge in daylight) produced from many of the same blocks (*betsuzuri*). This scene has an extra block for the moon, while the daytime scene has the addition of a shepherd and his dog herding his sheep in the foreground, and a flock of birds in the sky. The combination of the Japanese technique and Urushibara's artistic heritage give these views of Stonehenge a distinctive look.

From England, mid 20th century AD
Ht 24.8 cm
W. 37.4 cm
Gift of Professor Luke Herrmann

Crucifixion of Christ

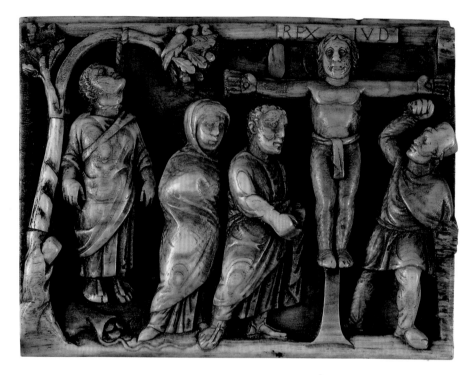

THIS IS ONE OF THE earliest known depictions of the Crucifixion in Christian art. It was made in Rome about AD 420–30, at a time when the Roman empire in Western Europe was fragmenting. The panel is one of four, originally mounted on the sides of a small ivory casket, each carved with a scene from Christ's Passion.

In this image the Crucifixion is combined with another scene of death: the suicide of the disciple Judas after he has betrayed Jesus. The stiff, clothed body of Judas pulls down the branch of a tree, and a spilled sack of coins lies at his feet. In contrast the exposed limbs of Christ still appear vigorous, and he gazes at the viewer, triumphant in death. A plaque over Christ's head is inscribed REX IUD (King of the Jews). The Virgin Mary and John the Baptist stand to the left of the cross, while on the right Longinus steps from beneath the arm of the cross.

Probably made in Rome, AD 420–30
Ht 7.5 cm

Rembrandt van Rijn (1606–69), *The Three Crosses*

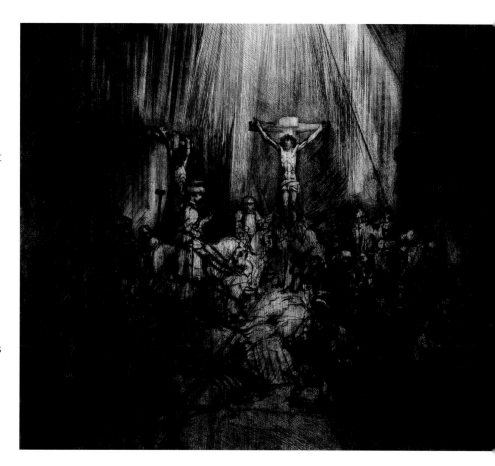

THE BRITISH MUSEUM holds many images of the Crucifixion from Christian art across the world. This example is also one of the Dutch artist Rembrandt's most formidable masterpieces as a printmaker. The drypoint print illustrates the moment of Christ's death, when 'there was darkness over the whole land' (Mark 15:33). A flood of supernatural light illuminates the ground immediately around the cross. Dark shadows fill the four corners, and the figures hurrying away in the foreground are silhouetted against the brightness.

Rembrandt printed so many prints from the original copper plate he engraved for this print that the surface wore away. He then re-engraved the plate three times, so there are four different versions or 'states' of this image. For this, the fourth and final state, he drastically reworked the surface to produce a very different image. The extraordinary painterly effects he achieved with this fourth state must have astonished his contemporaries and have rarely been rivalled since.

From The Netherlands, signed and dated AD 1653
Ht 38.7 cm

Admonitions handscroll

THIS HANDSCROLL, one of the earliest surviving paintings on silk made in China, is the Museum's most important Chinese painting. It illustrates a poem entitled 'The Admonitions of the Instructress to the Court Ladies', which offers a code of ethics to the women of the imperial court. The painting is probably a copy made in the late fifth or sixth century of an original by the leading Chinese figural painter Gu Kaizhi (*c.* AD 344–406), who was renowned for his ability to capture the spirit of his subjects.

The painting is also important because of who collected it. It was recorded in the collection of the emperor Huizong of the Northern Song dynasty (r. 1101–25) and has an inscription by the emperor Zhangzong of the Jin dynasty (r. 1189–1208). During the Yuan and Ming dynasties it passed through various private hands until in the Qing dynasty it entered the collection of the emperor Qianlong (r. 1736–95).

Painted in China, c. 6th century AD
Ht 25 cm

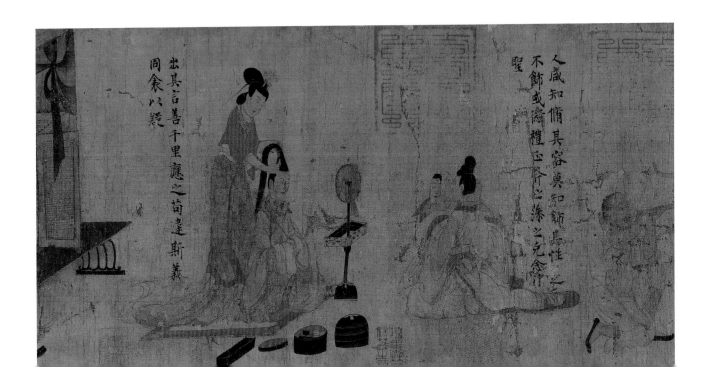

Franks casket

WHEN IT CAME TO LIGHT in the nineteenth century, this magnificent rectangular whalebone casket was being used as a family workbox in Auzon, France. At some point during its mysterious history it was dismantled and one end panel was separated from the rest of the box. This piece was bequeathed to the Museo Nazionale del Bargello in Florence.

The carvings on the casket tell stories from Germanic legends (Weland the Smith), Christianity (the Adoration of the Magi) and the classical world (Romulus and Remus suckled by the wolf). It is also inscribed with Anglo-Saxon runic letters. The style of the carvings and the dialect of the inscriptions show it was made in northern England and demonstrates the international culture that flourished there in the eighth century AD. It is known as the Franks Casket after Sir Augustus Franks, who gave it to the Museum.

From Northumbria, England, first half of the 8th century AD
Ht 10.9 cm
Given by Sir A.W. Franks

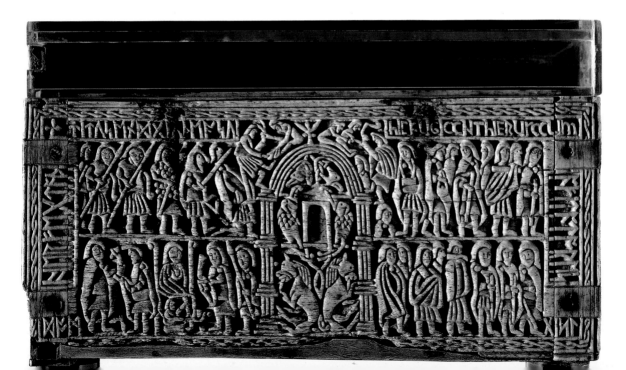

Carved calcite cobble

THIS SMALL SCULPTURE is one of the oldest human images in the British Museum. It is about 10,000 years old and was carved from a calcite cobble, its natural shape used to represent the outline of a pair of lovers. Their heads, arms and legs appear as raised areas around which the surface has been picked away with a stone point or chisel. The arms of the slightly larger figure hug the shoulders of the other and its knees are bent up underneath those of the slightly smaller figure. The image is also phallic when viewed from any angle.

The piece was made when the people of the Ain Sakhri region were beginning to domesticate sheep and goats instead of living primarily by hunting wild animals. The sculpture may have had special significance at that time, perhaps representing ideas about fertility or reflecting a new understanding of the part men played in reproduction.

Probably from the cave of Ain Sakhri, Wadi Khareitoun, Judea, c. 8000 BC
Ht 10.2 cm

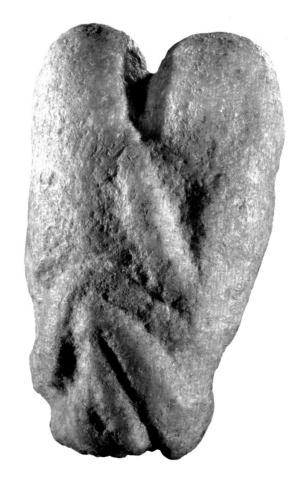

Warren cup

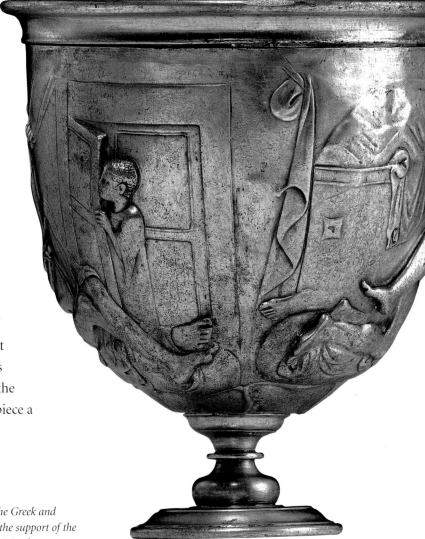

THIS ROMAN SILVER CUP IS decorated with homoerotic scenes. The Romans had very different views about sexuality than we do today, while in the Greek world the partnering of older men with youths was an accepted element of their education. Representations of sexual acts are widely found in Roman art, on glass and pottery vessels, terracotta lamps and wall-paintings in both public and private buildings. Such images would have been seen by men and women of all ages and social classes.

The cup takes its name from its first owner in modern times, the art-lover and collector Edward Perry Warren (1860–1928). After Warren's death the cup remained in private hands, largely because of the nature of the subject matter. Only with changing attitudes in the 1980s was the cup exhibited to the public, and in 1999 the British Museum was able to give this important piece a permanent home in the public domain.

Said to be from Bittir (ancient Bethther), near Jerusalem
Roman, mid 1st century AD
Ht 11 cm
Purchased with the aid of several members of the Caryatids (the Greek and Roman Department's international group of supporters), and the support of the Heritage Lottery Fund, the Art Fund and the British Museum Friends

Asante-style drum

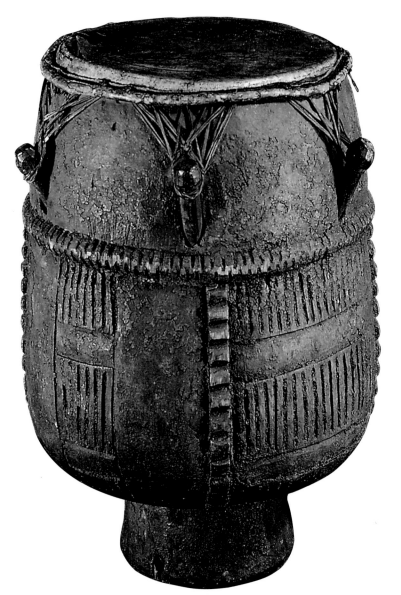

THIS DRUM WAS MADE in the style of the Asante people of Ghana, West Africa, but was collected in Virginia, then an English colony in North America, around AD 1730–45. It is one of the earliest known surviving African-American objects and was probably brought to the New World on the middle passage of a slave-trading voyage. The first passage was from Britain to Africa carrying goods, the second from Africa to the American colonies carrying slaves, and the third from America to Britain carrying trade goods.

The drum is made of native African wood, vegetable fibre and deerskin. It is not known who took the drum to America. It may have been owned by an officer or the captain of a British ship, rather than an African. It was collected by a Reverend Mr Clerk on behalf of Sir Hans Sloane, whose collection was the foundation of the British Museum.

Made in West Africa, collected in Virginia, AD 1730–45
Ht 40 cm

'EAST INDIA SUGAR *not made by* SLAVES'

THIS BLUE GLASS SUGAR BOWL is also a piece of political propaganda from early nineteenth-century Britain. The bowl is from a tea box that also contained compartments for black and green (unfermented) tea. The bowl is inscribed in gilt with the words *EAST INDIA SUGAR not made by SLAVES*.

The campaign for the abolition of slavery began at the end of the eighteenth century and supporters urged a boycott of sugar from West Indian slave plantations. Alternative sources of sugar were found in the emerging European sugar beet industry and in cane sugar from Mauritius in the Indian Ocean. East India sugar merchants took advantage of the boycott to market their sugar as not made by slaves. The claim was more a marketing ploy than a gesture of humanitarian support because conditions on plantations in the East Indies may have been little better than those in the Caribbean.

From Bristol, England, c. AD 1800–30
Ht 11 cm

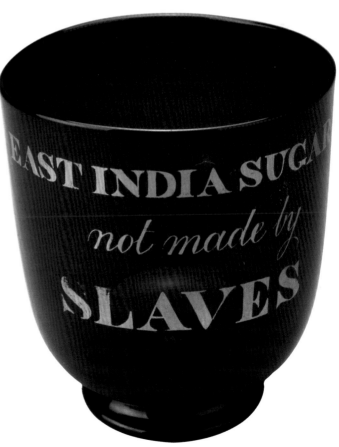

Asante ewer

THIS BRONZE EWER was made in England during the reign of Richard II (1377–99) and was discovered in 1896 in the Asante kingdom on the west coast of Africa. The front of the jug bears the royal arms of England and each of the facets of the lid contains a lion and a stag. These symbols date the jug to the last nine years of Richard's reign, when he adopted the badge of the white hart.

Two more English bronze jugs from the same period were found at Kumasi, the Asante capital, at the same time as this example. Perhaps all three were a set from the household of Richard II. How they came to the west coast of Africa remains a mystery, but there was extensive trade between West Africa and Western Europe across the Sahara Desert in the Middle Ages.

Made in England, c. AD 1390–1400
Found in the Asante kingdom (modern Ghana), West Africa
Ht c. 62 cm

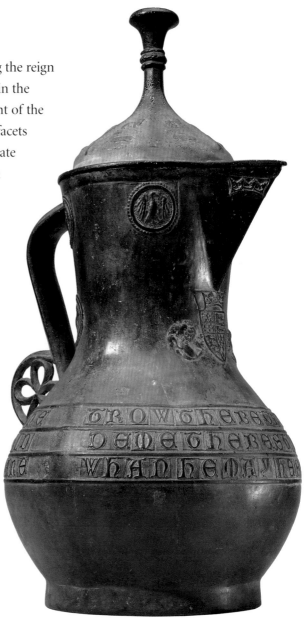

Brass head with beaded crown and plume

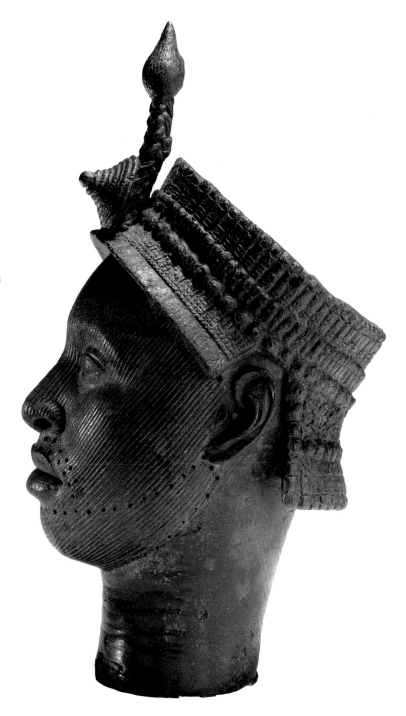

THESE OBJECTS REVEAL different aspects of the cultures and history of West Africa in the twelfth to fifteenth centuries. This striking brass sculpture represents a ruler (*oni*) from Ife, capital state of the Yoruba peoples, on the River Niger in southwestern Nigeria. The head was probably used in funerary ceremonies and may have been attached to a wooden figure. Ife was one of several powerful states and empires in West Africa during this period.

The art of Ife is unique in Africa in representing humans with an almost portrait-like realism. It has often been compared with European naturalistic traditions such as those of ancient Greece and Rome, and assumptions were made that Ife art had been influenced by these traditions. In fact, there is no historical connection with any European culture, and the sculpture of Ife is today rightly seen as one of the highest achievements of African art and culture.

Yoruba, from Ife, Nigeria, probably 12th–14th century AD
Ht 36 cm

'Empress' pepper pot from the Hoxne hoard

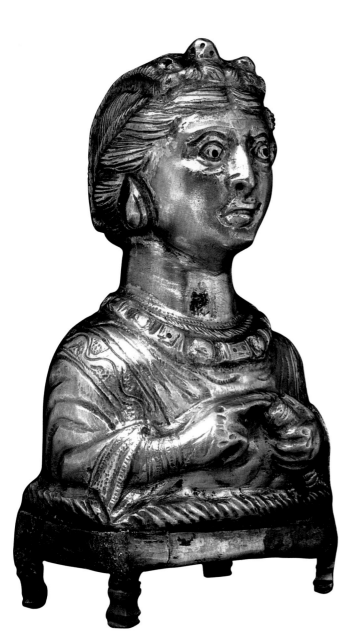

PEPPER AND SPICES HAVE been highly valued and traded for thousands of years. This ornate Roman gilded silver pepper pot was one of four pepper pots found in the Hoxne hoard, the richest find of treasure ever found in Britain.

Pepper was grown in India and came to the Roman world by sea across the Indian Ocean from India to Egypt, along with other spices and luxuries. *Piperatoria*, the special containers for this expensive spice, are very rare finds. This example takes the form of a hollow silver bust of an imperial lady of the late Roman period, probably a generic imperial image rather than a portrait of a specific empress. The pot has a disc in the base which could be turned to three positions: one closed, one with large openings to enable the pot to be filled with ground pepper, and a third which revealed groups of small holes for sprinkling.

From Hoxne, Suffolk, buried in the 5th century AD
Ht 10.3 cm
Treasure Trove, acquired with the aid of major grants from the National Heritage Memorial Fund, Art Fund, J. Paul Getty Trust, British Museum Friends, Goldsmiths Charitable Trust, Lloyds Private Banking and many donations from private individuals

Ivory salt cellar

THIS ORNATE IVORY salt cellar is evidence for different links of trade between Europe and West Africa a thousand years after the pepper pot on the previous page was used. It would have graced the table of a wealthy European family in the 1500s. The carvings show four Europeans, probably Portuguese, along the base. On the lid, in a boat, is a fifth figure holding a telescope.

This salt cellar was made in the West African kingdom of Benin specifically for Portuguese traders and marks the beginning of regular direct contact and trade between Western Europe and West Africa. Carved ivory objects were highly desired by the Portuguese. Although traditionally ivory carvings were produced only for the royal court in the city of Benin, the king allowed decorated salt cellars, horns, spoons and forks to be made for European visitors.

From Benin, Nigeria, 16th century AD
Ht 30 cm

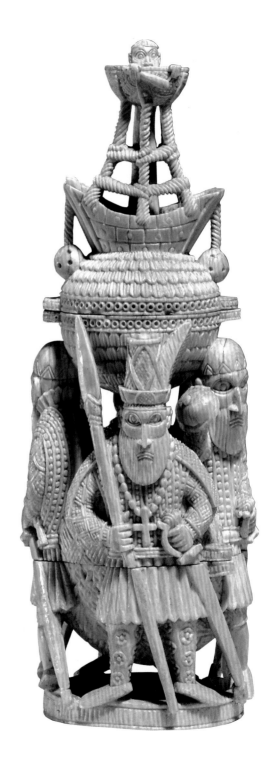

Scene from a satirical papyrus

THIS SATIRICAL PICTURE comes from a 3000-year-old document painted in Egypt during the Twentieth Dynasty (about 1186–1069 BC). It is one of several fragmentary papyri possibly found at the site of Deir el-Medina. These papyri form a unique collection of artistic works satirizing society during the reigns of the last Ramesside kings. The scenes are parodies showing animals undertaking human activities.

The natural behaviour of the animals is also exploited to satirical effect so that, in a reversal of the 'natural order', they are chosen as particularly inappropriate for the human activities they perform. For example, a cat is shown herding geese or ducks, and in these scenes foxes or jackals form a protective guard for their charges, possibly goats. To the left a lion and an antelope or gazelle play a board game, probably the popular Egyptian game of *senet*.

Possibly from Deir el-Medina, Thebes, Egypt, Late New Kingdom, c. 1100 BC
Ht 15.5 cm

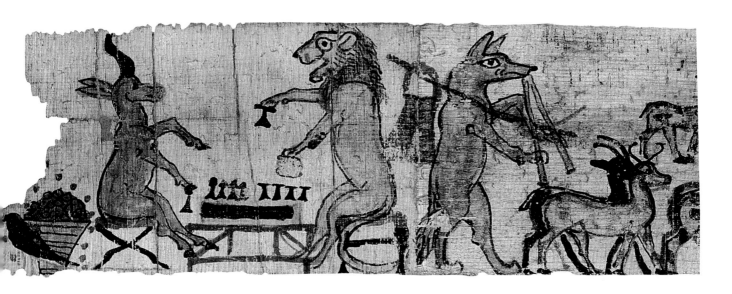

James Gillray (1756–1815), *Promis'd Horrors of the French Invasion, -or- Forcible Reasons for Negociating a Regicide Peace*

THE BRITISH MUSEUM holds one of the world's largest collections of prints. Some of the most famous are political satires and prints from the time of the French Revolution and subsequent wars against Napoleon. In this example, James Gillray is presenting a nightmare image of French soldiers in London after a successful invasion of Britain.

It was made in 1796, after Napoleon Bonaparte's lightning campaign in northern Italy, when Britain considered peace with France. The print is attacking supporters of one of the two main political factions in British politics of the time, the Whigs, showing them as supporting the foreign invaders and throwing up their hats and cheering outside their headquarters, Brooks's Club. In the centre of the scene the Whig leader, Charles James Fox, flogs the Tory Prime Minister, William Pitt. Many people are surprised that the British Museum collects a wide range of objects about politics and continues to acquire modern examples.

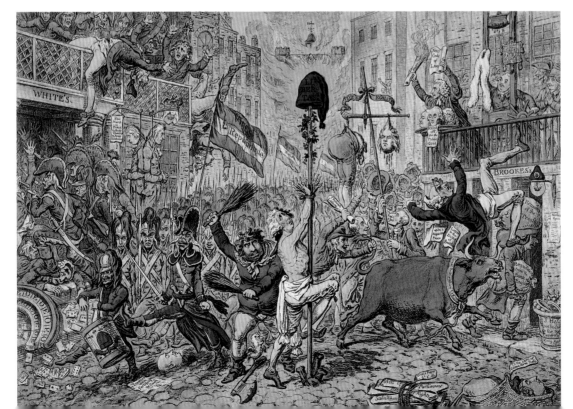

Published in London, AD 1796
Ht 32.4 cm

1 Seeing the Divine

ALL AROUND THE MUSEUM are images of gods, goddesses, saints, and figures from the myths and religious texts of almost every culture in the world. These range from great works of art to simple crafted artefacts, pieces that may have taken months to create or mass-produced as cheap objects for daily devotion. This plethora of pictures, statues and sacred objects reveals the central importance of the role religion has played in human life for at least the last 40,000 years. Some of the oldest works of art ever created (and the oldest in the Museum) were probably images of myth created for ceremony and ritual. Religious impulses have driven people throughout history to create images of the divine for a range of purposes. Some statues and images were a focus for worship while others might act as a container for the deity, or may actually be, or at times become, the deity. Other images were not intended for use in worship but created as a means for telling the myths and important stories of a religion, or even simply as decorative art.

As well as these images of gods and divine beings, there are many objects across the Museum collections that were used in rituals and worship, such as Olmec votive axes, or as containers for objects of veneration, such as the Buddhist and Christian reliquaries, or as souvenirs of pilgrimage or as aids for religious journeys. Some of the largest objects in the Museum are religious images from China and Easter Island. The size of these statues physically embodies the role religion has in people's lives but also shows how religious images were used to demonstrate the power of a group or to prove the wealth of an individual.

One of the oldest works of art in the British Museum, perhaps an image of an ancient myth

The objects in this chapter allow us to compare and contrast the ways different cultures and religions have conceived how the divine might look, with images of manifestations of the divine spanning 4000 years across the world. They include gods and goddesses from ancient Greece and Rome, Babylon and Mexico alongside Hindu deities, the Buddha, Christian saints and angels and deities from the Pacific and North America. There are striking differences between them, of course, but there are also similarities, such as a widespread conception of the divine as a human-like form. However, although the Museum contains numerous images of gods, goddesses and other divine beings, it is important to remember that not every religion considers it appropriate to create images of the divine. Of the three great monotheist religions that originated in the Middle East, Christianity is unusual in allowing, indeed often encouraging, images of Christ, Mary, angels, saints and other biblical scenes. In stark contrast, Islam and Judaism forbid images of God. Even in Christianity there have been movements that rejected, even actively destroyed, religious images. Examples include the iconoclastic movement in Byzantine Orthodox Christianity and some Protestant groups during the Reformation. For the first 300 years of Christianity very few

images seem to have been created showing Christ or scenes from the Bible. The British Museum has one of the oldest known images in the history of Christianity, which depicts Christ as a human, and also the oldest known image of the Crucifixion.

Images of the Buddha are also common across Asia, yet it was considered inappropriate for 400–500 years after the Buddha's death to create an image of the Buddha in his human form. An interesting question for a museum, considering how many images of the divine have been created across the world, is how to convey the choice not to create such pictures and statues – perhaps by displaying an empty case?

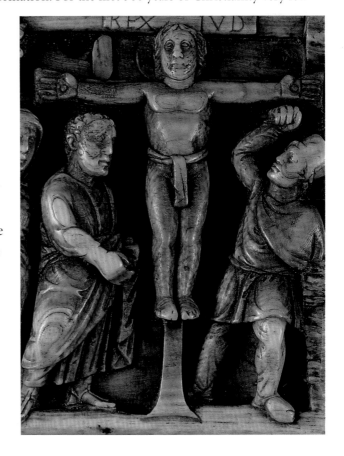

Detail from one of the oldest known images of the Crucifixion in Christian art

Limestone panel depicting the *Buddhapada*

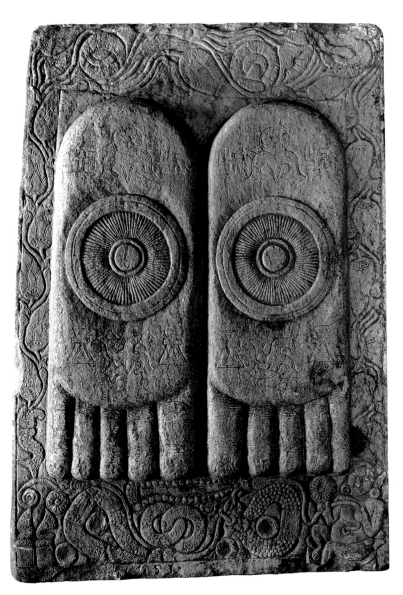

IN EARLY BUDDHISM, images of the historical Buddha as a human figure were not considered appropriate. Instead the Buddha was represented through symbols such as those on this relief, which depicts the *Buddhapada* (Buddha's footprints). The 'lotus feet' of gods and gurus are still revered in India today, and worshippers are expected to have bare feet in temples, shrines and private houses. The Buddha's feet can be identified by their characteristic toes of equal length.

In Buddhist sculpture, divine status is indicated by auspicious signs or special symbols. On this panel, at the centre of each foot, is a finely spoked *dharmachakra* (Wheel of the Law, set in motion when the Buddha gave his First Sermon). An important change took place in Buddhist art in the centuries after this image was made, as the first images of the Buddha in human form began to be created.

From the Great Stupa at Amaravati, Guntur District,
Andhra Pradesh, India, 1st century BC
Ht 67.5 cm
Transferred from the India Museum

Icon of the Triumph of Orthodoxy

THIS CHRISTIAN ICON, a devotional image from the Orthodox tradition, is itself a picture of another icon and celebrates the end of a period in Orthodox Christianity when the use of icons and other religious images were banned and destroyed.

Strongly opposed views about the use of images of Christ and the saints in Orthodox Christian worship led to bitter conflict and violent destruction of images in the eighth century AD (iconoclasm). The restoration of holy icons under the Byzantine empress Theodora in 843 became known as 'The Triumph of Orthodoxy'. The most famous icon from Constantinople, that of the Virgin Mary Hodegetria (Mother of God), is depicted at the top of this icon. It was believed to have been painted by St Luke and therefore to be an actual life portrait of the Virgin. The regent empress Theodora and her young son, the emperor Michael III (r. 842–67), appear on the left, wearing jewelled crowns and robes.

From Constantinople (modern Istanbul), Turkey c. AD 1400
Ht 39 cm
Purchased with the assistance of the Art Fund (Eugene Cremetti Fund)

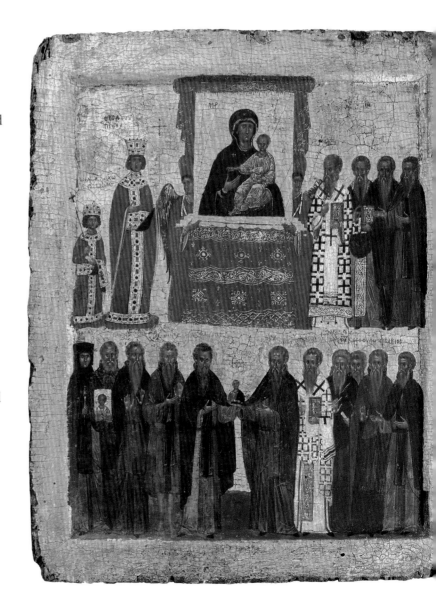

Hinton St Mary mosaic

THIS MAGNIFICENT MOSAIC floor contains what is thought to be one of the earliest representations of Christ in human form in the history of Christian art. It was made 300 years after the religion began, when Christianity had become the official religion of the Roman empire. Before this time, Christians represented Christ through symbols. The mosaic floor was made for a large villa in Britain and the design reflects how old pagan beliefs were blended with the new religion.

One part of the mosaic shows the Greek mythological hero Bellerophon, mounted on his winged horse Pegasus. In the centre of the larger pavement is a roundel (shown here) containing the bust of a clean-shaven man. Behind his head are the Greek letters *chi* and *rho*, the first two letters of Christ's name. Placed together as a monogram like this, they formed the Chi Rho, the usual symbol for Christianity at this time.

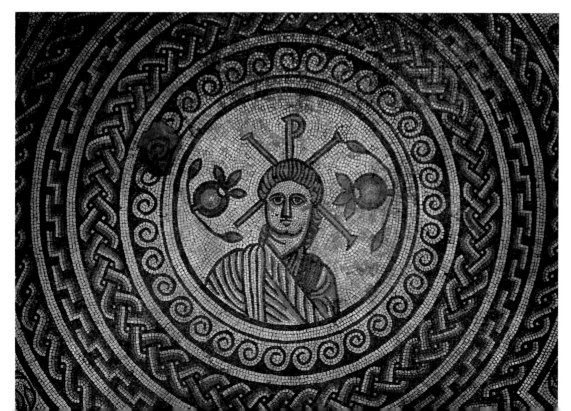

From Hinton St Mary, Dorset, England, 4th century AD
L. 810 cm, W. 520 cm

Head from a statue of the Buddha

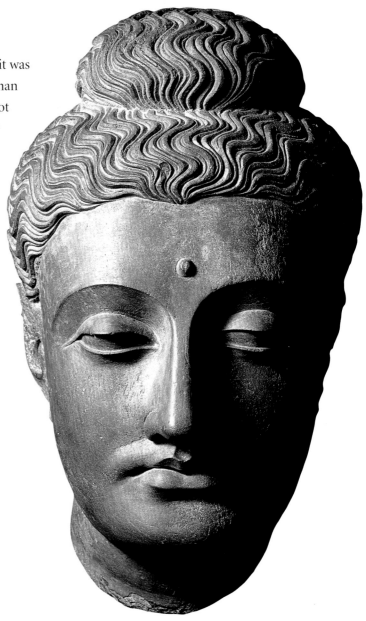

As shown on previous pages, in early Buddhism it was not thought appropriate to represent the Buddha in human form. The images of the Buddha so familiar today did not begin to appear until the first to third centuries AD, over 500 years after the Buddha's death. This early image of the Buddha was made in Gandhara, an area that today is in Pakistan and Afghanistan.

Due to its geographical position, Gandhara was always a crossroads of the major Asian trade routes. Following the invasion by Alexander the Great in 326 BC, Gandhara was ruled by Greek kings for over 300 years until the region fell to the Sakas, Parthians and Kushans. Drawing from the various cultures that either settled or moved along these trade routes, Gandharan art took on a distinctive style, combining Graeco-Roman, Indian, Chinese and Central Asian influences.

From Gandhara, northwest Pakistan, 1st–5th centuries AD
Ht 38.7 cm
Collected by Major-General Sir Frederick Richard Pollock
Gift of Lord Buckmaster as executor of the Dighton Pollock Bequest

Raphael (1483–1520), *The Virgin and Child*

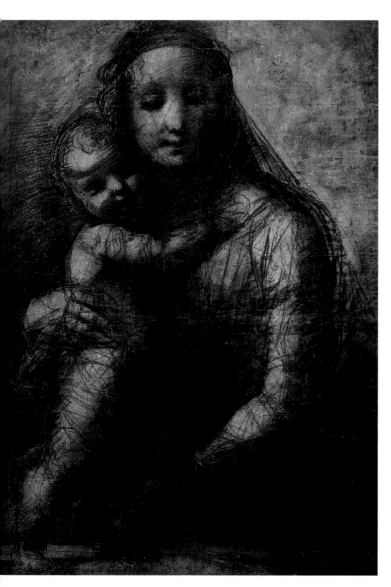

SOME OF THE WORLD'S greatest works of art depict religious imagery. The image of the Virgin Mary holding Christ her son, has been drawn, painted and sculpted by artists thousands of times.

This cartoon (full-size preparatory drawing) was made by the Italian Renaissance artist Raphael and corresponds to a painting by him, known as the *Mackintosh Madonna*, now in the National Gallery, London. The painting has been damaged and heavily restored, but this black chalk drawing gives us an excellent idea of what it originally looked like. The figures of the Mother and Child are arranged in a pyramidal composition recalling the drawings and paintings of Leonardo da Vinci, Raphael's older contemporary, which he studied while he was in Florence. The forms in this drawing, however, are fuller and more solid.

From Italy, c. AD 1510–12
Ht 70.7 cm

Gilded bronze figure of Tara

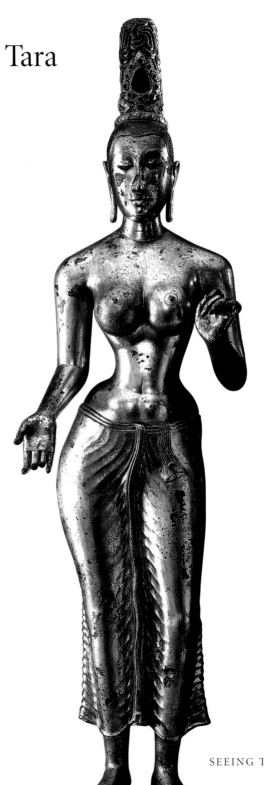

WE DO NOT KNOW the name of the artist who created this image of the goddess Tara. Images of Tara have been made for hundreds of years. She was originally one of the Hindu mother goddesses, and with the development of Buddhism she became associated with the consort of Avalokiteshvara, the *bodhisattva* of compassion. *Bodhisattva* are beings who have reached the highest degree of enlightenment, but choose to remain in the world to help in the salvation of others.

This figure was made from a single piece of solid cast and gilded bronze. It is one of the finest examples of figural bronze-casting known from Asia. Originally the eyes and hair would have been inlaid with precious stones, and a small niche in the headdress would have contained a seated image of the Buddha. Tara's right hand is shown in the position of *varadamudra*, the gesture of giving; her left hand is empty but may once have held a lotus flower.

Found between Trincomalee and Batticaloa, Sri Lanka, made in the 8th century AD
Ht 143 cm
Gift of Sir Robert Brownrigg

'Queen of the Night' relief

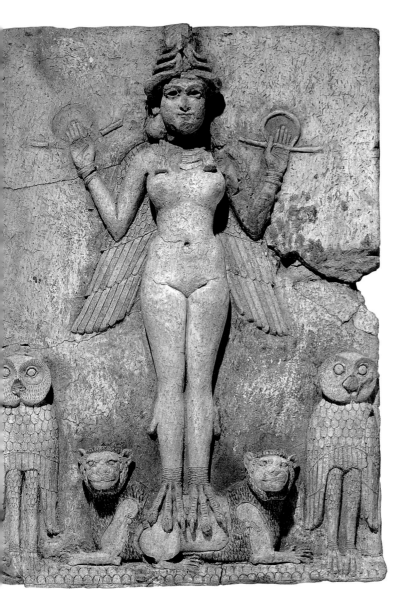

THIS SPECTACULAR TERRACOTTA plaque shows the image of an unidentified goddess from ancient Babylon. The plaque is made of baked straw-tempered clay and modelled in high relief. The curvaceous central female figure wears the horned headdress characteristic of Mesopotamian deities and holds a rod and ring of justice, symbols of her divinity. Her wings hang downwards, indicating that she is a goddess of the Underworld. She was originally painted red, with multicoloured wings, and the background was originally painted black, suggesting that she was associated with the night.

The plaque probably stood in a shrine. The figure could be an aspect of the goddess Ishtar, the Mesopotamian goddess of sexual love and war, or of Ishtar's sister and rival, the goddess Ereshkigal who ruled over the Underworld, or of the demoness Lilitu, known in the Bible as Lilith.

From southern Iraq, 1765–1745 BC
Ht 49.5 cm
Acquired with the support of the Heritage Lottery Fund, British Museum Friends, Art Fund (with a contribution from the Wolfson Foundation), Friends of the Ancient Near East, Sir Joseph Hotung Charitable Settlement and The Seven Pillars of Wisdom Trust

Sandstone stele with a figure of Harihara

THIS SCULPTURE FROM India combines two Hindu deities in a single being, called Harihara. The four-armed figure is the composite form of the gods Shiva and Vishnu. The right side represents Shiva and the left side Vishnu. The background figures on the right are associated with Shiva and include his sons Ganesha and Kartikeya. The figures on the left side and on top of the stele are Vishnu's ten incarnations. Shiva's hair is in an elaborate coif adorned with a serpent and skull, and he holds a rosary and a trident symbolic of his power and ascetic nature. In keeping with his regal role as the preserver of order in the universe, Vishnu wears a tall kingly crown. In his ear he wears an elaborate earring and he holds his attributes of the conch and wheel. Sculptures such as this would have been placed in a niche in a temple wall.

From Khajuraho, Madhya Pradesh, central India,
10th century AD
Ht 165 cm
Bridge Collection

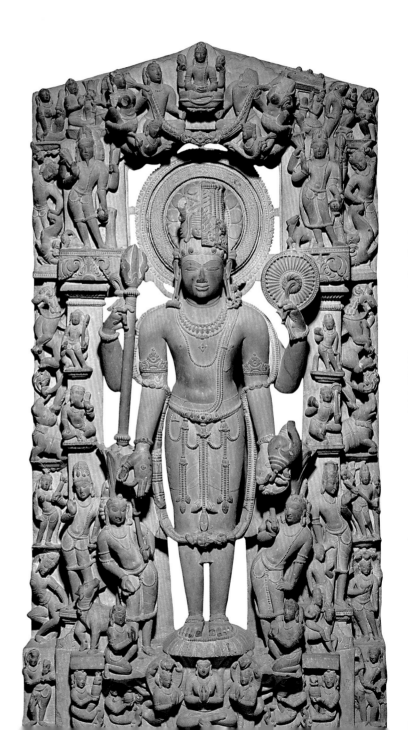

Bimaran reliquary

THIS GOLD RELIQUARY, an elaborate container for holding holy relics, was found in the nineteenth century in a stone box with an inscription stating that it contained some of the actual bones of the Buddha. However, both its lid and contents were missing. The reliquary was deposited in a stupa with pearls, beads and four coins dating to about AD 50 and is a crucial object in the study of the history of Buddhism.

If the reliquary is from the same period as the coins, then it is the best-preserved example of goldwork to survive from early India and its decorative frieze contains one of the earliest depictions of the Buddha. In the frieze, framed by arcades, the Buddha is flanked by Indra and Brahma, gods of early Indian origin. Also depicted is a worshipper, possibly a *bodhisattva* – a semi-divine being who has attained enlightenment but remains in the world in order to help the non-enlightened.

From stupa 2 at Bimaran, Gandhara, 1st century AD
Ht 6.7 cm

Holy Thorn reliquary

THIS CHRISTIAN RELIQUARY was made to house a thorn from the Crown of Thorns, the wreath of thorns placed on the head of Christ at his crucifixion. Like the bones of the Buddha, the Holy Thorn was a very important and powerful religious relic.

A dramatic scene of the Last Judgement surrounds the relic. Around the outside are the twelve Apostles, with God the Father at the top. At the bottom, four angels sound trumpets as the dead emerge from their tombs. Behind the figure of God is a gold relief of the Holy Face on the Cloth of St Veronica, a fragment of which may have been held in the secondary compartment at the reverse. This is protected by two gold doors decorated with images of saints Christopher and Michael. It is thought the reliquary may be connected to Jean, Duc de Berry (1340–1416).

From Paris, c. AD 1400–10
Ht 30.5 cm
Bequeathed by Baron Ferdinand de Rothschild

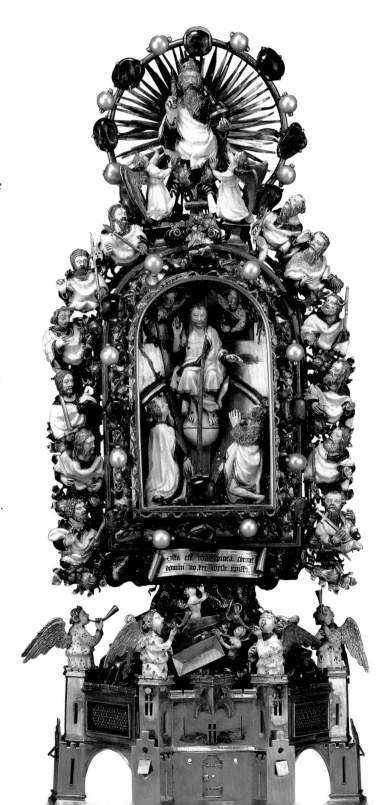

Wooden *bodhisattva* mask

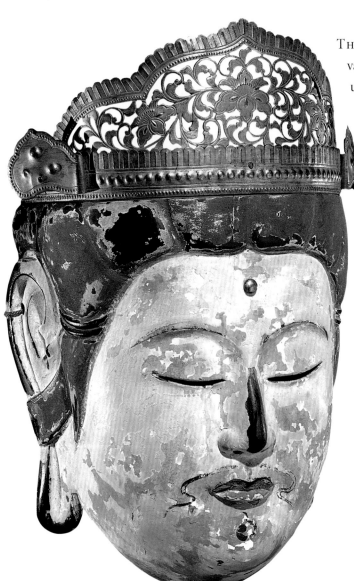

THE MUSEUM CONTAINS numerous masks from various parts of the world, many of which were made for use in religious ceremonies. This lacquered and gilded wooden mask from Japan is over 700 years old. It represents a Buddhist *bodhisattva* and would have been worn during a *gyōdō* ceremony. This was an outdoor procession of Buddhist priests wearing masks, led by dancers carrying a *shishi* (lion) mask to exorcise the route. Often these processions were part of the inauguration of a new temple or a dedication. The masks represent specific Buddhist figures including guardian deities, dragon gods and *bodhisattvas. Bodhisattva* masks are particularly associated with the *raigō* forms of these ceremonies.

From Japan, Kamakura period, 13th century AD
Ht 23 cm
Gift of Lady Francis Oppenheimer

Mask of the *Nulthamalth* (fool dancer)

THIS MASK WAS MADE by members of the Kwakwaka'wakw nation, who live on Vancouver Island and the surrounding mainland of the Canadian province of British Columbia. It is used during the potlatch, a ceremony in which wealth is demonstrated through the act of giving it away, which is an important element of Kwakwaka'wakw culture.

The *Nulthamalth* (fool dancer) is a character in the Kwakwaka'wakw Winter Ceremonial who enforces correct behaviour. These beings are said to have very large streaming noses and matted hair and, despite their role in the potlatch, they are thought to hate cleanliness and order. A slimy mucus substitute is spread around during the dance, and the performer afterwards pays for damage to the guests' clothing and possessions.

It has been suggested that this particular type of nineteenth-century mask may incorporate characteristics from a carved lion's head found on the figurehead or decoration of a European sailing ship.

Kwakwaka'wakw, from British Columbia, 19th century AD
Ht (without hair) 33.5 cm
Gift of Mrs H.G. Beasley

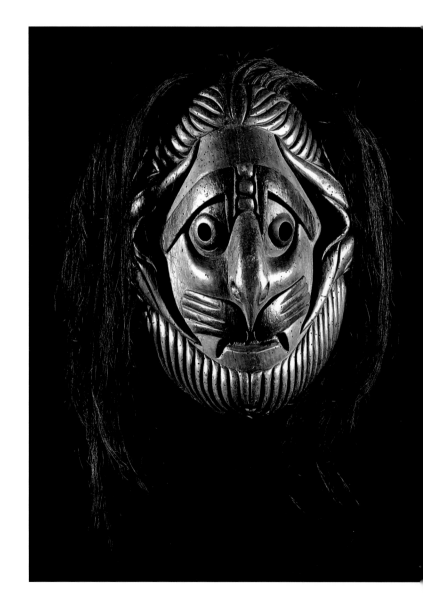

Marco Zoppo (*c.* 1432–78), *Dead Christ Supported by Angels*

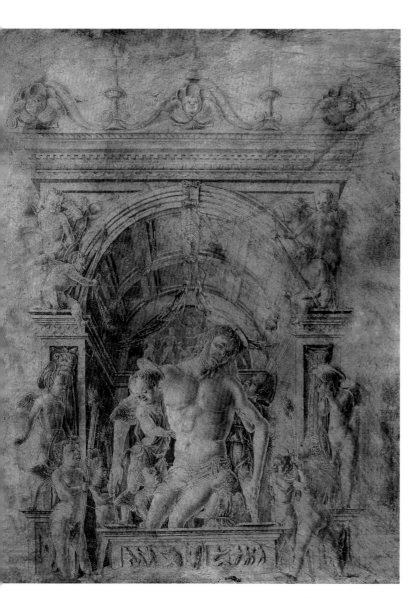

THE INTENSITY OF THE PAIN and suffering depicted here on Christ's face, together with the emotions of the angels, suggest that this drawing on vellum was designed as a private work for personal devotion. Vellum was an extremely expensive medium, and it is possible that this drawing was made for presentation to a patron or as a highly finished work in its own right.

Most of the drawing was executed in brush, though the architecture and some additions to the faces of the angels are drawn in a fine pen. Christ's torso is particularly well modelled, and the drapery of the two angels who hold Christ's upper body is depicted with great intricacy. Zoppo, who was originally from the area around Bologna, evidently studied the Paduan works of the Florentine sculptor Donatello (1386–1466) during his brief apprenticeship in the city from 1453 to 1455.

From Italy, c. AD 1455–60
Ht 35 cm
Purchased with the assistance of the Heritage Lottery Fund

Mithras slaying a bull

THE CULT OF MITHRAS originated in Persia but spread throughout
the Roman empire during the first three centuries AD. In this marble
statue the god Mithras is depicted killing a bull, the spilling of whose
blood was believed to bring about the rebirth of light and life. The dog and
the snake trying to lick the blood feature prominently in Persian religious
imagery, as does the scorpion attacking the bull's genitals.

 After a secret initiation, devotees of the cult of Mithras would rise
through ranks such as 'soldier', 'raven' and ultimately 'father'. They ate
bread and water, representing the meat and blood
of the bull, at communal meals. This,
combined with the cult's emphasis on
regeneration, earned them the particular
enmity of the Christians. Mithraism's
popularity lay partly in its appeal to the
army, but like all mystery religions
(including Christianity) it benefited
from the move towards
monotheism in the Late Empire.

From Rome, 2nd century AD
Ht 133 cm

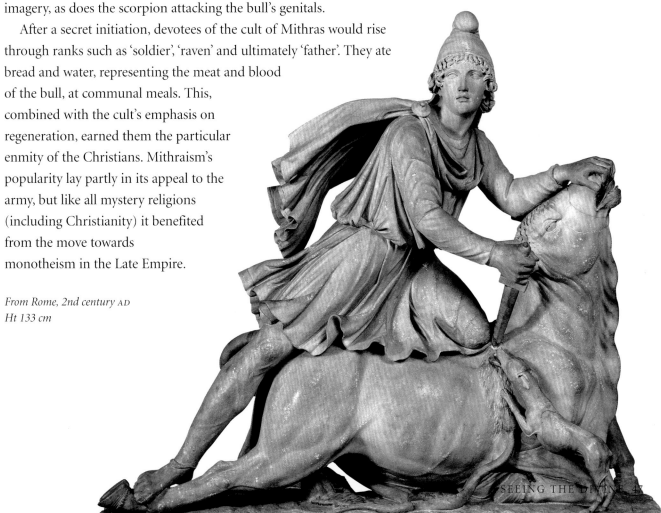

Nataraja, Lord of the Dance

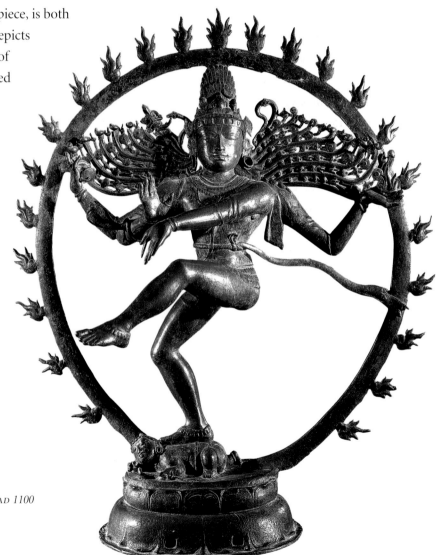

THIS BRONZE FIGURE, cast in a single piece, is both a creative and a technical masterpiece. It depicts the Hindu god Shiva as Nataraja, the lord of the dance. Nataraja figures, which are placed in temple shrines and paraded during festivals, were particularly popular during the Chola dynasty in Tamil Nadu in the tenth to twelfth centuries.

Shiva as Nataraja appears at the end of one cosmic cycle and the beginning of the next, associated with both creation and destruction. In one hand he holds fire, symbolizing destruction, and in another the double-sided drum which summons up new creation. Nestling in his hair is the small figure of the goddess Ganga, the personification of the holy River Ganges. Also visible in his hair are the crescent moon and the intoxicating datura flower, both closely associated with his wild nature. Beneath his foot he tramples the dwarf of ignorance, Apasmara.

From Tamil Nadu, southern India, Chola dynasty, c. AD 1100
Ht 89.5 cm

Upper part of a colossal limestone statue of a bearded man

THIS LARGE GREEK sculpture from Cyprus probably represents a priest of the god Apollo. It would originally have been placed in the centre of a series of statues in the front of the main court of the sanctuary of Apollo.

In 526–525 BC Cyprus became part of the Persian empire. As a result Cypriot sculptors became influenced by art from other parts of the empire, which then stretched from Greece and Egypt to India and Afghanistan. This figure combines both Greek and Persian influences. He is dressed in Greek fashion in a *chiton* (tunic) partly covered by a *himation* (cloak). The short hair, secured by a laurel wreath decorated with rosettes, is also East Greek in style, as is the smile on the lips. However, the double bank of snake curls on the forehead and the treatment of the artificially curled beard reflect Achaemenid Persian fashion.

From the Sanctuary of Apollo at Idalion (modern Dhali), Cyprus, c. 500–480 BC
Ht 104 cm
Excavated by Sir Robert Hamilton Lang

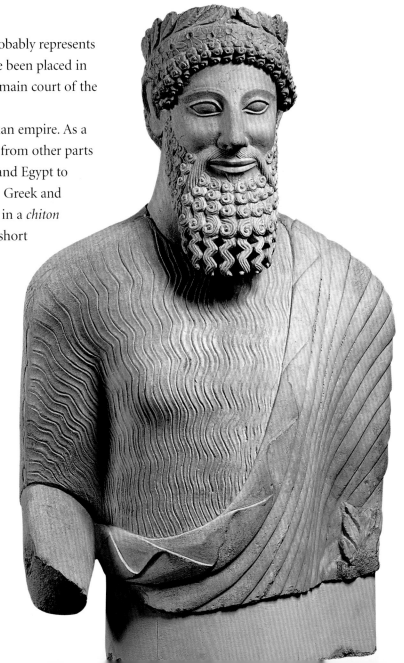

Wooden male figure

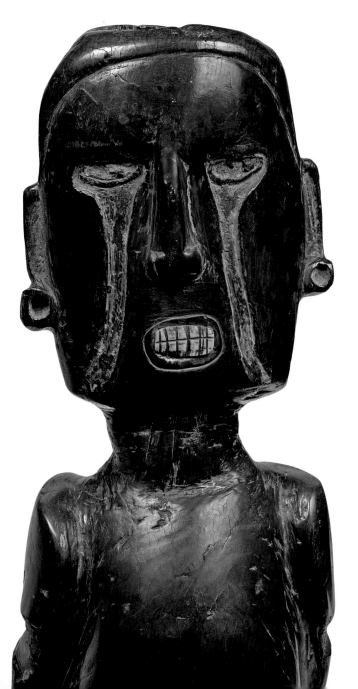

THIS RARE WOODEN image is evidence for the religious beliefs and rituals of the people who lived in the Caribbean before the arrival of European conquerors. It was made by Taíno, whose communities were ruled by elite classes of chiefs, called *caciques*, and spiritual leaders.

Taíno religion focused on the spiritual forces of the human world versus the forces of the natural world. These opposites balanced each other and potentially affected humans in both good and bad ways. Natural forces included the spirits of rain, manioc and the earth, and the Taíno created images of these deities in stone and wood. This standing wooden male figure has channels carved from its eyes down its cheeks. These 'tear channels' are associated in Taíno myth with twin *zemis* (spirit helpers), one related to the sun and the other to rain. This figure may therefore represent a deity or ancestor.

From Jamaica, AD 1200–1500
Ht 40 cm
Christy Collection
Isaac Alves Rebello Collection

Clay mask of the demon Huwawa

THIS CLAY MASK is in the shape of coiled intestines, represented by one continuous line. In Mesopotamia the examination of the shape and colour of the internal organs of a sacrificed animal was a method for predicting the future. Experts compiled records of these signs or omens together with the events they were believed to predict.

A cuneiform inscription on the back of this mask suggests that it represents intestines found in the shape of the face of the demon Huwawa (also called Humbaba), who appears in the epic of Gilgamesh as the guardian of the Cedar Forest who is defeated by Gilgamesh and Enkidu. Intestines in such a shape would be an omen of revolution. The divination expert who made the mask is named in the inscription as Warad-Marduk. It was found at Sippar, the cult centre for the sun god Shamash, who was responsible for omens.

From Sippar, southern Iraq, c. 1800–1600 BC
Ht 8.4 cm

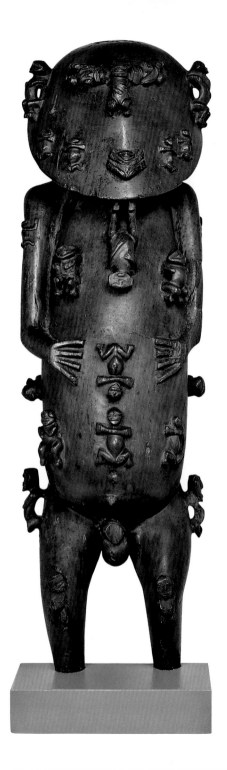

Carved hardwood figure known as A'a

THIS FIGURE PROBABLY represents the god A'a and was made on the Island of Rurutu in the Pacific Ocean. It was one of a number of figures presented to a mission station by the Rurutuans in 1821 as a symbol of their acceptance of Christianity.

The god is depicted in the process of creating other gods and men, represented by the small figures covering his body. The figure itself is hollow and originally contained 24 small figures, since destroyed. Contemporary Rurutuans explain that the exterior figures correspond to the kinship groups that make up their society.

Since it came to London the figure has attracted considerable attention and is widely regarded as one of the finest pieces of Polynesian sculpture still in existence. It influenced the twentieth-century British sculptor Henry Moore and is also the subject of a poem by William Empson, 'Homage to the British Museum'.

Made on Rurutu Island, Polynesia, probably 18th century AD
Ht 117 cm

Bronze figure of the Buddha Shakyamuni

THIS BEAUTIFUL BRONZE statue of the Buddha was created in a Buddhist monastery workshop, probably in the Indian state of Bihar. It was made shortly after the end of the Gupta dynasty (AD 320–550) and displays many of the features typical of the Gupta period: the figure is soft, gentle and simple, with heavy-lidded, downcast eyes and 'snail shell' curls. The downward cast of the eyes also indicates that it was designed to be installed in an elevated position, on an altar, and, on occasions, to be carried in processions.

The figure displays a number of the supernatural marks of Buddhahood, including the *usnīsa* (protuberance at the top of the head) and webbed fingers. This type of Buddha is important in the stylistic development of Indian cultural influence and is credited with creating the quintessential Buddha type, which was copied throughout the Asian Buddhist world.

From eastern India, 7th century AD
Ht 35.5 cm
Jointly owned by the British Museum and Victoria and Albert Museum, purchased with contributions from the Heritage Lottery Fund, Art Fund, Brooke Sewell Permanent Fund (BM), Victoria and Albert Museum, Friends of the V&A and private donors

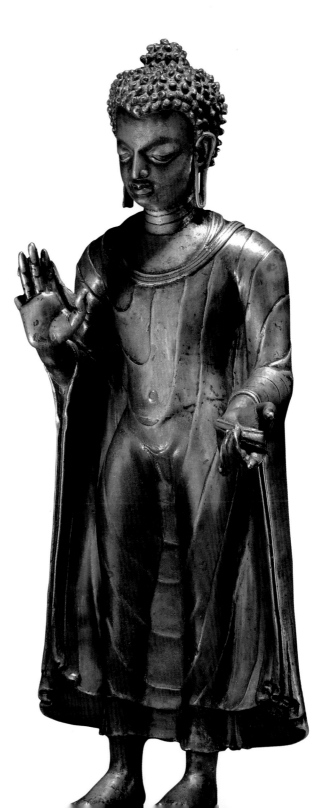

Door lintel (*pare*) from a house

RELIGIOUS IMAGES have been made in many different materials, but those in perishable materials such as wood may not survive across the centuries. This wooden carving is the lintel (*pare* in Maori) from above the door of a small house. The image is thought to represent Papatuanuka, the Earth Mother, giving birth to the principal gods. Another interpretation is that it depicts Hinenuitepo, the goddess of death, defeating the demigod Maui as he attempts to gain immortality for mankind.

The central figure in such images is usually depicted as female, but in this case the genital area has been carved with a face mask. The figure is flanked by outward-facing *manaia* – a motif in which the body is often depicted in profile. The three figures have inlaid pearl shell eyes, and the area between them is carved with smaller figures, loops and spirals.

From the Poverty Bay area, New Zealand, AD 1800–20
W. 98 cm
Gift of Sir George Grey

Wooden guardian figure

THIS RARE WOODEN image is nearly 2500 years old. Figures like this were placed as guardians in tombs in the ancient Chinese state of Chu in what is today Hunan and Hubei province. When this figure was made, the Chu ruled a large part of China.

The Chu venerated and feared a large number of spirits, and shamans were used to intercede and communicate with them. The wearing of antlers seems to have been significant in shamanistic rituals. Carved wooden figures, such as this example with dry lacquer antlers, probably represented the shamans or their powers. The Chu are renowned for their sculptural tradition and wood-carving skills, which also embraced more realistic creatures such as cranes and deer.

From Southern China, Eastern Zhou period, 4th century BC
Ht (from base) 43.7 cm

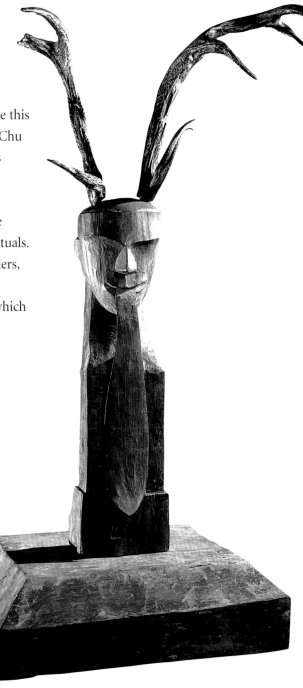

Michelangelo Buonarroti (1475–1564), *Epifania*

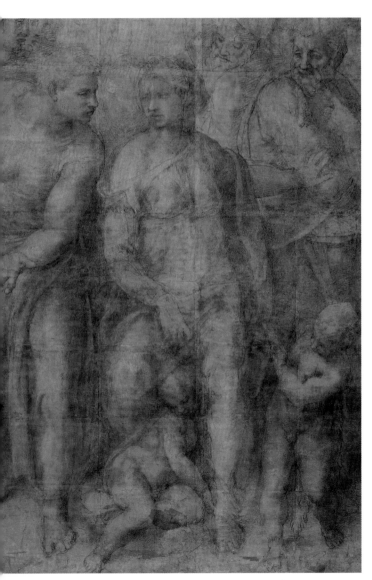

THIS CARTOON (a full-size preparatory drawing) is drawn on 26 sheets of paper and is over 2 metres high. Many alterations are visible, showing how Michelangelo changed his mind about the forms and the composition.

In the centre is the Virgin Mary, with Christ sitting between her legs. She pushes away a male figure to the right, probably St Joseph, with the infant St John the Baptist in front. On the left is an unidentified figure and others are just visible in the background. The imagery refers to the brothers and sisters of Christ mentioned in the Gospels. The title may refer to the fourth-century Greek saint St Epiphanias (*c.* AD 315–403), who believed they were the children of St Joseph by a previous marriage and that Mary's marriage to Joseph was never consummated. This would also explain Mary's gesture towards Joseph.

From Rome, c. AD 1550–53
Ht 232.7 cm
Gift of John Wingfield Malcolm

Stone sculpture of Tlazolteotl

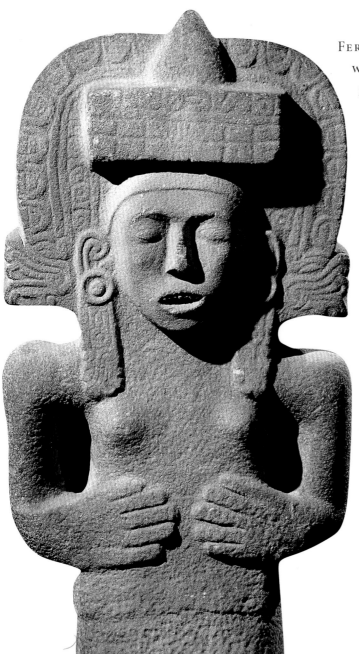

FERTILITY IS A recurring theme in Huastec art, in which it is represented by stone sculptures of female goddesses, elderly men and phalluses. The female figures are associated with Tlazolteotl, an earth goddess. Representations of Tlazolteotl are also found in codices (painted books), pottery figurines and engraved on shell pendants.

The Huastec inhabited the northern part of the Gulf Coast of Mexico, roughly the modern states of Veracruz, San Luis Potosí, Hidalgo and Tamaulipas. It was a fertile region where cotton was an important crop and a principal item of tribute and trade.

Sculptures of Tlazolteotl share characteristics such as a rigid posture, hands over their stomach, bare breasts and long skirt. The large headdress is generally composed of a rectangular section with a conical cap on top and a fan-shaped crest. However, in this example, there are no indications of clothing, and the fan-shaped crest is carved on the back of the head.

Huastec, from the River Pánuco region, Mexico, AD 900–1521
Ht 93 cm
Gift of Captain Vetch

Bronze head of Apollo ('Chatsworth Head')

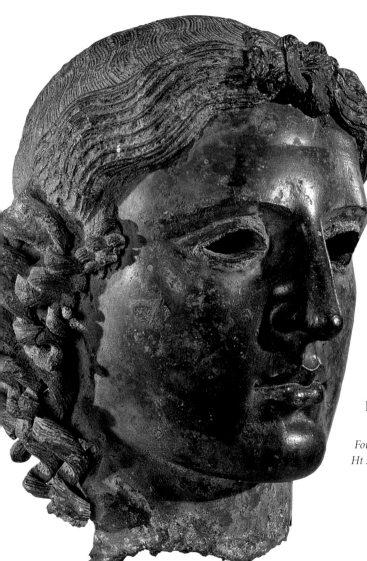

THIS BRONZE HEAD comes from a slightly over life-size statue. At the time it was made, in the fifth century BC, the Greeks usually represented only deities as over life-size, so it is probably the image of a god rather than an idealized human. The long curly locks of hair suggest that it is from a statue of the 'golden-haired' god Apollo, who was associated with light, beauty and music. The eyes were originally inlaid and the lips may have been painted.

This statue was discovered in Cyprus in 1836. Surviving bronze statues are rare, as they were often melted down for reuse over the centuries, and unfortunately the rest of this statue met the same fate shortly after its discovery. The head is known as the Chatsworth Head because it once belonged to the Dukes of Devonshire and was kept at Chatsworth House in Derbyshire.

Found near Tamassos, Cyprus, c. 460 BC
Ht 31.6 cm

Wooden figure of the war god Ku-ka'ili-moku

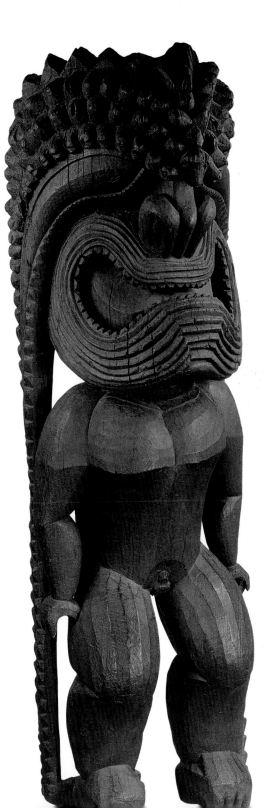

THIS LARGE AND intimidating figure is a temple image of the Hawai'ian war god Ku in his aspect as Ku-ka'ili-moku (snatcher of land). Standing over 2.5 metres high, it is not meant to be a representation of the deity but a receptacle which the god would be induced to enter through prayer and ritual. Only when the god was within would it become sacred.

The figure is characteristic of the god Ku but his hair, incorporating stylized pig heads, suggests an additional identification with Lono, god of peace, fertility and music. Ku was the personal god of King Kamehameha I, who unified the Hawai'ian islands in 1795. Kamehameha built a number of temples to Ku in the Kona region of Hawai'i, seeking the god's support in his further military ambitions. This figure was erected by Kamehameha and is likely to have been a subsidiary image in the most sacred part of one of these temples.

From Hawai'i, probably AD *1790–1810*
Ht 272 cm
Gift of W. Howard

Bronze mask of Dionysos

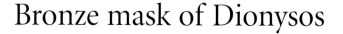

THIS MASK ORIGINALLY supported the handle of a ritual vessel with a handle ring (now missing) projecting from the top of the head. It shows great craftsmanship, both in the high quality of the bronze casting and in the use of metal inlay to highlight the details. Grapes, ivy berries and the lips are inlaid with copper, an iron band encircles the forehead, and the eyes are inlaid with silver.

This image is probably a result of the merging of Greek and Egyptian religions after Alexander the Great conquered Egypt in 332 BC. Dionysos, the Greek god of wine, became assimilated with Osiris, consort of the Egyptian god Isis. The vessel of which the mask was part was probably a cross between a Dionysiac wine-mixing bowl and the ritual bucket (*situla*) used in the worship of Isis to hold 'the milk of life'.

From Greece, c. 200 BC–AD 100
Ht 21.4 cm
Purchased with the aid of the National Heritage Memorial Fund

Jade votive axe

THIS AXE WAS not intended for use as a tool but as a religious and ceremonial object. It was carved from jade by the Olmec culture of Mexico over 2000 years ago. The axe is shaped as a figure, with a large head and short stocky body narrowing into a blade edge. Such votive axes combine the features of humans and animals such as the jaguar, toad or eagle. The flaming eyebrows, as on this example, have been interpreted as representing the crest of the harpy eagle. The combination of human and animal traits and representations of supernatural beings is common in Olmec art.

Most Olmec axes have a pronounced cleft in the middle of the head. This indentation has been interpreted as the open fontanelle (soft spot) on the crown of newborn babies or the deep groove in the skull of male jaguars or on the heads of certain species of toads.

From Mexico, 1200–400 BC
Ht 29 cm
Christy Collection

Corbridge *lanx*

THIS MAGNIFICENT silver platter is decorated with a scene of classical pagan gods. It was found on the bank of the River Tyne at Corbridge, near Hadrian's Wall, in 1735. The Latin term *lanx* means tray.

The scene shows a shrine of Apollo with the god holding a bow, his lyre at his feet. His twin sister Artemis (Diana), the hunter goddess, enters from the left, and the helmeted goddess with her hand raised to indicate conversation is Athena (Minerva).

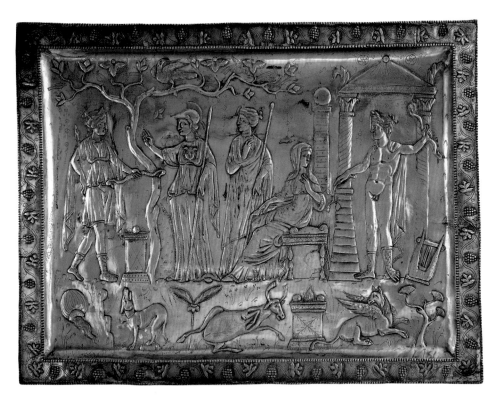

The decoration of the platter and its style indicate that it was made in the fourth century AD, at which time Christianity was the official religion of the Roman empire. Although it was found in northern England, it was probably made in the Mediterranean area, in North Africa or the Near East. Ephesos, in modern Turkey, has been suggested because of its links with the cults of Artemis and Apollo.

Found at Corbridge, Northumberland, 4th century AD
L. 50.6 cm
Presented by the Secretary of State for National Heritage, with the aid of the National Heritage Memorial Fund,
Art Fund and British Museum Friends

Stone sculpture of Shakti-Ganesha

GANESHA IS THE elephant-headed son of the Hindu gods Shiva and Parvati, renowned throughout India as the Lord of Beginnings. For this reason he is worshipped before the start of any new venture.

Ganesha is usually depicted with one head and four arms, but in this rare sculpture he is shown with five heads and ten arms. He holds weapons including a trident, a discus and a bow and arrow as well as other objects such as a pomegranate, a fly-whisk and his broken tusk. Ganesha usually appears alone, but here a female *shakti* (consort) sits on his left leg. His *vahana* (vehicle), the small rat on which he rides, appears in the cave at the base of the image. The base is supported by *ganas* (dwarves), the attendants of Shiva and Parvati. Ganesha is the chief of these dwarves, and another name for him is Ganapati ('lord of the *ganas*').

Probably from Konarak Orissa, eastern India,
13th century AD
Ht 102 cm
Bridge Collection

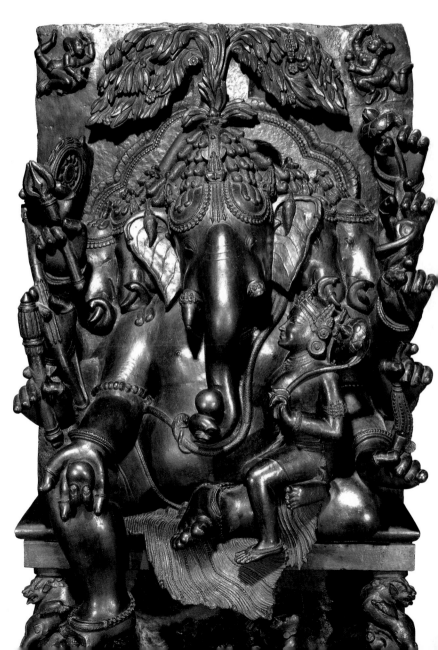

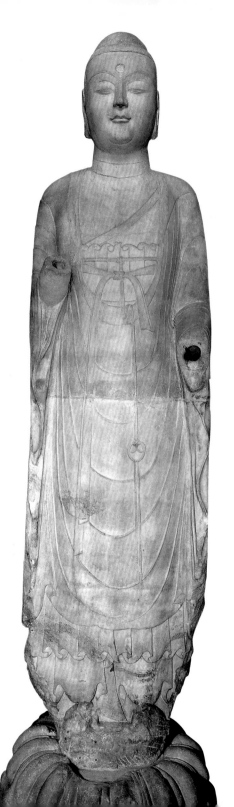

Marble figure of the Buddha Amitabha

TWO OF THE LARGEST objects in the Museum are religious images. This huge marble statue of the Buddha Amitabha is almost 6 metres tall and originally stood in a temple in northern China. It was erected by the first emperor of the Sui dynasty, Wendi, who converted to Buddhism and encouraged its spread throughout China.

Wendi distributed Buddhist relics throughout his empire and was responsible for the creation and repair of many religious images. In Buddhist teaching, Amitabha rules over the Western Paradise, a heavenly land into which all who call upon his name will be reborn.

The hands are missing, but the right hand would have been raised, palm outwards, in the gesture of reassurance (*abhaya mudra*) and the left hand lowered in the gesture of liberality (*varada mudra*). The figure is very solid with crisply carved drapery in flat folds, typical of the Sui period.

Dedicated at Chongguang temple, Hancui village, Hebei province, northern China,
Sui dynasty, AD 585
Ht 580 cm
Gift of the Chinese Government in memory of the Chinese Exhibition in London 1935–6

Hoa Hakananai'a

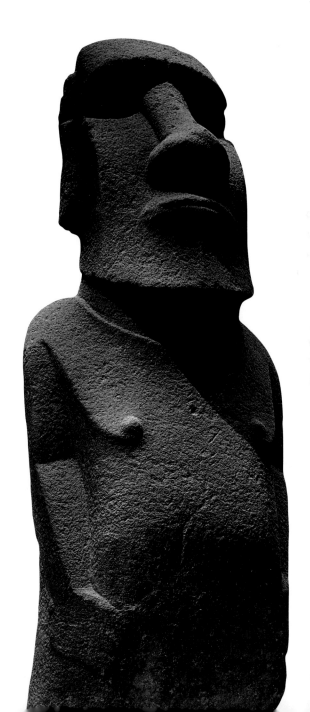

THIS MONUMENTAL carving of the head and torso of a man is known as Hoa Hakananai'a (stolen or hidden friend). Easter Island is famous for monolithic basalt statues (*moai*) such as this one. They were probably carved to commemorate important ancestors and were made from around AD 1000 until the 1600s. Originally many stood on stone platforms (*ahus*).

The figure's back is covered with ceremonial designs, thought to be later additions as they relate to the island's birdman cult, which developed after about AD 1400. On the upper back and shoulders are two birdmen facing each other. In the centre of the head is the carving of a small fledgling bird with an open beak. As the cult developed, the *moai* were gradually pushed from their platforms. After 1838, at a time of social collapse following European intervention, all remaining *moai* were toppled.

Collected in AD 1868 by the crew of HMS Topaze, from Orongo, Rapa Nui (Easter Island), c. AD 1000
Ht 242 cm
Gift of HM Queen Victoria

2 Dress

A WIDE VARIETY OF JEWELLERY, ornaments and other items of dress from all cultures and periods of history can be found throughout the Museum. Humans seem to have been using clothing and adornment to make statements about who we are and who we would like to be ever since the beginning of what archaeologists call the Modern Age, 40,000 years ago. Some of the oldest jewellery in the Museum are pieces of necklaces from the last Ice Age.

Jewellery has been made from various metals as well as a host of other materials and ranges from simple items to some of the best examples of a culture's craftsmanship. Jewellery has sometimes been worn to display the wealth or signify the importance of the wearer and often embodies other aspects of their power or their role in the community. For instance, styles of brooches and the different ways they were worn can indicate differences between neighbouring groups, regions and peoples.

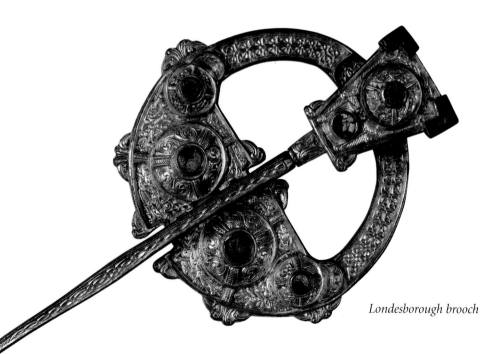

Londesborough brooch

Within this diversity there are common features, such as which parts of the body have attracted adornment. For example, it is common to see objects made to wear around the head, neck and shoulders. These may differ in form from one culture to another, but as the capes, crowns, necklaces and torcs in this section show, jewellery and clothing meant for this area of the body have often been used to proclaim power and rank. Other parts of the body often highlighted with jewellery might be called the transitions: between hands and arms, feet and legs, and at the waist.

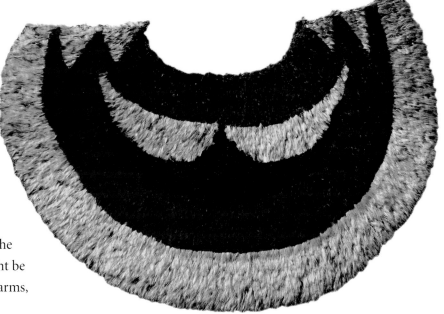

Feather cloak

The jewellery that has survived from the past, while often intricately made from precious materials, would have been only one aspect of the overall appearance of the wearer. The delicate and unique thick gold necklaces and brooches of the Winchester Hoard, for instance, are clearly masterpieces of metalwork and probably represented both the power and foreign connections of their owners. However, it can be difficult to imagine how these would have looked when worn along with the clothing, hairstyles and even make-up of the original wearers. Sometimes images may survive from the past, showing how people looked and dressed, and more rarely actual clothing may survive, but often we can only speculate.

The delicate cloak made of feathers from Hawai'i which begins this section belongs to a little-known category of the Museum's collections, encompassing thousands of textiles and items of clothing made from cloth, animal skins, furs, plants and even bird feathers. Some are up to several thousand years old, such as fragments and occasionally larger pieces of cloth and clothing from Egypt and South America. There is even a wig from ancient Egypt. Collected throughout the world over the last 250 years are African textiles and clothing from the Pacific, the Americas and the Arctic. Mostly made from perishable organic materials, they require considerable care by specialist staff to preserve and handle them. Because of their fragile nature, these materials can only be displayed in public for short periods, which is why such important sources of information about how people dressed and looked are being made accessible through images and the internet.

Hawai'ian feather cape

THIS CAPE MADE of bird feathers showed the importance and status of its wearer. In the Hawai'ian islands of Polynesia, only men of high status wore such featherwork regalia in ceremonies and battle. The cape is made from olona fibre (*Touchardia latifolia*) netting, on to which tiny bundles of feathers have been attached in overlapping rows. The red feathers come from the 'i'iwi bird (*Testiaria cocchinea*), and the yellow and black feathers from the 'o'o (*Moho nobilis*). Red feathers were reserved for those of highest rank, but yellow feathers became the most highly prized colour due to their rarity.

Large numbers of feathered cloaks and capes were given as gifts to the sea captains and their crews who were the earliest European visitors to Hawai'i. Captain Cook himself was presented with five or six feathered cloaks during his last, fatal, visit there in 1779. It is not known, however, who brought this particular cape back to Britain.

From Hawai'i, Polynesia,
probably before AD 1850
W. 70 cm
Gift of Sir AW
Franks

Mold gold cape

LIKE THE HAWAI'IAN feather cape, this unique Bronze Age cape also demonstrated the importance of its wearer. It was found in fragments inside a stone-lined grave, around the remains of a skeleton. Only much later, when it was examined by a conservator at the British Museum, was it realized that the fragments came from a cape.

The cape is one of the finest examples of prehistoric sheet-gold working and is unparalleled in both form and design. It was laboriously beaten out of a single ingot of gold, then embellished with dense decoration of ribs and bosses mimicking strings of beads amid folds of cloth. Perforations along the upper and lower edges indicate that it was once attached to a lining, perhaps of leather, which has decayed away. When worn, the cape covers the upper arms, severely restricting any movement. It would therefore have been unsuitable for everyday wear and was probably used for ceremonial purposes, perhaps as a symbol of religious authority.

From Mold, Flintshire,
North Wales, c. 1900–1600 BC
Wt 560 g

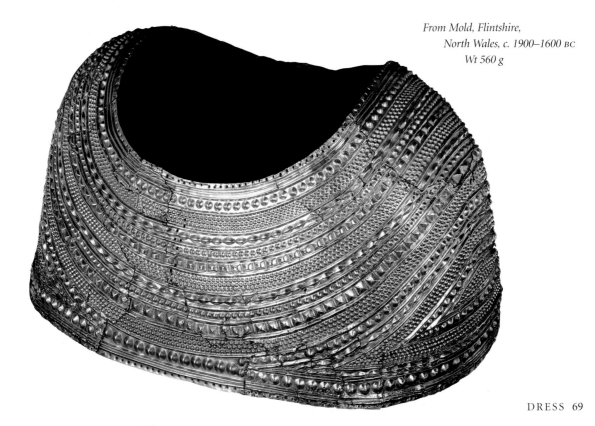

Stone funerary bust of Aqmat

THIS FUNERARY BUST is from Palmyra, a city that grew rich from the caravan trade linking the Gulf of Arabia and the Mediterranean. The city was incorporated into the Roman empire by the end of the first century AD but was destroyed in AD 273 following two insurrections.

According to the Aramaic inscription, this is a funerary monument to a woman called Aqmat. Her image, known as *nefesh* ('soul' or 'personality'), enabled the owner to exist in the next world. We also get a good impression of the clothing and elaborate hair style that would have been worn by a wealthy woman of her world, as well as the type of jewellery she owned. The white appearance of Aqmat's dress is probably misleading, as these portraits were originally richly coloured.

From Palmyra, Syria, late 2nd century AD
Ht 50.8 cm

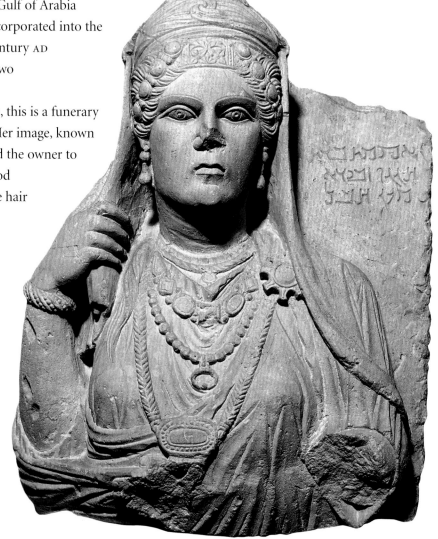

Winchester hoard

THIS GROUP OF Iron Age gold jewellery was
discovered on a hill near Winchester, in Hampshire. It
contained two sets of jewellery comprised of thick neck
rings called torcs, brooch pairs linked by a chain, and
two bracelets, made from very pure gold.

The torcs are of a unique construction, different from
that of any others known from Iron Age Britain, Ireland
or France. One is bigger than the other, possibly because
it was made for a man and the other for a woman.

Unfortunately, unlike the monument from
Palmyra on the opposite page, there are almost
no surviving images of people from Iron Age
Britain, nor does clothing survive, so the only
evidence for their dress and appearance is
jewellery such as these pieces.

From Hampshire, southern England, c. 75–25 BC
Wt (total) 1.160 kg

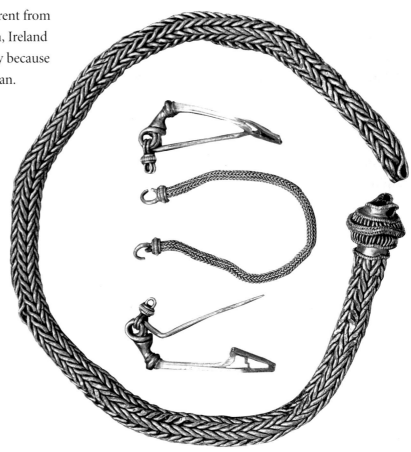

Mummy portrait of a woman

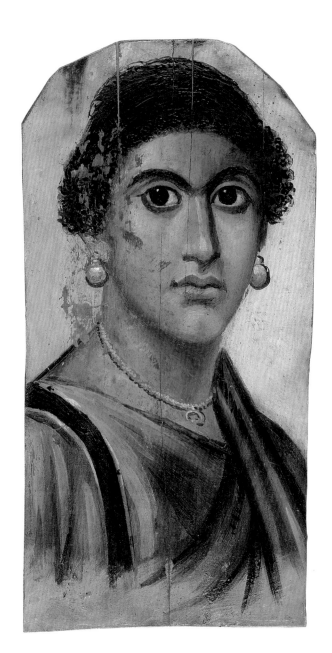

EGYPTIANS CONTINUED to mummify their dead after the Roman conquest of 30 BC, but aspects of this long-standing practice begin to show the influence of Roman culture. Instead of the idealized faces of traditional Egyptian art, mummies from this period bear realistic portraits, characteristic of Roman art. The impact of Rome can also be seen in their dress.

Most surviving portraits have become separated from the mummies to which they were once attached, so we rarely know the identities of the subjects. However, the clothing, jewellery and hair styles depicted can suggest an approximate date for their death. Those worn by the woman in this portrait indicate that she died some time during the reign of the Roman emperor Nero (AD 54–68). The portrait is painted in encaustic, a mixture of pigment and beeswax with a hardening agent such as resin or egg.

From Hawara, Egypt, AD 55–70
Ht 41.6 cm
Excavated by W.M. Flinders Petrie
Gift of the National Gallery, London (1994)

Aigina Treasure pendant

THE AIGINA TREASURE is one of the most important groups of jewellery to have survived from the Greek Bronze Age (around 3200–1100 BC). It was found somewhere on the Greek island of Aigina, but it is now thought to have been made by Minoan Cretan workshops. Minoan colonists are known to have lived on Aigina and it is possible that the treasure came from one or more of their tombs.

This pendant represents a Cretan god standing in a field of lotuses, each hand holding a goose by the neck. Behind him curve stylised bull's horns, a common motif in Minoan religious iconography. This pose, known as that of the 'Master (or Mistress) of the Animals', is intended to show that as the deity subdues the wild animals, so they have control over nature. It unusual to see a male Minoan god in this pose, as it is more commonly depicted with a female central figure.

Minoan, found on Aigina, Greece, 1850–1550 BC
Ht 6 cm

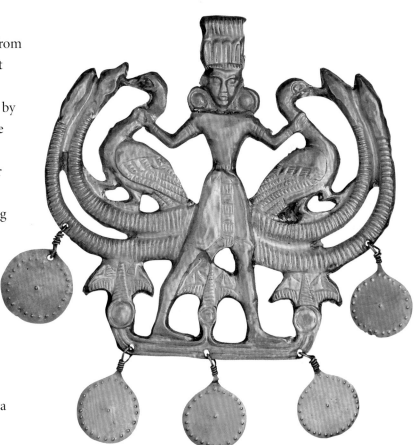

Fuller brooch

THIS SPLENDID BROOCH was made and worn in England, at the same period when the brooch on the next page was worn in Ireland. It is made from hammered sheet silver inlaid with niello and decorated with the earliest known representation of the Five Senses. In the centre is Sight, which during the medieval period was considered the most important of the senses. Surrounding Sight are: Taste, with a hand in his mouth; Smell, standing between two tall plants; Touch, rubbing his hands together; and Hearing, with his hand to his ear.

At one time this brooch was thought to be a forgery, but it was later re-examined and confirmed as genuine due to its niello inlay, which is of a type only used during the early medieval period. Far from being a forgery, the brooch may even have been made in the court workshops of King Alfred the Great (died AD 899).

Anglo-Saxon, from England, late 9th century AD
D. 11.4 cm
Part gift of Captain A.W.F. Fuller

Londesborough brooch

THIS LARGE SILVER and gold cloak brooch was made in Ireland over a thousand years ago. It has been decorated in the style of 'Insular' Celtic art that was common in Ireland at this time, which combined Celtic, Germanic and classical elements. It is covered with complex patterns of interlace, spirals, animal and bird motifs. Unusually, this fine decoration was cast with the body of the brooch rather than soldered on separately. The glittering effect has been heightened through the use of chip-carving, best seen on the panels of interlace. Two L-shaped fields at the top corners of the pin once held blue glass. The back of the brooch is also decorated with amber and two inset gilt-bronze discs with Celtic triskele motifs.

The brooch is named after the 1st Baron Londesborough, from whose collection it came.

From Ireland, 8th–9th century AD
L. (pin) 24 cm
D. (hoop) 10.2 cm

Gold pectoral

GOLD HELD A profound symbolic significance in American Indian beliefs. The precious metal was particularly prized for its durability and association with the sun in South America before the Spanish Conquest. Long before European contact, Native American goldsmiths had developed great skill in making gold objects, using techniques such as hammering, casting and gilding.

This hammered and embossed chest ornament is an example of such jewellery. Its shape echoes the spread wings of a powerful bird of prey such as the eagle, associated in American Indian religion with the masculine, generative powers of the sun. The closed eyes of the human face in the centre of the pectoral suggest that it represents a shaman or priest in a meditative trance. His thoughts are not directed outwards towards the physical world but inwards, to the spirit realm.

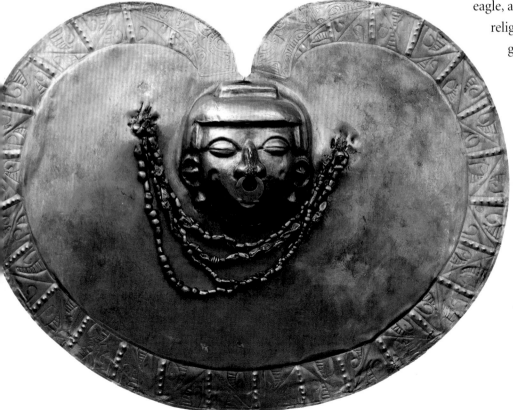

From Calima, Colombia
AD *100–1500*
W. *36 cm*

Great Torc from Snettisham

LARGE IMPRESSIVE pieces of jewellery made of precious metals have been held in high esteem in numerous cultures at various periods. Often they were worn around the neck or across the chest, emphasizing the head of the wearer.

This object is a neck ring or torc, crafted in Britain with great skill and tremendous care over 2000 years ago. It contains just over a kilo of gold mixed with silver and is one of the most elaborate golden objects ever made in ancient Europe. It is made from 64 threads, each just 1.9 mm wide. Eight threads were twisted together at a time to make eight separate gold ropes. These were then twisted around each other to make the final torc. The ends of the torc were hollow cast in moulds and then welded on to the ropes.

Found at Ken Hill, Snettisham, Norfolk,
England
c. 75 BC
D. 20 cm
Wt 1.080 kg
Gift of the Art Fund

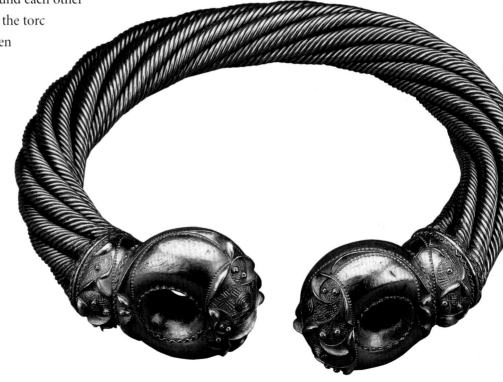

Gold griffin-headed armlet

THIS LARGE GOLD armlet is one of a pair. Originally the hollow spaces would have contained inlays of glass or semi-precious stones. It is made in a style typical of the imperial court of the ancient Achaemenid Persians, and pictures of similar armlets are depicted as tribute offerings on reliefs at their capital of Persepolis in Iran. The Greek writer Xenophon (born *c.* 430 BC) wrote that armlets were among the items considered gifts of honour at the Persian court.

This armlet was found as part of the Oxus Treasure, the most important collection of gold and silver to have survived from the Achaemenid period (550–331 BC). The exact findspot of the Treasure is unknown but is thought to be somewhere along a branch of the River Oxus.

From the region of Takht-i Kuwad,
Tajikistan, 5th–4th century BC
Ht 12.8 cm
Bequeathed by Sir A.W. Franks

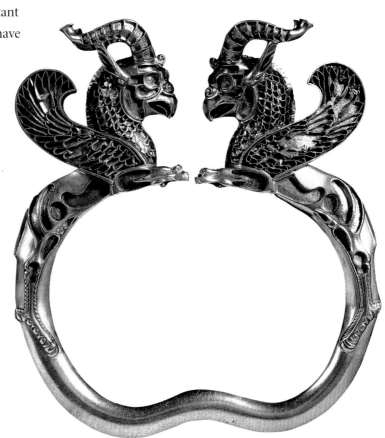

Gold shoulder clasps

THESE HEAVY GOLD shoulder clasps were found in the famous ship burial at Sutton Hoo, thought to be the tomb of Raedwald, a powerful East Anglian king. They would originally have been attached to lightweight body armour, probably made of leather as no trace of it remained in the grave.

The clasps are covered with immaculately executed decoration consisting of hundreds of individual gold cells filled with garnet, millefiori glass and intense opaque blue glass. The bold designs of entwined boars are made with some of the largest garnets known from Anglo-Saxon England. Their strong shoulders are made from large slabs of millefiori, their tusks from blue glass and their spiky crests and curly tails delicately picked out in small garnets. The boar motif, based on an animal respected for its ferocity, strength and courage, may have symbolized the prowess of a warrior.

From Mound 1, Sutton Hoo, Suffolk, England, early 7th century AD
L. 12.7 cm
W. 5.4 cm
Gift of
Mrs E.M. Pretty

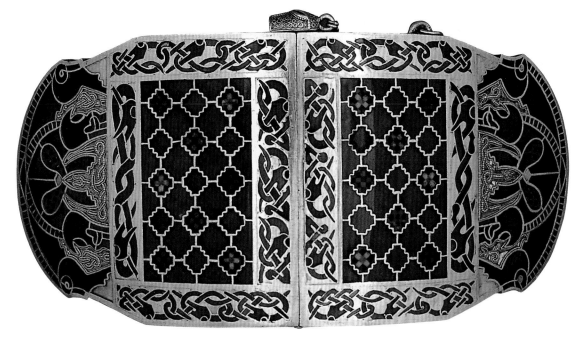

Feather bonnet of Yellow Calf

THIS MAGNIFICENT feather headdress belonged to Yellow Calf, the last traditional chief of the Arapaho Nation. He was photographed wearing the headdress in 1927, a few years before his death in 1935.

The Arapaho, who call themselves Inuna-ina ('Our People'), had a highly organized and military society which stressed the importance of age grades and honour in warfare. Traditional dress included fringed war-shirts and feather headdresses such as this one. These were originally a method of displaying war honours, such as scalp locks taken from defeated enemies, and therefore demonstrated the bravery of the wearer. This bonnet is constructed from a cloth skull cap around which is an intricately and colourfully beaded front band. Feathers are attached, in this case the highly prized immature tail feathers of a golden eagle, their tips decorated with hair symbolizing scalp locks. Feathers were valuable in the nineteenth century, a full set of twelve being worth one pony.

Arapaho, from the American West,
North America, c. AD 1927
Ht 75 cm
Gift of G.M. Mathews

Red deer antler headdress

THIS IS THOUGHT to be a headdress worn by ancient Britons nearly 10,000 years ago. The holes would have been used to tie it to the head with a leather thong. It may have been worn by hunters as a disguise, but it is more likely to have been part of a costume worn on special occasions, perhaps during religious ceremonies.

Twenty-one adult red deer skull parts with antlers were excavated from the Mesolithic site of Star Carr in Yorkshire. All had been skinned using flint tools. The bones forming the top of the nose were then broken off and the edges of the remaining skull part trimmed. The antlers were also broken off and the remaining stumps thinned down and trimmed around the base. The two holes in the back of the skull were made by cutting and scraping away bone on both sides.

From Star Carr, Vale of Pickering, North Yorkshire, England
Early Mesolithic, c. 7500 BC
Ht 15 cm
Presented by Professor J.G.D. Clark

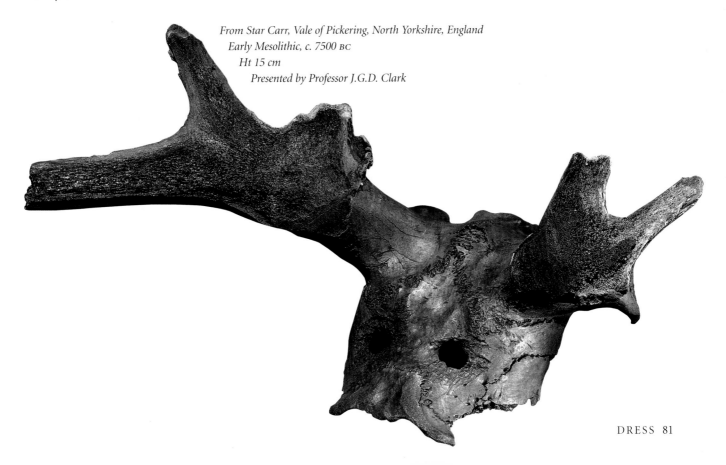

3 Rulers

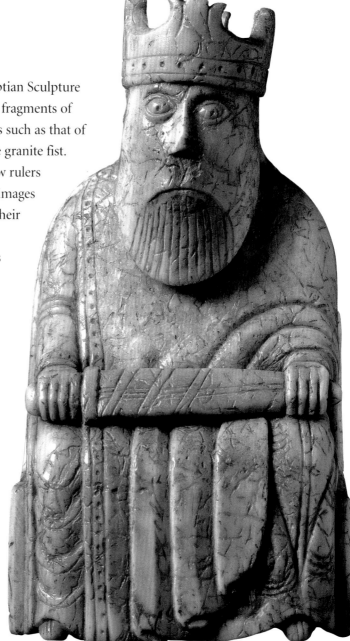

Physically dominating the huge Egyptian Sculpture Gallery in the British Museum are numerous fragments of massive images of pharaohs, from huge heads such as that of Ramesses II to, perhaps more tellingly, a large granite fist. These fragments are a strong reminder of how rulers throughout the world have created powerful images of themselves to celebrate or commemorate their power, might and achievements, and sometime these images have lasted thousands of years after their deaths. Examples from various times and places can be found throughout the Museum, of which only a small selection are shown here. But as the tiny ivory of a pharaoh that opens this chapter also reminds us, images of rulers and powers can be far more intimate and intended for a wide variety of purposes.

Lewis Chessman (king)

The images of the rulers in these pages are rarely realistic portraits. They usually present an idealized image, sometimes possibly far from what the ruler may have looked like. Rare exceptions are the medal of the Byzantine emperor John VIII Palaeologus, often said to be the earliest portrait medal of the European Renaissance, and the desire of the Mughal rulers of India to be depicted in life-like portraits. The wooden *ndop*, for example, were not intended to be naturalistic portrayals, but representations of the king's spirit and as an encapsulation of the principals of kingship.

The images here were made for many different reasons. Some, such as the head of Alexander the Great and the image of the first Japanese shogun, were made centuries after their subjects had died, in order to commemorate their achievements. Others were made by the rulers to keep the memory of their achievements alive after their deaths. The 3600-year-old statue of Idrimi, king of Alalakh in what is today Turkey, is visually striking but also contains a long inscription describing his life story. The two images of the Roman emperors in this chapter are among the many statues of Roman emperors erected across the Roman empire – not simply to remind the people of the empire who was the ruler, in the way images of Queen Victoria were found across the British empire, but also to act as a focus of the religious cult that surrounded the emperor, a central element of the way the empire worked.

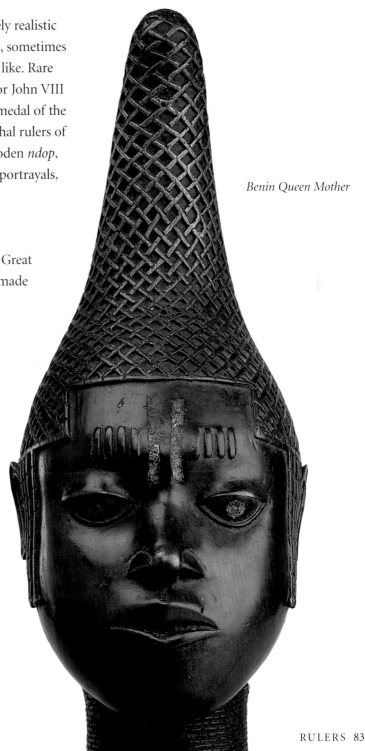

Benin Queen Mother

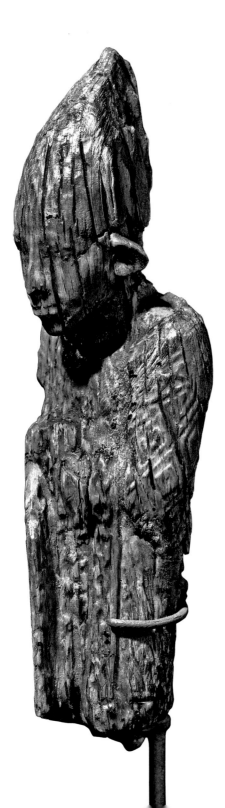

Ivory statuette of a king

THIS FIGURINE, discovered in the Temple of Osiris at Abydos, is one of the earliest surviving portraits 'in the round' of an Egyptian king. It cannot be associated with any particular ruler, although there are tombs of a number of kings of the period not far from the Temple.

The king is depicted wearing the White Crown of Upper Egypt and a long robe. By emphasizing the stoop of the shoulders the craftsman may have been attempting to portray an aging ruler. The robe, decorated with a fine pattern of diamond shapes enclosed by double lines, is of the distinctive type worn by kings during the *sed* or Jubilee Festival, celebrated after a ruler had been on the throne for thirty years, and then every three years after that. This figurine may be evidence that this festival was held from the very beginning of the historical period in Egypt.

From the Temple of Osiris, Abydos, Egypt
Early Dynastic period, perhaps mid 1st Dynasty (c. 3000 BC)
Ht 8.8 cm
Gift of the Egypt Exploration Fund (1903)

Colossal bust of Ramesses II

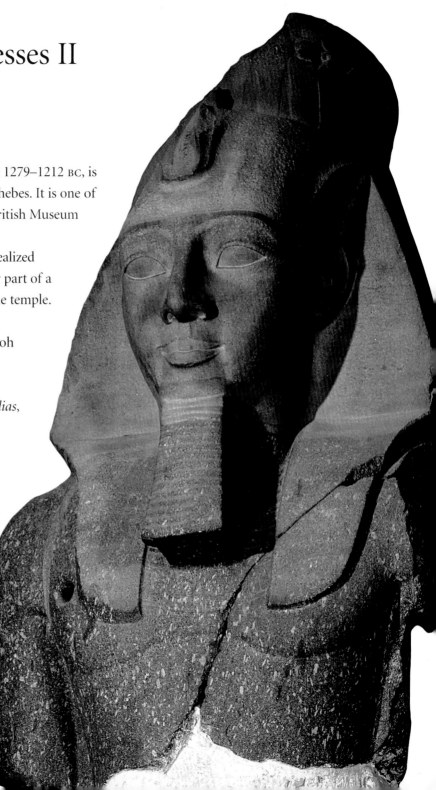

THIS BUST OF RAMESSES II, ruler of Egypt 1279–1212 BC, is from the Ramesseum, his mortuary temple at Thebes. It is one of the largest pieces of Egyptian sculpture in the British Museum and weighs 7.25 tons.

This mammoth fragment, representing an idealized image of Ramesses as a young man, is the upper part of a seated statue originally in the second court of the temple. This huge image is part of a long tradition of celebrating and marking the power of the pharaoh through raising monumental statues.

The head was brought to Britain in 1818 and provided the inspiration for the poem *Ozymandias*, by Percy Bysshe Shelley:

… 'My name is Ozymandias, king of kings:
Look on my works ye mighty, and despair!'
Nothing beside remains. Round the decay
Of that colossal wreck …

From the Ramesseum mortuary temple at Thebes,
Egypt, 19th Dynasty, c. 1250 BC
Ht 2.668 m
Henry Salt Collection

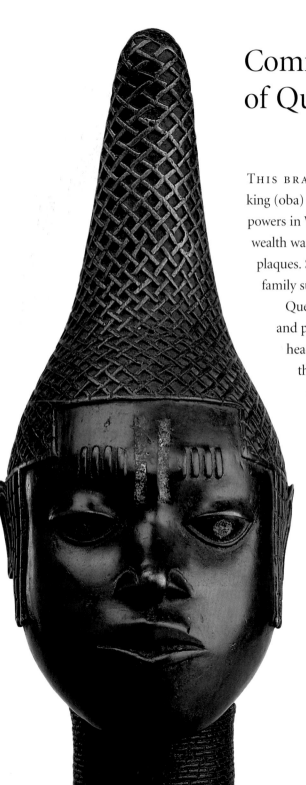

Commemorative head of Queen Idia

THIS BRASS HEAD represents Queen Mother Idia, whose son Esigie was a king (oba) of the Benin people about 1504–10. Benin was one of the major powers in West Africa, in the region of modern south-west Nigeria. Its wealth was expressed in many art forms such as cast brass figures and plaques. Some of the most beautiful objects include castings of the royal family such as this head.

Queen Idia was an important warrior who fought for her son in battle and played a key role in his military campaigns. This brass portrait head was made to be placed in her altar following her death. It is said that Oba Esigie instituted the title of 'Queen Mother' and established the tradition of casting heads of this type in honour of her military and ritual powers. Such heads were placed in altars in the palace and in the Queen Mother's residence.

From Benin, Nigeria, early 16th century AD
Ht 40 cm

Carving of Queen Victoria

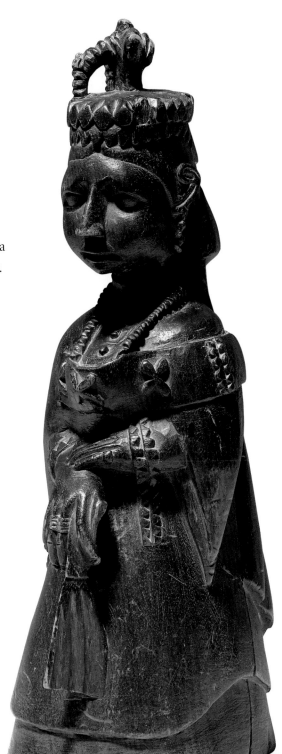

THE YORUBA OF NIGERIA are renowned for their skill in carving wood, an artistic tradition hundreds of years old. They produce ceremonial masks, everyday objects and sculptures, depicting both secular and religious subjects.

This wooden figure of the British queen Victoria (reigned 1837–1901) was made by a Yoruba carver. In 1861 the city of Lagos became a British crown colony, formally beginning the British administration of Nigeria. As in other parts of the British empire, official and unofficial photographs of Queen Victoria were widely available across Nigeria. These were probably used for reference by skilled Yoruba carvers. The resulting three-dimensional figures of the Queen, such as this one, show her with European dress and posture but rendered in a traditional Yoruba style.

Yoruba people, Nigeria, 19th century AD
Ht 37 cm
Donated by H.V.A. Lambert

Gold *mohur* commemorating the father of a Mughal emperor

THE MUGHAL EMPEROR of India traditionally distributed special presentation coins (*nazarana*) and coin-like commemorative medals on the anniversary of his accession, or at New Year. The New Year ceremony took place at the beginning of the solar year and was an excuse to show off the wealth of the emperor's treasures. These coins and medals, which were of unusual designs and exceptional size, were not intended for general circulation.

In 1605, the first year of his reign, Jahangir (reigned 1605–27) issued a gold *mohur* coin bearing a memorial portrait of his father Akbar (reigned 1556–1605). The Arabic inscription beside the fine portrait translates 'God is Great auspicious year 1'. The large sun on the reverse is a reference to the Ilahi era introduced by Akbar, which was based on the solar calendar.

From India, minted 1014 AH/AD 1605
D. 2.3 cm
Wt 10.86 g
Gift of the Art Fund and H. Van den Bergh

Manohar, *Emperor Jahangir receiving his two sons*

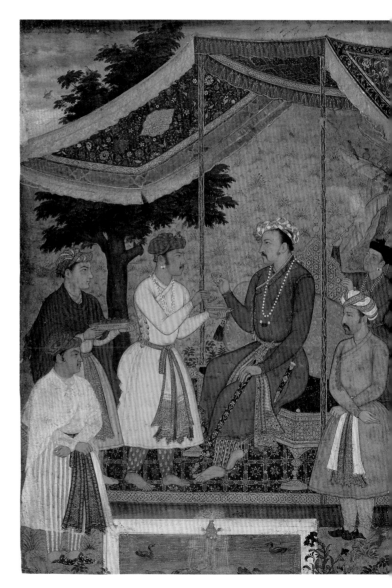

THIS ALBUM PAINTING in gouache on paper depicts the Mughal emperor Jahangir (reigned 1605–27), who ordered the gold *mohur* on the opposite page to be made. Jahangir is shown beneath a richly decorated canopy being served food and drink by his sons Khusrau and Parviz. Below Jahangir's feet is an inscription reading *Camal Manuhar* (the work of Manohar). Manohar was a court artist who began his career during the reign of Jahangir's father Akbar (1556–1605). His style reached maturity under Jahangir, of whom he is known to have made at least ten portraits.

Perhaps inspired by European art, the Mughal emperors encouraged their artists to create particularly life-like portraits. *Chihranami*, or painting faces, was the most highly esteemed category of painting in the Mughal atelier, and artists were often ordered to re-paint the faces of figures in older paintings.

From India, about AD 1605–6
Ht 20.8 cm
Transferred from the Department of Oriental Manuscripts and Printed Books, British Library

Ivory chess piece in the shape of a seated king

THIS IS ONE OF the two kings from a medieval chess set, one of several sets found in mysterious circumstances in the vicinity of Uig on the Isle of Lewis in the Outer Hebrides, some time before 11 April 1831.

This striking image shows the king wearing a crown and seated on his throne, with a sword lying across his lap. Each of the kings from the chess sets is slightly different, and the backs of their thrones are elaborately decorated. Chess came to Europe from the Islamic world and was popular among the aristocracy in the late eleventh century. With kings, queens, bishops, knights, rooks and faceless pawns, the Lewis chess sets appear to embody medieval European feudal society.

The Lewis chess sets are made from elaborately worked walrus ivory and whales' teeth. They were probably made in Norway and may have belonged to a merchant traveling from Norway to Ireland.

Found on the Isle of Lewis, Outer Hebrides, Scotland
Probably made in Norway c. AD 1150–1200
Ht c. 10 cm

Limestone door lintel

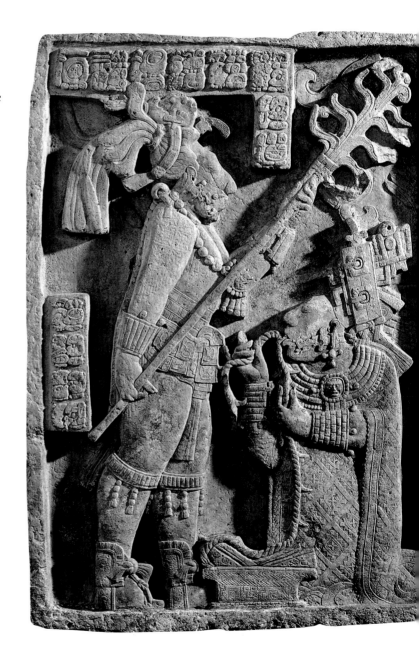

THIS LINTEL, considered a masterpiece of Maya art, is one of a series of three panels from Structure 23 at Yaxchilán, Mexico. The scene represents a bloodletting ritual performed by the king, Shield Jaguar II, and his wife, Lady K'ab'al Xook. The king holds a flaming torch over his wife, who is pulling a thorny rope through her tongue. Scrolls of blood can be seen around her mouth.

The scene is carved in fine detail, showing the embroidery on the clothes of the king and queen and the intricacy of their jewellery and headdresses. On the left side and above the images are glyphs. The first two at the top of the lintel indicate the event and the date on which it took place (AD 709). The last glyph represents the Emblem Glyph (the city name in Maya hieroglyphs) of Yaxchilán. The text on the left of the panel contains the queen's name and titles.

Maya, from Yaxchilán, Mexico, Late Classic period
(AD 600–900)
Ht 109.7 cm
Gift of A.P. Maudslay

Marble portrait of Alexander the Great

THIS PORTRAIT OF the great Macedonian leader is probably from Alexandria, the city founded by Alexander after he conquered Egypt in 332 BC, and where he was eventually buried.

Most of Alexander's portraits were produced long after his death and share similar general characteristics. He was always shown clean-shaven, whereas all previous portraits of Greek statesmen or rulers had beards. Alexander was also the first king to wear the royal diadem, a band of cloth tied around the hair that was to become the symbol of Hellenistic Greek kingship.

After his death Alexander was worshipped as a god and the forefather of the Ptolemaic dynasty which ruled Egypt. Earlier portraits of Alexander, in heroic style, look more mature than the portraits made after his death, such as this example. These show a more youthful and perhaps more god-like character. He has longer hair, a more dynamic tilt of the head and an upward gaze.

Said to be from Alexandria, Egypt, 2nd–1st century BC
Ht 38.1 cm

Bronze head of Augustus

THIS HEAD ORIGINALLY belonged to a statue of the Roman emperor Augustus (reigned 27 BC–AD 14). In 31 BC he took possession of Egypt, and the writer Strabo reported that statues of Augustus were erected in Egyptian towns near the first cataract of the Nile at Aswan. The statues, like many others throughout the Roman empire, were a continuous reminder of the all-embracing power of Rome and its emperor.

This head was found at Meroe in Sudan, buried in front of the steps of a Kushite temple. In 29 BC the Romans advanced into Kush, provoking a war. It is probable that the statue was made in Egypt and later, because of its symbolic importance, was decapitated and the head taken south by Kushite raiders. Burying the head in front of the temple steps would have signified that it was permanently under the feet of its captors.

Roman, from Meroe, Sudan, c. 27–25 BC
Ht 47.7 cm

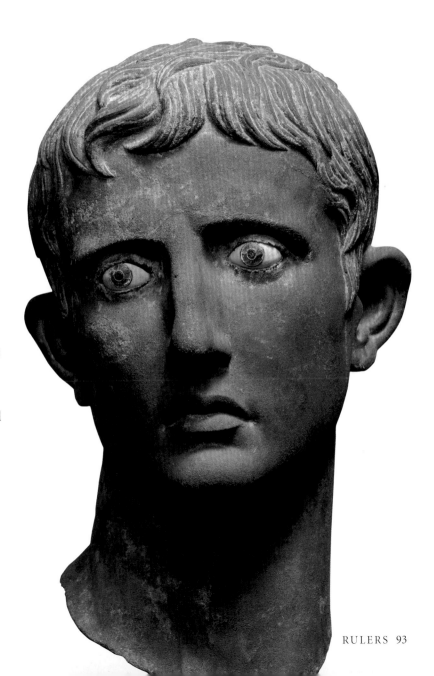

Silver plate showing Shapur II

ABOUT AD 224 the Parthians were defeated by Ardashir, a descendant of Sasan who gave his name to the new Sasanian dynasty in Iran. One of the most energetic and able Sasanian rulers was Shapur I (AD 240–72). By the end of his reign, the empire stretched from the River Euphrates to the River Indus and included modern-day Armenia and Georgia.

This gilded silver dish is typical of the high-quality silverware produced during the Sasanian empire. Sophisticated techniques of relief decoration and partial gilding were used. The reliefs were created by cutting the figures from a thin sheet of silver, embossing them, and then soldering them to the surface of the dish. The king in this hunting scene wears the distinctive crown of Shapur II (reigned AD 309–79), who restored the Sasanian empire after a short period during which much territory was lost. The scene of kings hunting animals has a long history in the Middle East.

Sasanian, 4th century AD
Ht 12.8 cm
Bequeathed by Sir A.W. Franks

Helmet from the ship burial at Sutton Hoo

THIS EXTRAORDINARY iron helmet was found in a rich grave that contain a ship, along with many other objects. The grave belonged to a powerful ruler, who would have worn this helmet in battle, hiding the features of the wearer beneath the elaborate mask.

The helmet is covered with panels of tinned bronze decorated with animal ornament and heroic scenes, common motifs in the Germanic world at this time. The face mask is the most remarkable feature of the helmet. The bronze eyebrows are inlaid with silver wire and garnets. Each ends in a gilt-bronze boar's head, possibly a symbol of strength and courage. Placed against the top of the nose, between the eyebrows, is a gilded dragon head that lies nose to nose with a similar dragon head placed at the end of the low crest that runs over the cap. The nose, eyebrows and dragon make up a great bird with outstretched wings.

Anglo-Saxon, from Mound 1, Sutton Hoo, Suffolk, early 7th century AD
Ht 31.8 cm
Gift of Mrs E.M. Pretty

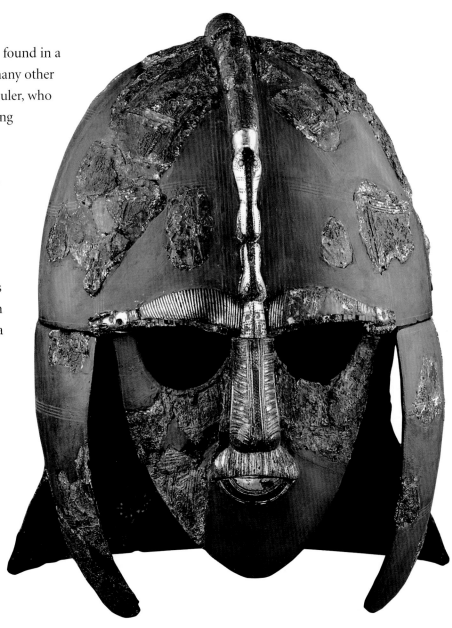

Bronze head from a statue of the emperor Hadrian

IMPERIAL CULTURE played an important role in Roman provincial administration. Statues and busts of emperors were placed in official and public places across the empire, symbolizing the power of the Roman state, as with the head of Augustus earlier in this chapter. This head comes from a statue of the emperor Hadrian (reigned AD 117–38) which probably stood in Roman London in a public space such as a forum. The complete statue would have been one-and-a-quarter life size.

The statue may have been put up to commemorate Hadrian's visit to Britain in AD 122, during which time he started the building of the famous wall from the Solway Firth to the River Tyne. Hadrian spent much of his reign travelling throughout the empire, and his imperial visits generally gave rise to building and refurbishment programmes. There are many known marble statues of him, but this bronze example is a rare survival.

Found in the River Thames near London Bridge
2nd century AD
Ht 43 cm

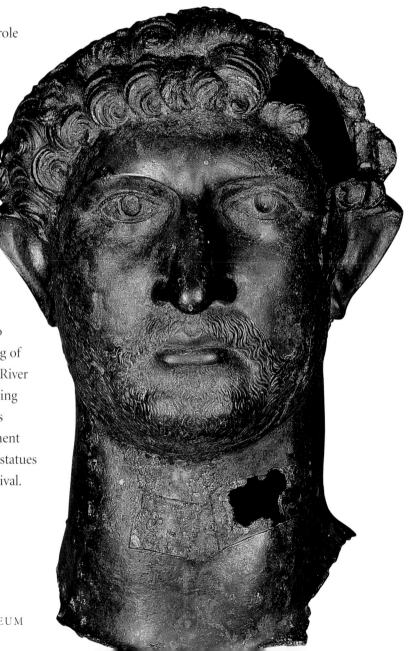

Pisanello (*c.* 1395–1455), cast bronze medal of John VIII Palaeologus, emperor of Byzantium

THIS MEDAL IS a portrait of John VIII Palaeologus, the last but one ruler of the Byzantine empire. The medal was produced to commemorate the visit of this emperor to the city of Ferrara in 1438 at the invitation of Pope Eugenius IV, for a council intended to unite the Greek and Latin churches. Plague in the city forced the council's removal to Florence in February 1439 and thus the piece's inception, if not its actual execution, can be precisely dated.

The artist, Pisanello, spent most of his career in the princely courts of Italy, and his presence in Ferrara is documented by eye-witness drawings he made of the emperor and his entourage. It is thought the medal's production was inspired by two medals of the Roman emperors Constantine and Heraclius (these were actually of early fifteenth-century French workmanship, but they were originally thought to have been antique).

Cast in Ferrara, Italy, c. AD 1438–42
D. 10.3 cm
George III Collection

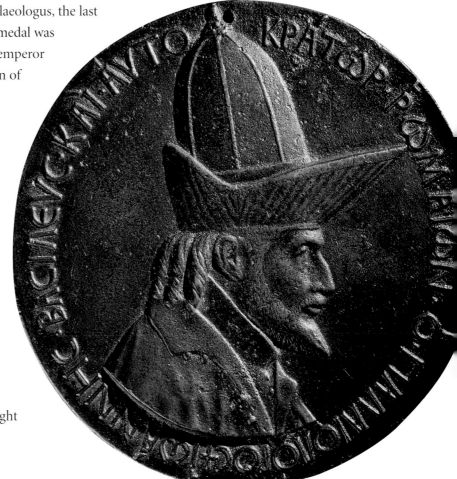

Gold medallion showing Constantine the Great at prayer

CONSTANTINE'S REIGN (AD 306–37) marks a turning point in Roman history. He created the city that would become the capital of the Byzantine empire (Constantinople) and adopted Christianity as the official state religion.

Constantine is shown here gazing heavenwards, perhaps in an attitude of prayer or looking to make some sort of sacred contact. In ancient times both pagans and Christians prayed with arms outstretched and eyes raised to the sky. This is not a new or specifically Christian invention, as it can be seen on portraits of Alexander the Great (336–323 BC). Constantine makes the connection with Alexander even clearer by showing himself crowned with a diadem, the Greek symbol of kingship, rather than the Roman laurel wreath.

The reverse of the medal depicts Constantine brutally dealing with his enemies, the legend *GLORIA CONSTANTINI AVG* proclaiming this activity as glorious.

Roman, minted in Siscia (modern Sisak, Croatia), AD 306–37
D. 2.4 cm
Wt 6.8 g

Nicholas Hilliard (1547–1619), cast and chased gold medal of Elizabeth I

THIS MEDAL SHOWS an image of the English queen Elizabeth I (reigned 1558–1603). Originally hung with drop pearls, this was probably a gift from Elizabeth I to a favoured courtier or political ally. Miniatures were often given as gifts of this kind. The portrait miniaturist Nicholas Hilliard appears to have been the first English artist to make medals in any numbers.

On the reverse is a laurel tree labelled with the royal monogram *ER* (Elizabeth Regina). The legend translates as 'Not even danger affects it', a reference to the legend that laurel was immune from lightning. This is likely to symbolize Elizabeth's resistance to the threat of Catholicism both at home and abroad. This image of Elizabeth is one of many created in various materials during her reign.

Cast in London, England, c. AD 1580–90
Ht 5.6 cm
Wt 57.57 g
Edward Hawkins Collection

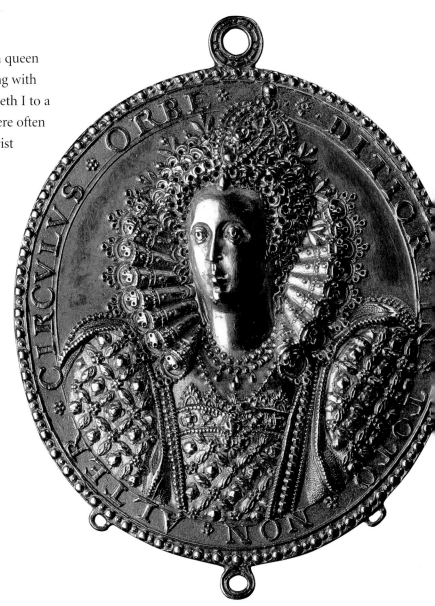

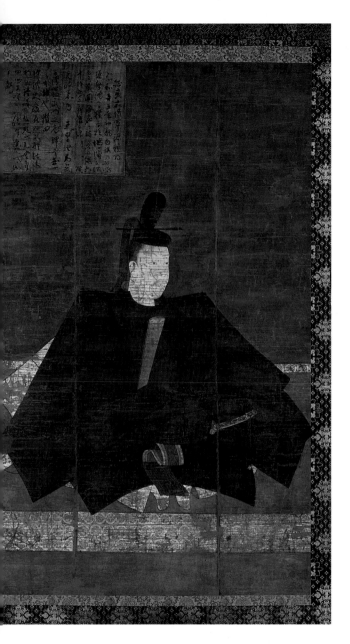

Minamoto no Yoritomo in court dress

THIS IS A COPY of a hanging scroll painting, one of a set of three, said to depict Minamoto no Yoritomo (1147–99), the first Shogun of Japan. Following his victory in the civil wars against the Taira clan in 1185, Yoritomo founded the Kamakura Shogunate, a new system of warrior rule. This ended a period of some 600 years of centralized rule from the imperial court at Kyoto.

Yoritomo is shown wearing formal court costume and cap, and carrying a ceremonial board. The decorated hilt of a long sword juts forward from his waist. The inscription above in coloured cartouches celebrates his military prowess and political authority.

A recent theory suggests the three original scrolls may instead depict the Ashikaga dynasty (1336–1573). The inscription on this copy identifies the sitter as Yoritomo, but recent analysis suggests it may have been made as late as the Edo period (1600–1868). The original identity of the sitter is still hotly debated.

From Japan, Kamakura period, 14th century AD, or later
Ht 145 cm
Purchased with the assistance of G. Eumorphopolous and the Art Fund

Ndop, wooden carving of King Shyaam aMbul aNgoong

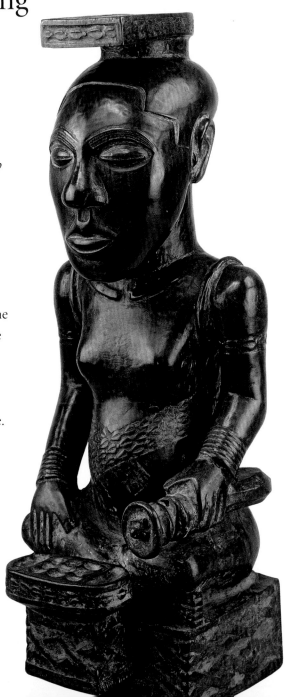

NDOP ARE ROYAL memorial 'portraits' carved by the Kuba people of Central Africa. They are not naturalistic portrayals but are intended as representations of the king's spirit and as an encapsulation of the principals of kingship. *Ndop* were carved in the eighteenth century, making them some of the oldest surviving examples of African wood sculpture.

The wooden portraits were part of the 'royal charms', sculptures which contained the living king's magical powers. The charms were kept in the king's shrine and when he was absent from the capital, the *ndop* were rubbed with oil to preserve the essence of kingship at the centre of the kingdom.

The individual ruler is identified by a small emblem on the plinth at the base of the sculpture. This *ndop* is of King Shyaam aMbul aNgoong, founder of the Bushoong ruling dynasty, and shows his emblem of a mancala board.

Kuba-Bushoong, from the Democratic Republic of Congo, probably late 18th century AD
Ht 54.5 cm
Gift of Emil Torday

Statue of Idrimi

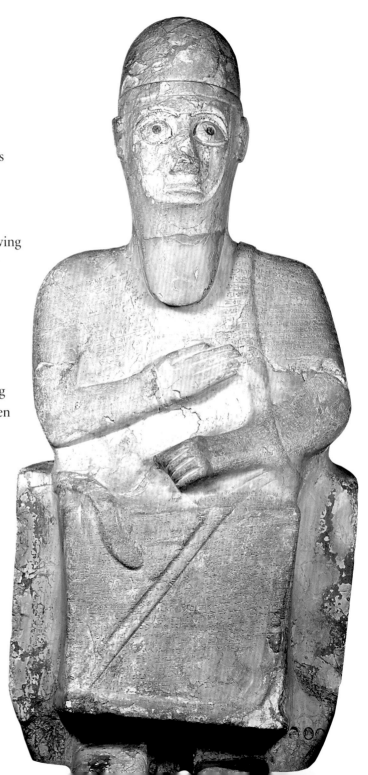

THIS EXTRAORDINARY magnesite statue represents Idrimi, ruler of Alalakh, a city-state in ancient Syria, around 1500 BC. It is inscribed in cuneiform with his biography.

Idrimi was of the royal house of Aleppo, and following a failed revolt, he and some of his family fled to Emar (now Meskene) on the River Euphrates. Determined to restore the family fortunes, Idrimi went to Canaan where he gathered troops and mounted a seaborne expedition to recover his territory. Eventually he became a vassal of the Mitannian king Parattarna, who installed him on the throne of Alalakh. According to the text, Idrimi had been ruling for thirty years when he had the statue inscribed, though it has been suggested that the inscription was added around 300 years later, to bolster national pride. The text ends with curses on anyone who would destroy the statue and blessings on those who honour it.

From Tell Atchana (ancient Alalakh), modern Turkey,
16th century BC
Ht 104.1 cm
Excavated by Leonard Woolley

Cameo portrait of Augustus

THIS CAMEO WAS carved from a three-layered sardonyx. The different coloured layers in the gem have been cut away to create a raised image that contrasts with its background. The jewelled headband was added in the medieval period.

The cameo is a fragment of a larger portrait of the first Roman emperor, Augustus (27 BC–AD 14), who emerged as the sole ruler of Rome after a series of bloody civil wars. He is shown in a majestic pose and wears a sword belt, symbolizing his military authority, and the protective *aegis* (goatskin breastplate) usually attributed to the goddess Minerva. Such a depiction of the emperor assuming a divine attribute was probably only intended to be seen by a few. It could have proved controversial for such an image to be widely circulated, since at this time Roman society was still mistrustful of monarchy, with many hoping for a return to the Republic.

Roman, c. AD 14–20
Ht 12.8 cm
Strozzi and Blacas Collections

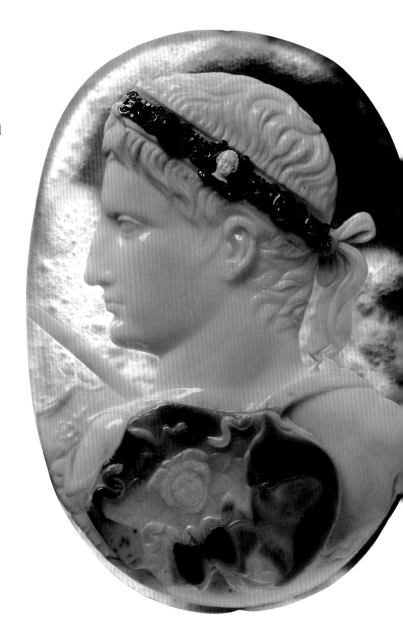

4 Violence and War

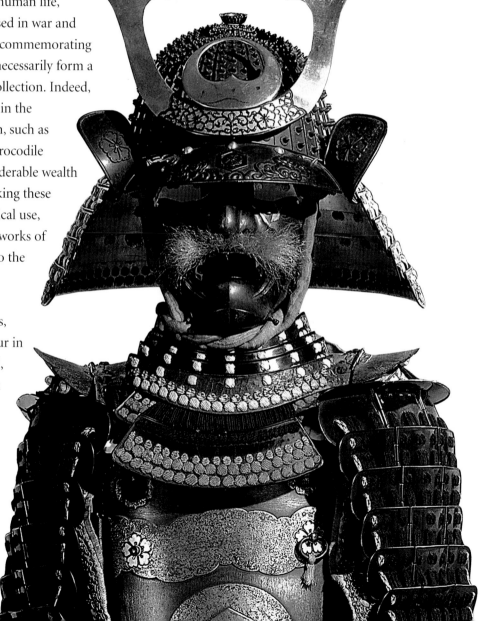

VIOLENCE IS A CONSTANT in human life, however regrettable, and objects used in war and violent sports, or in celebrating or commemorating war, martial virtues and violence, necessarily form a significant part of the Museum's collection. Indeed, some of the most popular exhibits in the Museum have a martial connection, such as the set of Samurai armour or the crocodile armour from Roman Egypt. Considerable wealth and skill have been invested in making these items, whether for display or practical use, and of course numerous powerful works of art have been created in response to the strong emotions aroused by the experience of violence.

There is a huge variety of swords, other weapons and pieces of armour in the Museum from across the world, only a few of which are included in these pages. Some are evidence of great expertise, such as that of the earliest Japanese sword makers,

Japanese Samurai armour

while others demonstrate the technical advances made over the centuries. Many highly crafted objects associated with war were intended for display rather than use, but others were employed in actual combat.

Many cultures over the millennia have celebrated the skills, virtues and roles of their warriors, whether as brave individuals or invincible armies. Commemorating the conquests and victories of kings and emperors is another common feature. Some of the earliest images of the rulers of ancient Egypt and Mesopotamia show them as victors in battle, and this became a standard way for these rulers to be depicted for thousands of years. However, as the tiles from Chertsey in this chapter demonstrate, the image of the victorious king slaying his enemy can sometimes be a lie. These and other images also show the often close connection between a person's position in society and his role as a warrior, whether it be the medieval knight, as seen in the seal of Richard Fitzwalter, or the hoplite in an ancient Greek city. This connection might be the major factor defining someone's rank or social status, if only a limited proportion of the population identify themselves primarily as warriors. However, it is also true that, in many cultures around the world, carrying weapons or being a warrior has been seen (and may still be seen) as simply part of being an adult.

The objects in this chapter and indeed many others across the Museum demonstrate the continuing role that violence and war have played in human history. But there other objects, such as the Throne of Weapons, which serve to remind us that humans can celebrate peace, as well as war.

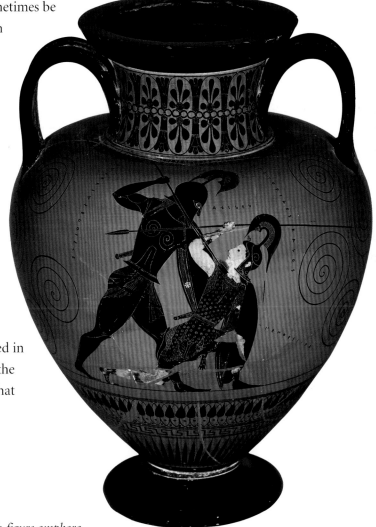

Greek black-figure amphora

Ceremonial bronze dirk

A MAN WALKING in woods in East Anglia literally stumbled across this dirk (short sword) in 1988. It had been thrust vertically into soft peaty ground nearly 3500 years ago, but erosion had exposed the hilt-plate, which caught his toe.

The 'weapon' has the same shape as early Middle Bronze Age dirks used in Britain, but it is much larger than normal dirks. The edges of the blade are very neatly fashioned but deliberately blunt, and no rivet holes were ever provided at the butt for attaching a handle. The dirk was evidently never intended to be used as a weapon. Instead, it was probably designed for ceremonial use.

This dirk is the only example of its type found in Britain, but four have been found in continental Europe. All five weapons are so similar that it is possible they were all made in the same workshop.

From Oxborough, Norfolk, England, 1450–1300 BC
L. 70.9 cm
Wt 2.368 kg
Purchased with the assistance of the Art Fund

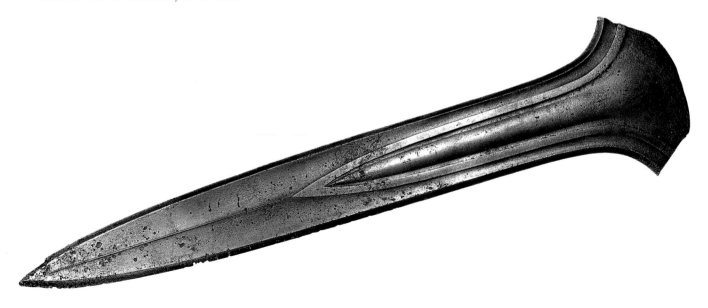

Samurai sword blade

THE BLADES MADE by Japanese swordsmiths from the Heian period (795–1285) onwards are renowned for being both technically and aesthetically outstanding. They were made by repeatedly folding and hammering a piece of iron which was given a final heating and quenching in water to harden the edge. An individual sword blade could be identified by the grain of the body and the *hamon*, the pattern created by the crystalline structure of the cutting edge.

This *tachi* blade is signed 'Bishi Osafune Moro (Kage)' (Morokage from Osafune in Bizen province). Morokage was one of a group of fourteenth-century swordsmiths who are thought to have moved from Ōmiya in Kyoto to Osafune. The blade is of the typical long and slender Osafune shape dating from the reign of Ashikaga Yoshimochi (1394–1428). It has a mixed *hamon* of clove pattern and *gunome* (abrupt undulation).

From Bizen province, Japan
Muromachi period, c. AD 1400
Length 69.3 cm

The Battle of Zonchio (Navarino)

THIS MAY BE the first European print to depict an actual historical naval battle. The Battle of Zonchio was fought between the Ottoman Turks and the Venetians in August 1499 off Zonchio, north of Navarino, in the Greek Peloponnese. The Ottomans were victorious. One of the Venetian commanders was killed during the battle and the other was taken as a prisoner to Istanbul, where he was sawn into pieces on the order of the Ottoman sultan Bajazet II.

The woodcut print was developed during the fifteenth century and quickly became the most important medium for producing images of topical interest. This impression, coloured using stencils and from a famous album of early woodcuts that once belonged to the Holy Roman Emperor Rudolph II, is the only one of this print that survives, although many must have been made. One is known to have been part of the now-lost collection of Ferdinand Columbus, son of Christopher Columbus.

From Italy,
c. AD 1499
Ht 54.8 cm

Automated clock in the form of a galleon, by Hans Schlottheim (1545–1625)

THERE WAS A great fascination for automated machines at the end of the sixteenth century. Hans Schlottheim of Augsburg was one of the most famous makers of these machines.

This gilt-copper and steel automaton was designed to trundle along a grand table to announce a banquet. It is made in the form of a galleon, with sailors wielding hammers to strike the hours and quarter hours on bells in the crow's nests. It also shows the time on a dial at the bottom of the main mast. Music is played on a small regal organ and a drum-skin stretched over the base of the hull. On board, the Electors of the Holy Roman Empire, led by heralds, process before their emperor, who is seated on a throne beneath the main mast. As a grand finale, the ship fires its cannons for the entertainment of the dinner guests.

From Augsburg, South Germany, c. AD 1585
Ht 99 cm
Gift of Octavius Morgan, MP

Crocodile-skin suit of armour

WHEN EGYPT BECAME part of the Roman empire in 31 BC, Romans came into direct contact with Egyptian culture and religion. As elsewhere in the empire, Roman soldiers were closely integrated into the civic and religious life of Egypt and participated in local cults. Around Manfalut, on the banks of the River Nile in central Egypt, Roman soldiers were particularly attracted to the crocodile cult.

This imposing armour is made from the skin of a crocodile. It comprises a helmet and cuirass (body armour) and would have been used in military-style ceremonies of the regional crocodile cult. The skin was presented to the British Museum in 1846 by a Mrs Andrews, who visited Manfalut and found grottoes containing the mummified remains of humans and animals, including many crocodiles. Although the cold, dry environment of the grotto preserved the suit, it has since been painstakingly remoulded by the Museum's conservators.

Found near Manfalut, Egypt
Roman, 3rd century AD
Ht (helmet) 49 cm
Gift of Mrs Andrews

Set of Samurai armour

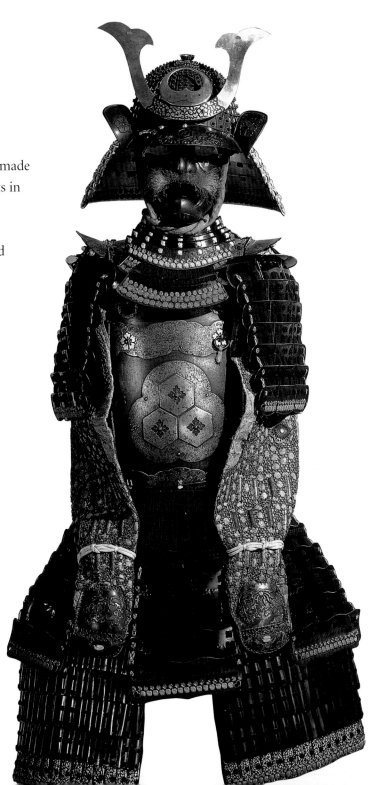

THIS SUIT OF Japanese armour brings together parts made at different times and is one of the most popular exhibits in the Museum.

The earliest Japanese sets of armour were developed during the Heian period (794–1185) to protect mounted samurai warriors against arrows. The armour was designed to be flexible and gave protection without compromising the ability to move easily during battle.

With the arrival of firearms in the sixteenth century, bullet-proof cuirasses (chest plates) based on European models were adopted in Japan. This helmet, though made in the seventeenth century, is in the tradition of earlier pieces made during the period of continuous civil wars (1467–1568), when helmets were often given a hideous face-mask with bristling whiskers to strike terror into the enemy. The neck-piece, shoulder flaps, divided skirt and leg pieces were made in the eighteenth and nineteenth centuries and are made of lacquered iron platelets held together with cords and colourful silk braids.

From Japan, Momoyama period, late 16th century (cuirass and sleeves); Edo period, 17th century (helmet); 18th–19th century (remainder)
Ht (as mounted) 125 cm

Black-figured amphora

THIS GREEK AMPHORA (wine-jar) shows the moment when Achilles, the greatest of the Greek warriors, kills Penthesilea, queen of the Amazons, during the Trojan War. Achilles' face is masked and protected by his helmet, contrasting with Penthesilea, whose helmet is pushed back to expose her features and emphasize her vulnerability. Her spear passes harmlessly across Achilles' chest, while his pierces her throat and draws blood. According to a later version of the story, at this very moment the eyes of the two warriors met and, too late, they fell in love.

The vase is signed, just behind Achilles' right arm, by Exekias as potter. The painting has also been attributed to him. The spirals around each handle emphasize the amphora's taut and rounded shape, and the figures, patterned decoration and the writing are all immaculately rendered. Exekias was perhaps the finest of all painters to use the black-figure technique.

Made in Athens, Greece, c. 540–530 BC, and found at Vulci (now in Lazio), Italy
Ht 41.6 cm

Bronze hoplite helmet

THIS ANCIENT GREEK helmet was captured in a battle between two city-states, Argos and Corinth, and was dedicated by the winners to the Greek god Zeus at his sanctuary at Olympia.

City-states in Greece were often either united against a common enemy or at war with each other. By the fifth century BC a key element in warfare was groups of heavily armed soldiers known as hoplites, a name derived from the round shield (*hopla*) they carried. Each city-state was defended by its own citizens, and the hoplites were usually the richer men, as equipment was expensive and each soldier had to provide his own.

Hoplite armour varied according to region; this bronze helmet is of the rather elegant shape particularly associated with the city of Corinth. Beaten out entirely from one piece of bronze, it required exceptional skill on the part of the bronze-worker.

Probably from Corinth, south-central Greece, c. 460 BC
Ht 25.4 cm
Bequeathed by R. Payne Knight

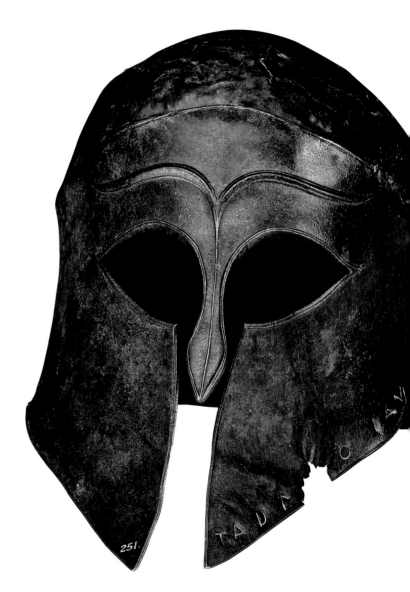

Cavalry sports helmet

IN 1796 A CLOGMAKER'S son, playing behind his house in Ribchester, Lancashire, discovered a mass of corroded metalwork. It turned out to be a hoard of Roman military equipment, mainly for use in cavalry sports.

Cavalry sports were flamboyant displays of military horsemanship and weapons drill. They served both as training sessions and to entertain the troops. The most colourful events were mock battles among the elite riders of the unit. Both men and horses wore elaborate equipment such as that found in the Ribchester hoard.

This embossed bronze helmet, decorated with a scene of a skirmish between infantry and cavalry, is the most spectacular piece from the hoard. When used, the head-piece and face-mask would be held together by a leather strap. A crest-box and a pair of trailing streamers or 'manes' would also have been attached to the head-piece.

From Ribchester, Lancashire, late 1st or early 2nd century AD
Ht 27.6 cm

Enamelled bronze pan

THIS DECORATED PAN (*trulla*) would originally have had a handle and base, which are both missing. Like the helmet on the previous page, this is evidence of the Roman army in Britain. Below the rim is an inscription inlaid with enamel that encircles the pan: *MAIS* (Bowness-on-Solway) *COGGABATA* (Drumburgh) *VXELODVNVM* (Stanwix) *CAMMOGLANNA* (Castlesteads) *RIGORE VALI AELI DRACONIS*.

The first four names are forts in the western sector of Hadrian's Wall. The second part of the inscription is more difficult to interpret. *RIGORE VALI* seems to be a direct reference to Hadrian's Wall, known in Roman times as the 'Vallum'. Aelius was Hadrian's family name, so *AELI* may specify 'the wall of Hadrian'. Alternatively, it could belong with the word *DRACO*, forming the personal name Aelius Draco (or Dracon), possibly a soldier who had the pan made as a souvenir of his military service on the Wall.

From Staffordshire Moorlands, England, 2nd century AD, D. 9.4 cm
Joint acquisition between the British Museum, the Potteries Museum and Art Gallery (Stoke-on-Trent) and the Tullie House Museum and Gallery (Carlisle), purchased with substantial and generous support of the Heritage Lottery Fund

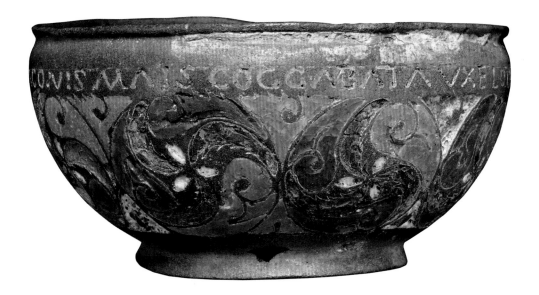

Bronze aquamanile

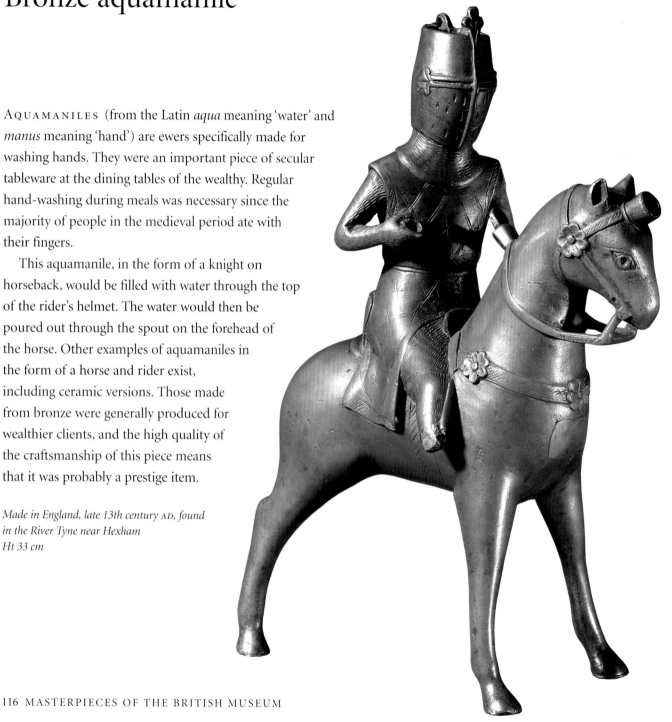

AQUAMANILES (from the Latin *aqua* meaning 'water' and *manus* meaning 'hand') are ewers specifically made for washing hands. They were an important piece of secular tableware at the dining tables of the wealthy. Regular hand-washing during meals was necessary since the majority of people in the medieval period ate with their fingers.

This aquamanile, in the form of a knight on horseback, would be filled with water through the top of the rider's helmet. The water would then be poured out through the spout on the forehead of the horse. Other examples of aquamaniles in the form of a horse and rider exist, including ceramic versions. Those made from bronze were generally produced for wealthier clients, and the high quality of the craftsmanship of this piece means that it was probably a prestige item.

Made in England, late 13th century AD, found in the River Tyne near Hexham
Ht 33 cm

Quilted cotton horse armour

IN THE ARMIES of the great African empires south of the Sahara, such as Ghana, Mali, Songhai, Hausa and Kanem-Bornu, horses were equipped with heavy quilted cotton garments. In full battle armour the horse would also have worn chainmail or pieces of leather across the flanks. A chamfron (headpiece) of metal and cloth completed the outfit. These colourful horses did not always go into battle, but sometimes acted as bodyguards for the commander in the field. The armour was also worn at grand military parades. Today these fabulous costumes are worn only on ceremonial occasions.

This particular horse armour was probably taken during or shortly after the Battle of Omdurman (2 September 1898), which marked the end of the Mahdist state in Sudan. This state was founded in 1885 by Muhammed Ahmad, the Mahdi, and was fully established by his successor, the Khalifa, whose forces were defeated by the British under General Kitchener at Omdurman.

From Sudan, Africa,
19th century AD
L. 170 cm
W. 84 cm
Gift of Major Maxse

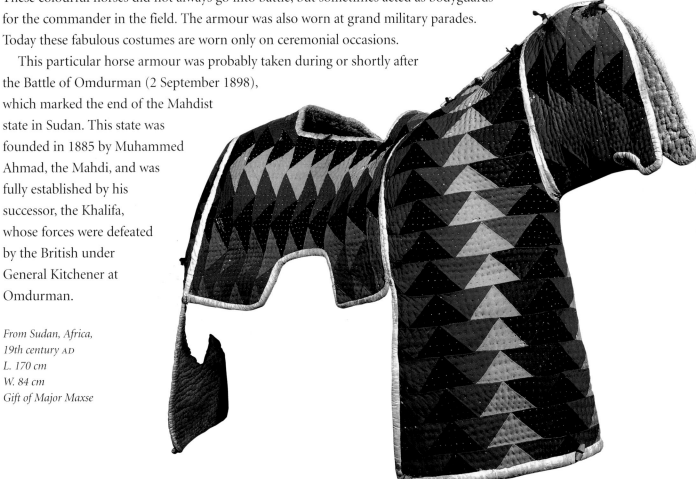

Gold dagger handle

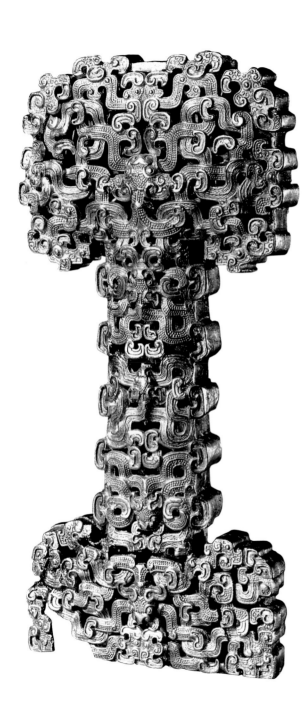

IN ANCIENT CHINA gold was not as prestigious as jade or bronze. It was mainly used for decorative purposes, such as inlay or coating on bronze or lacquer objects, and only very rarely for creating the objects themselves. In the Eastern Zhou period (771–221 BC), however, gold began to be used on a larger scale. Gold-working still relied to a great extent on well-established bronze technology such as casting objects using moulds.

This gold dagger handle has a conspicuous line on its sides, showing that it was probably cast in a two-piece mould. The hilt is hollowed out and both sides are decorated with a design known as dragon interlace. The handle is very fragile, which probably made it impractical for use on a real dagger. It may have been made for display or for placing in a tomb for use in the afterlife.

From China, Eastern Zhou dynasty, 6th–5th century BC
Ht 9.8 cm

Sword from the armoury of Tipu Sultan (1750–99)

TIPU SULTAN WAS the Muslim ruler of the south Indian state of Mysore (now part of Karnataka state) from 1782. Known as 'the Tiger of Mysore', this powerful ruler was able to play the opposing forces of the British East India Company, the French and the Marathas off against each other in the last quarter of the eighteenth century.

He fought against the British during the First Mysore War in 1767 and defeated British troops during the Second Mysore War in 1782, forcing them to sign the Treaty of Mangalore. Finally, in May 1799, the British stormed Seringapatam, Tipu's capital. They broke through the city walls, defeated the Sultan's forces and killed him. The battle marked a crucial turning point in the British East India Company's military policy, changing from defensive to offensive. This sword is a trophy of the Battle of Seringapatam and bears an inscription indicating that it comes from Tipu Sultan's armoury.

From Seringapatam, Karnataka, India, AD 1790s
L. 97.5 cm
Gift of Major-General Augustus
W.H. Meyrick

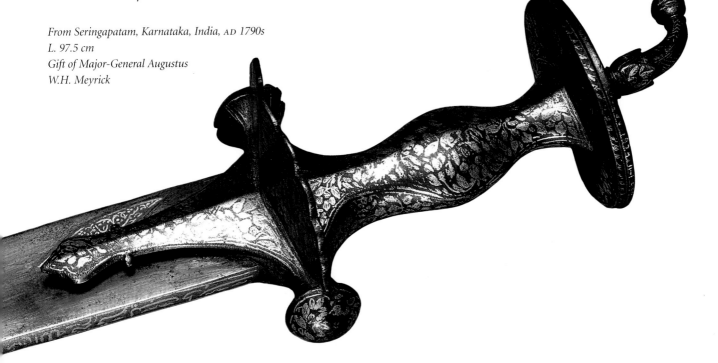

Tiles showing Richard and Salah-al-Din

THESE FLOOR TILES were found at Chertsey Abbey in Surrey. The tiles depict a vigorous display of valour: the English king Richard I (reigned 1189–99) slaying the Ayyubid Sultan Salah-al-Din (1138–93) with his lance. In fact, although Richard and Salah-al-Din were famous adversaries during the Third Crusade (1189–92), Richard never killed Salah-al-Din. The scene is a dramatic invention and was clearly intended to act as a tribute to Richard's bravery in battle.

The subject had a natural appeal for later English kings and was a particular favourite of Henry III (reigned 1216–72), who had it painted on the walls of the Antioch Chamber at Clarendon Palace. The quality and draughtsmanship of the tiles is superior to other tiles produced at Chertsey and may suggest that they were intended to furnish a royal palace.

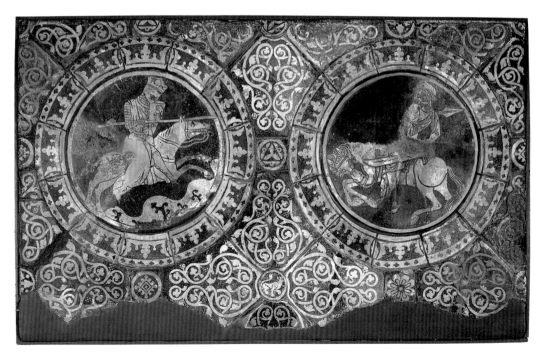

From Chertsey, England
c. AD 1250–60,
L. 17.1 cm
W. 10.4 cm
Gift of HM Queen
Victoria and Dr H.
Manwaring Shurlock

Seal-die of Robert Fitzwalter

A SEAL-DIE IS an engraved stamp used to impress a design on to hot wax in order to seal documents. This impressive example is made of silver and engraved to the highest standard. It shows the arms of Robert Fitzwalter (died 1235), one of the most influential English barons of the early thirteenth century, and is inscribed with the legend: + *SIGILLVM: ROBERTI: FILII: WALTERI* (the seal of Robert, son of Walter).

The shield depicted in front of the horse carries the arms of another baron, Saher de Quincy, who also included the arms of Fitzwalter on his seal. Fitzwalter and de Quincy were close political allies and played an important part in the barons' revolt against King John (reigned 1199–1216) that led to the signing of the Magna Carta in 1215. John was said to hate three men above all others: Archbishop Stephen Langton, Robert Fitzwalter and Saher de Quincy.

From England, c. AD 1213–19
D. 7.3 cm

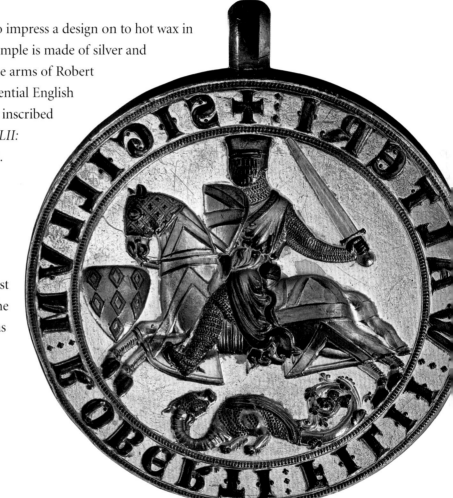

Battersea shield

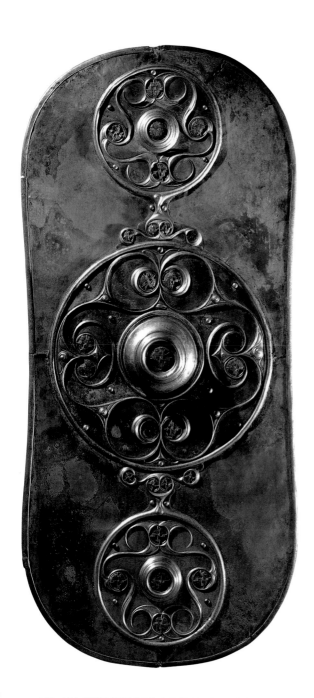

THIS IS A RARE example of an Iron Age shield from Britain. It has survived only because it was thrown or placed in the River Thames, where many weapons were offered as sacrifices.

The shield was not made for serious warfare. It is too short, and even with its original wooden backing the thin sheet bronze and complicated decoration would be easily destroyed. Instead, it was probably made for flamboyant display. The highly polished bronze and glinting red glass would have made for a great spectacle.

This shield is one of the most well-known pieces of early Celtic art from Britain. The domed boss in the middle of the central roundel is designed to protect the handle that was originally on the other side. The overall design is highlighted with 27 framed studs of red glass in four different sizes, the largest set at the centre of the boss.

Found in the River Thames at Battersea Bridge,
London, England, Iron Age, 350–50 BC
L. 77.7cm

Bronze gladiator's helmet

THIS BRONZE HELMET would have been worn by a heavily armed Roman gladiator such as the *samnite* or *murmillo*. Different types of gladiator were equipped with different weapons and armour. The *murmillo* was one of the heavyweight gladiatorial categories, fighting with a tall oblong shield and a sword with a broad straight blade, similar to those of the army infantry soldiers. The total weight of his arms and armour was around 16–18 kg. His most usual opponent would have been the *thraex* (Thracian) or *hoplomachus*, with a small shield.

This helmet is said to have been found in the gladiators' barracks at Pompeii. Although gladiators were sometimes slaves or criminals, many were professionals. Gladiatorial schools were run by a *lanista*, a private entrepreneur who bought or recruited suitable men, trained them and hired them out. There was strict discipline in the barracks, with a well-balanced diet, constant hard training and practice.

Said to be from Pompeii, Campania, Italy, 1st century AD
Ht 46 cm
Purchased with the assistance of Miss H.R. Levy

Leonardo da Vinci (1452–1519), *Military Machines*

THIS IS ONE of a number of sheets of drawings from a notebook by Leonardo in which he designed instruments of war. He drew these while working for Ludovico Sforza, Duke of Milan (1494–99). Under each drawing Leonardo has written words of explanation in his characteristic 'mirror' writing.

At the top of the sheet is a chariot with scythes on all sides. At lower left an armoured car is shown without its roof, revealing its inner workings. At lower right, the same tank-like vehicle is shown moving and firing its guns. At the far right is a more conventional weapon of the time, a large pike or halberd, perhaps more ceremonial than practical. It is highly unlikely that any of these machines were ever made or used in contemporary warfare.

From Florence, Italy, c. AD 1487
Ht 17.3 cm

Cristovao Canhavato (Kester) (1966–), *Throne of Weapons*

THIS THRONE SCULPTURE IS made from guns and parts of guns used in the devastating civil war in Mozambique. It was made by the Mozambican artist Kester from decommissioned weapons collected after the end of that war in 1992. It is a product of TAE (Transformaçaõ de Armas em Enxadas), a project which encourages the exchange of weapons for agricultural, domestic and construction tools. The result is a vivid reminder of sixteen years of devastating civil war as well as a symbol of hope for the future.

This throne is one of the most powerful masterpieces of art in the British Museum and has provoked strong emotions wherever it has been shown. The throne has not just been displayed in the Museum but has also been taken to other museums, schools, prisons, churches and other venues.

From Maputo, Mozambique, AD 2001
Ht 101 cm
Copyright Kester 2004

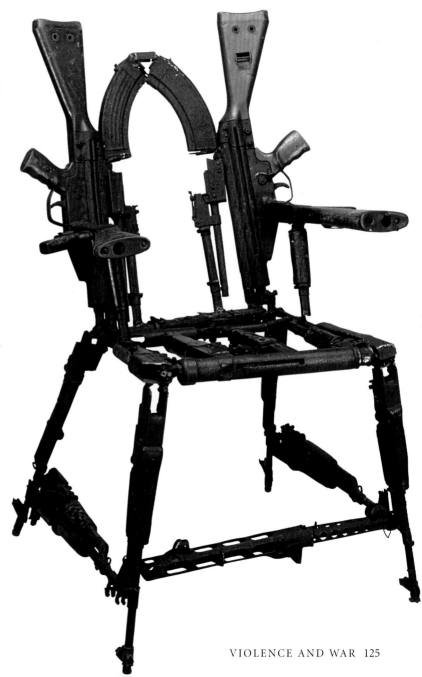

5 Mythical Beasts

THE MASSIVE WINGED BULLS from the royal palaces of the Assyrian empire in what is today Iraq have captured the imagination of visitors to the Museum since their arrival in the nineteenth century. These giant magical beasts have the bodies of bulls, the wings of birds and human bearded heads. They were guardian figures, as was the sphinx in Egypt.

Magical and mythical creatures play an important role in the stories, legends, religions and literature of most human cultures, so it is unsurprising that images of these creatures can be found across the Museum. We can look at these images as works of art and often as evidence of great technical skills, but they can also provide windows into a particular culture's myths and the ways they understood their worlds. This chapter offers a small selection of some of the mythical and magical beasts in the collections of the Museum. Some can be seen in the galleries, but others, such as the print by Cranach, drawing by Burne-Jones or the Maori kite, are made of delicate materials and can only be displayed to the public for short periods.

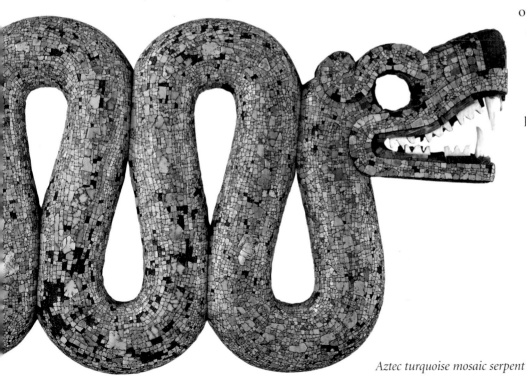

Aztec turquoise mosaic serpent

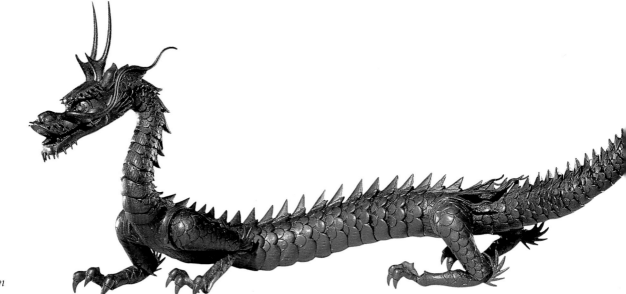

Japanese dragon

Many of the magical and fabulous creatures from the world's cultures are combinations of animal and human characteristics. The Assyrian winged bulls are just one example of this common feature. The sphinx, combining a lion's body with a human head, is another. Other examples combine the bodies of birds with human heads, such as the harpies or sirens of the Harpy Tomb from Turkey and the rare early Maori kite from New Zealand. Others repeat anatomical elements to stress their supernatural power, such as the wooden Kozo and the fabulous Aztec mosaic serpent chest ornament. Despite the similarities of combining, say, a bird body with a human head, or the use of double heads, these different cultures were not necessarily in contact with each other nor do they share a common origin. What they do have in common is the way the human brain works to imagine the fantastic.

Tracing magical and mythical beasts across the Museum allows us to consider how a particular myth or creature has been depicted in various cultures, time periods or by different artists. The dragon is a good example. There are considerable differences between the dragons of East Asia and those of Europe, and not just in their appearance. In European folklore the dragon or great worm is usually seen a malign, destructive and often evil creature, while Chinese dragons and their East Asian counterparts are generally considered auspicious.

This chapter brings together many images of dragons and related creatures from both East and West. In particular, four different depictions of the story of St George and the Dragon can be compared. Although St George is the Christian patron saint of England, his story was told in the *Golden Legend*, a very popular book throughout medieval Europe, and many images of him were created across the Continent, such as the print by Cranach the Elder. Other images shown here include a pilgrim badge and a Russian religious icon.

Granite sphinx

THE SPHINX IS a mythical creature with the body of lion and, usually, a human head, although sometimes the head might be that of a falcon, hawk or ram. Images of sphinxes were created in Egypt as guardian figures for temples or tombs. Although most people associate the sphinx with Egypt, this sphinx comes from what is today Sudan.

In about 720 BC, the Kushite ruler Piye conquered Egypt. Piye was the first of five Kushite (or Napatan) rulers who controlled Egypt and Nubia, now known as the Twenty-fifth Dynasty (747–656 BC).

Although they used the Egyptian language and wore Egyptian royal dress, the Kushite pharaohs retained links with their Nubian ancestry. The head of this sphinx is that of Taharqo, fourth pharaoh of the Twenty-fifth Dynasty, who reigned 690–664 BC. Although the general form of the sphinx is typical of Egyptian sculpture, it is adorned with a Nubian headdress and the face is carved in
a Nubian style.

From Temple T at Kawa, Sudan,
Kushite, 25th Dynasty, c. 680 BC
Ht 40.6 cm

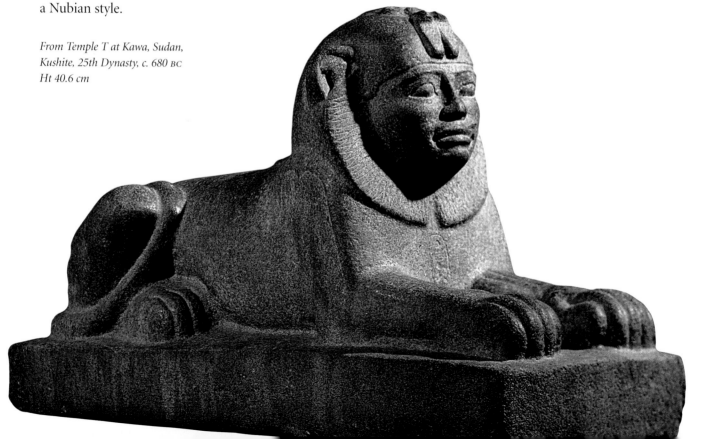

Kozo, double-headed dog

THIS KONGO WOODEN ritual figure is in the shape of a double-headed dog, known as Kozo. These figures were made in various human and animal forms, but Kozo was especially popular. His 'fur' is made from nails and sherds of metal, and on his back he carries a pack of medicines made from vegetable and mineral materials bound with clay. To instruct Kozo in a particular task a ritual specialist, the *Nganga*, would drive an iron blade into him with an accompanying invocation.

Among the Kongo, wild animals are associated with the dead, who are buried away from villages either in the forests or across rivers. Domesticated animals such as dogs live in villages but are used to hunt game in the forests. They are perfectly placed to mediate between the worlds of the living and the dead. Kozo's two heads and four eyes make him particularly powerful in this role.

Kongo, from Democratic Republic of Congo, c. AD 1900
Ht 28 cm

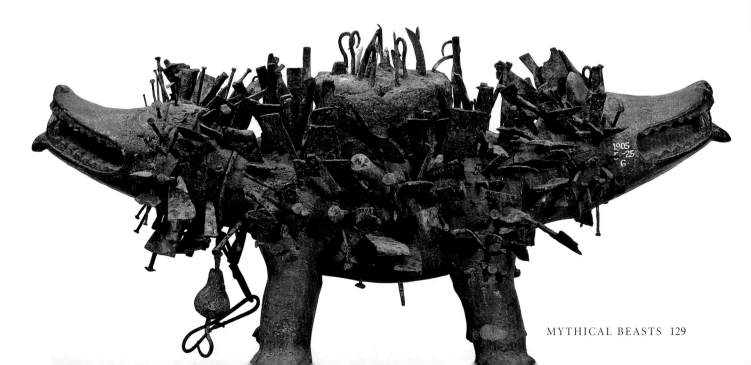

Double spout and bridge pottery vessel

THIS JAR DEPICTS a fantastic bird with a human face, adorned with a mouth mask and a diadem. The bird is holding a human trophy head in its mouth. Ritual beheading was a common practice in the Andes and scenes of decapitation are painted on Nasca vessels.

Some birds depicted in Nasca art are quite naturalistic, while others combine fantastic and anthropomorphic elements. Certain birds are still revered in the Andean region today. People of the modern town of Nasca believe that such birds as the condor, pelican and heron are manifestations of the mountain gods. To catch sight of one of these birds means that rain will fall in the mountains.

The technique and range of colours used on this large vessel mark the peak of Nasca achievement. Nasca artists used more colours than any other culture in the Americas before European contact.

From Peru, Nasca culture (200 BC–AD 600)
Ht 30 cm
Gift of Lady Dow Steel-Maitland

Colossal winged bull from the Palace of Sargon

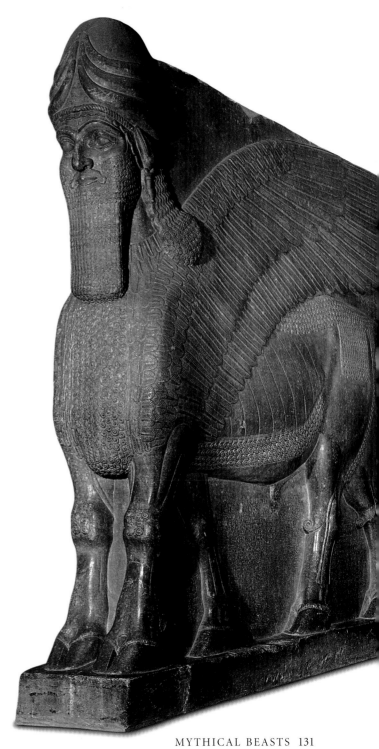

THIS IS ONE of a pair of human-headed winged bulls that once guarded an entrance to the citadel of Dur-Sharrukin, known today as Khorsabad. The city was built by the Assyrian king Sargon II (721–705 BC) as the new capital of his empire.

Assyrian records show that the building of entrances was accompanied by elaborate ceremonies, and they were given names as good omens to ward off evil. Magical gateway figures such as this were erected not only to decorate the building and impress visitors but also to protect the king. Small figurines buried under the entrances gave additional protection.

Between the legs of this figure is a long cuneiform inscription listing Sargon's titles, ancestry and achievements. Roughly scratched on the plinth, however, is a grid for the 'Game of Twenty Squares' (similar to the 'Game of Ur' in the final section), possibly the work of bored palace guards or people waiting to enter the citadel.

Made in Assyria, modern Iraq, c. 710 BC
Ht 4.42 m

Turquoise mosaic of a double-headed serpent

THIS ORNAMENT IS an icon of Aztec art. It was probably worn on ceremonial occasions as a pectoral (chest ornament). It is carved in wood and covered with turquoise mosaic. The eye sockets were probably originally inlaid with iron pyrites and shell. Red and white shell was used to add details to the nose and mouth of both serpent heads.

The serpent played an important role in Aztec religion. The word for serpent (*coatl*) in Nahuatl, the language spoken by the Aztecs, appears in the names of several gods including Quetzalcoatl (Feathered Serpent), Xiuhcoatl (Fire Serpent), Mixcoatl (Cloud Serpent) and Coatlicue (She of the Serpent Skirt, the mother of the Aztec god Huitzilopochtli). Images of serpents were also used as architectural elements, for example, in the wall of serpents (*coatepantli*) used to mark out sacred spaces within a ceremonial area.

Aztec/Mixtec, from Mexico, 15th–16th century AD
Ht 20.5 cm
Purchased with the Christy Fund

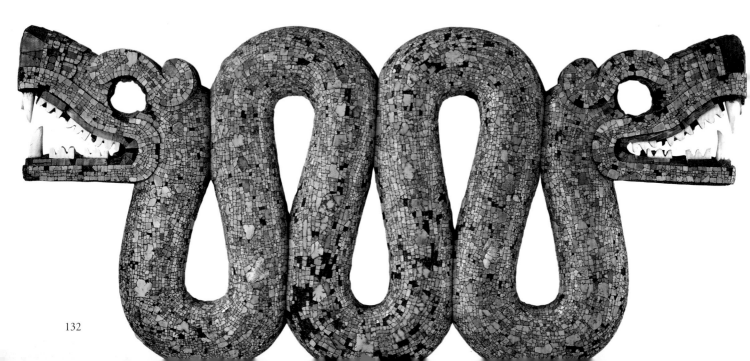

Ship's figurehead

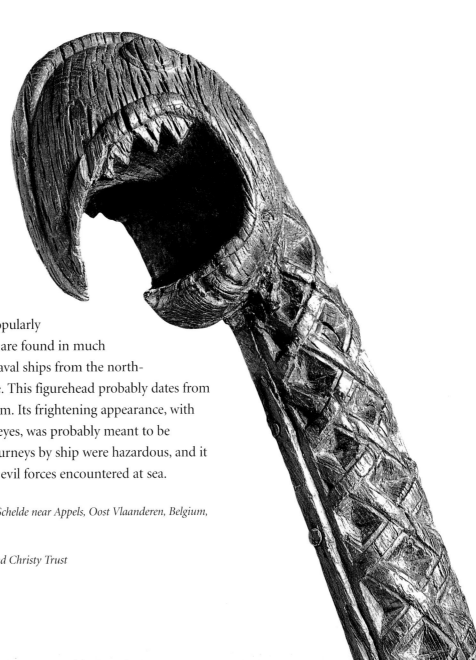

THIS FIGUREHEAD was discovered in 1934 and for a long time was widely thought to be from a Viking ship of the ninth to eleventh centuries. A few doubts, however, were raised about the style, and in 1970 the Museum's Research Laboratory undertook carbon-14 dating of the wood. The results left little doubt that the figurehead was carved much earlier than previously thought and did not come from a Viking ship.

Although animal figureheads are popularly associated with Viking longships, they are found in much earlier illustrations of merchant and naval ships from the north-east regions of the Late Roman empire. This figurehead probably dates from around this period, and is from Belgium. Its frightening appearance, with gaping jaws and prominent teeth and eyes, was probably meant to be protective and not just ornamental. Journeys by ship were hazardous, and it was believed necessary to ward off the evil forces encountered at sea.

Provincial Roman or Germanic, from the River Schelde near Appels, Oost Vlaanderen, Belgium, 4th–6th century AD
Ht 149 cm
Purchased with the assistance of the Art Fund and Christy Trust

Articulated model dragon, signed by Myochin Kiyoharu

ONE OF MANY images of dragons from different cultures in the Museum, this dragon comes from Japan. The fall of the Tokugawa shogunate in 1867 brought an end to the traditional warrior-based politics of Japan. As demand for armour decreased, many blacksmiths adapted their skills to making articulated iron models of animals. These were probably ornaments placed in the *tokonoma* (an alcove in the reception room of a house). They are astonishingly detailed and were created to display the technical virtuosity and artistic expertise of the maker.

The techniques used to rivet curved pieces of metal together to form armour were particularly effective when replicating feathers or scales, so animals such as fish, reptiles, beetles, shellfish, dragons and other mythical creatures were popular choices. The dragon's scales are reminiscent of the metal scales of samurai armour, and its neck, body, tail, legs and each individual claw are movable.

From Japan, 18th–19th century AD
L. 34.5 cm
Gift of Professor and Mrs John Hull Grundy

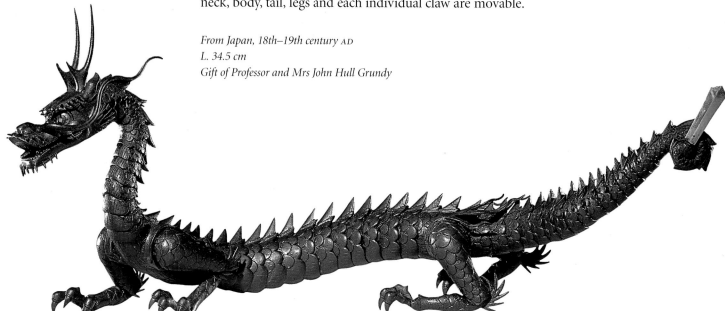

Cloisonné jar

IN CHINESE ART the dragon has a long snake-like body and, unlike dragons in European cultures, is seen as auspicious, not evil. Dragons were particularly associated with imperial power and authority. Imperial dragons, such as the dragon on this bronze jar, are often yellow or golden coloured and always have five claws.

This jar is decorated with the *cloisonné* enamel technique. First an object is cast in copper, in this case a lidded jar. Then the outline of the pattern is created with copper wires welded to the surface. Finally these cells are filled with coloured glass and the vessel heated until the glass melts and sets.

By the time this jar was made, *cloisonné* was considered appropriate for imperial use, and many superb pieces were made for palaces and temples. The inscription on the neck of the jar shows that it was made under the auspices of the Yuyongjian, a division of the Imperial Household.

From China, Ming dynasty, Xuande period (AD 1426–35)
Ht 62 cm

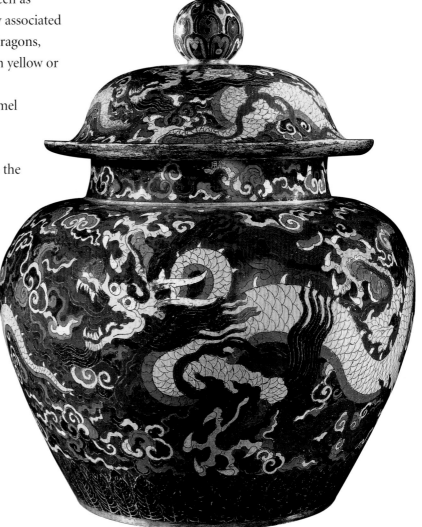

Icon of St George ('The Black George')

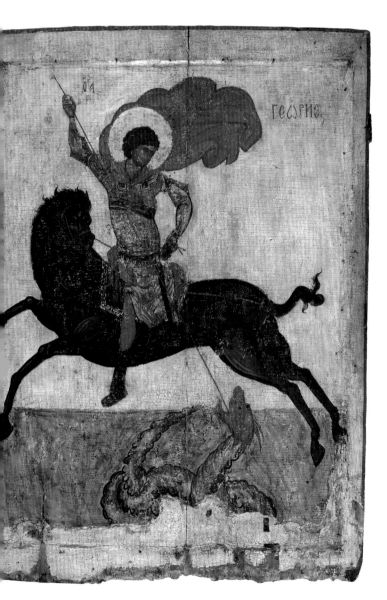

THE NEXT FEW pages all show images of the Christian saint George slaying the dragon. These are just four of the many different versions of this image across the Museum.

This extraordinary icon was discovered in 1959 when it was being used as the shutter of a barn window. Subsequent cleaning by conservators revealed that it had been overpainted several times. Below an eighteenth-century folk painting they uncovered a seventeenth-century layer and finally this outstanding fourteenth-century icon, which was immediately recognized as an early masterpiece of Russian painting.

The saint is painted in vigorous motion, captured at the moment of slaying the dragon. He stands in his stirrups, reining in his leaping horse, with his red cloak billowing behind. The representation of St George on a black rather than white horse is extremely rare and accounts for the icon's popular name, 'The Black George'.

From the village of Pskov, northwestern Russia
Byzantine, late 14th century AD
Ht 77 cm

Lucas Cranach the Elder (1472–1553), *St George and the Dragon*

THE ARTIST Lucas Cranach the Elder created many different images of St George and the Dragon, reflecting how popular St George was as subject matter for many late medieval and Renaissance artists in Europe.

This particular image, a sumptuously coloured print, is probably the earliest *chiaroscuro* ('light-dark') woodcut. To achieve this dramatic contrast, woodblocks were overprinted with differently coloured inks. The black line block was printed first and then the second block was printed, probably with glue, on to which the gold leaf was applied. The background highlights were added by scraping some colour from the paper.

In 1507 Cranach's patron Frederick III, elector of Saxony, sent a proof impression of this print to Conrad Peutinger, a councillor to the future Emperor Maximilian I. At that time Maximilian was seeking to promote the status of the Order of St George, so the figure of the knight may represent Maximilian in the guise of the saint.

From Germany, c. AD 1507
Ht 23.3 cm

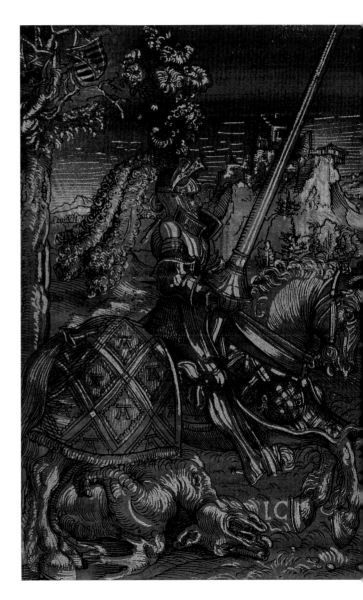

Edward Burne-Jones (1833–98),
St George fighting the Dragon

THIS CAREFULLY finished pencil drawing is one of a number of studies for a series of seven paintings illustrating the legend of St George, patron saint of England. The series was commissioned to decorate the house of artist Miles Birkett Foster at Witley in Surrey. The painting to which this drawing relates is now in the Gallery of New South Wales, Sydney, Australia, while others are in the Musée d'Orsay in Paris, the Forbes Collection in New York, and the Bristol Art Gallery.

The precisely observed but crisply stylized treatment of the foreground foliage and the background trees show the influence of Gabriel Dante Rossetti and other painters of the Pre-Raphaelite Brotherhood. Such highly worked preparatory drawings were useful to Burne-Jones, who often employed assistants to help him on larger schemes. The image of the dragon is inspired by a sixteenth-century German woodcut, probably from the collection of the British Museum.

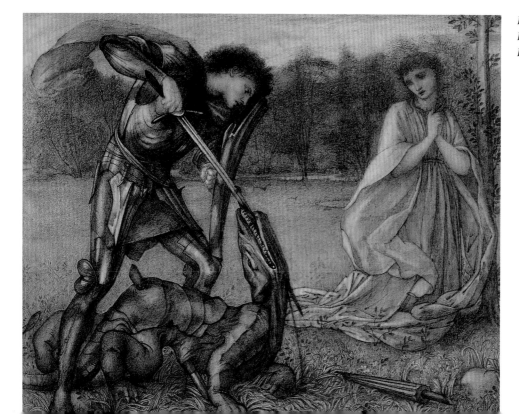

From England, c. AD 1865
Ht 35.1 cm
Bequeathed by Cecil French

Lead pilgrim badge depicting St George and the dragon

GOING ON PILGRIMAGE was an important part of Christian life in medieval Europe. Pilgrims often travelled hundreds or even thousands of miles to visit a saint's shrine. Some just wished to be close to the remains of the saint, while others hoped to find miraculous cures or forgiveness for sins.

Hundreds of pilgrim badges like this one, depicting St George, have been found in Britain. They were cheap and mass-produced, so everyone could afford them. People wore them to show where they had been on pilgrimage, or threw them into rivers or wells for good luck, or placed them in the fabric of their houses. The souvenirs usually show a saint, their symbol, or a scene from their life. This badge was probably a souvenir of a pilgrimage to the Royal Chapel at Windsor. It contained relics of St George, whose cult was particularly popular at the end of the fifteenth century.

From England, c. AD 1400–1550
Ht 2.9 cm

Relief panel from the Harpy Tomb

THIS PANEL IS from a monument known as the Harpy Tomb after the female-headed birds carved at its corners. They are perhaps better identified as sirens, escorts to the dead. The small figures they carry may represent the souls of the dead.

The monument was found at Xanthos in modern Turkey, the principal city of ancient Lykia. It is a fine example of a common type of Lykian tomb: a square limestone box perched on a tall pillar, decorated with sculpted marble panels. The sides all have similar scenes of seated figures, perhaps either deities or deified ancestors, receiving gifts from standing figures.

Although the style of carving is undeniably Greek in inspiration, some peculiar characteristics suggest that the sculptor was not Greek. The proposed date of the monument shows that the Archaic style (*c.* 600–480 BC) lasted longer in Lykia than on the Greek mainland or east Greek sites.

From Xanthos, modern Günük, Turkey, c. 470–460 BC
Ht (complete) 884 cm

Bird kite

THIS IS THE oldest surviving example of a Maori bird kite. Maori kites were made of a light wooden framework covered with imported cloth. Before cloth was introduced they were covered in barkcloth. Bird kites were generally given a human rather than a bird's head, on this example made from a contoured mask with shell eyes.

A large, complex and beautiful kite such as this one would have been flown by adults. Children flew simpler, quickly made kites. This kite has a wing span of over two metres and would have been flown by two men, using a very strong three-strand cord. Adults mainly flew kites for entertainment, occasionally holding kite-flying contests, but they also flew them for more serious purposes, such as divination. Omens were read from the way the kite mounted into the sky and from the places over which it hovered.

From the Bay of Plenty, North Island, New Zealand
Possibly early 19th century AD
Width 207.5 cm
Collected by Captain Manning, gift of Mr Reed

6 Death

On the ground floor of the Museum, close to the displays of monumental Egyptian sculpture, Assyrian winged bulls and the Parthenon marbles, is a smaller, quieter gallery containing sculptures from one of the Seven Wonders of the Ancient World. The Mausoleum of Halikarnasssos is a huge stone monument, 45 m tall, built 2300 years ago in Halikarnassos (modern Bodrum in Turkey). It housed the tomb of Maussollos, ruler of Halikarnassos, and was also a very visible memorial to his life and achievements. For many centuries after his death, this great building reminded all who saw it of the life and fame of its namesake. Only fragments now survive of this ancient wonder and the sculptures that originally decorated it, although Maussollos himself has achieved a form of immortality through the word mausoleum, originally used to describe his monumental tomb.

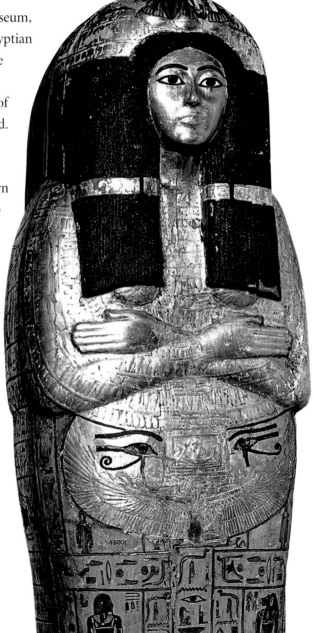

Outer coffin of Henutmehyt

142

Throughout the Museum are examples of the desire, common to many human societies, to commemorate the dead in the hope that the memory of their lives will endure beyond their deaths, although few have possessed the power or wealth to create such massive, long-lasting monuments as that of Maussollos. This desire has led to the creation of images immortalizing how the dead person looked (or, as the tomb relief of Seianti in this chapter demonstrates, how they ideally looked). In fact, as the tombstone from Cairo shows, the simplicity of words alone can also act as a powerful memorial.

While the fragments from the Mausoleum are a poignant example of how people have created objects and monuments to keep the memory of the dead alive for the living, many other objects across the Museum were created to help the dead in their new 'lives' after death. This is certainly true of Egyptian mummy cases and coffins, and of the objects placed with them in their tombs and graves. Among the most popular objects in the Museum are the mummy cases like that of Henutmehyt, which were made not just to contain the mummified body of the dead person but to act as a substitute body if their mummy perished. Burials from other societies and cultures also often contained goods for the dead to use in the afterlife. These include such famous objects as the Sutton Hoo helmet, part of a burial that also contains items to enable the inhabitant to host a lavish feast after death – a common feature of many burial customs in pre-Christian Europe.

Other objects found in burials are more enigmatic: we know that the jade *bi* and *cong* made by early Neolithic farming societies in China required great skill and much time, but their function and meanings are now lost to us. This is also true of the Folkton drums, created in England at about the same time as the Chinese jades and also placed in a grave.

Folkton drum

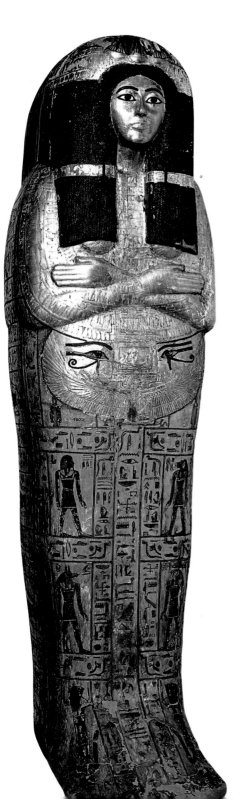

Gilded outer coffin of Henutmehyt

THE MUMMY CASES and coffins from Egypt are probably the most well-known objects associated with death in the British Museum. This is the gilded outer coffin of Henutmehyt, a Theban princess and a chantress of the god Amun who died over 3000 years ago. Her richly decorated outer coffin provides a magnificent idealized image of her, adorned with her full wig. A collar is spread over the breast, and below it hangs a pectoral (chest) ornament flanked by protective *wedjat* eyes. This human-shaped outer coffin not only provided protection for the mummified body, but was also believed to provide the spirit of the deceased with a substitute body if the mummy perished.

The coffin is covered with religious symbols intended to insure the deceased's rebirth and well-being in the Afterlife. These include the image of the sky-goddess Nut, who spreads her winged arms protectively across the body.

From the tomb of Henutmehyt, Thebes, Egypt, 19th Dynasty, c. 1250 BC
Ht 208 cm

Colossal statue of a man

THE WORD 'MAUSOLEUM' is used to describe a building that contains a tomb, but the word was first used for the tomb of Maussollos at Halikarnassos, one of the Seven Wonders of the Ancient World. This over life-size figure comes from that tomb. The excavator of the site, Charles Newton, claimed that it represented Maussollos himself, but later research suggests that there were originally 36 such colossal portraits on the tomb, probably representations of Maussollos' ancestors. Although this statue was restored from at least 77 pieces, it is the best-preserved of the figures from the tomb.

The statue was not intended as a true likeness, but as a generic portrait of an Asiatic. The figure represented is clearly not Greek. The tunic, long hair, closely cropped beard and drooping moustache reflect Asiatic fashions of the time.

From Halikarnassos (modern Bodrum), southwestern Turkey, c. 350 BC
Ht 300 cm

Wax death mask of Oliver Cromwell

MANY CULTURES HAVE made masks representing the dead but from the medieval period in Europe, masks were made from actual casts of the face of the deceased. When a famous person died, a death mask was often made as a record of how they looked. An initial cast provided a mould from which plaster or wax masks could be taken. These were widely distributed through private and public collections and also used as models for posthumous portraits.

This death mask of Oliver Cromwell (1599–1658) was originally owned by Sir Hans Sloane (1660–1753), whose collection contributed to the founding of the British Museum. It was taken after embalming and shows the cloth bound around the head to cover the cincture. The face has a beard and moustache, but Cromwell's famous wart has either been pared off or has disappeared due to the action of the embalming fluid. Several casts of Cromwell's death mask exist. Although the identification of this example has been questioned, it certainly entered the Museum as a representation of Cromwell.

From England, AD 1658–1753
L. 21.3 cm
W. 16.2 cm
Bequeathed by Sir Hans Sloane

Mosaic mask of Tezcatlipoca

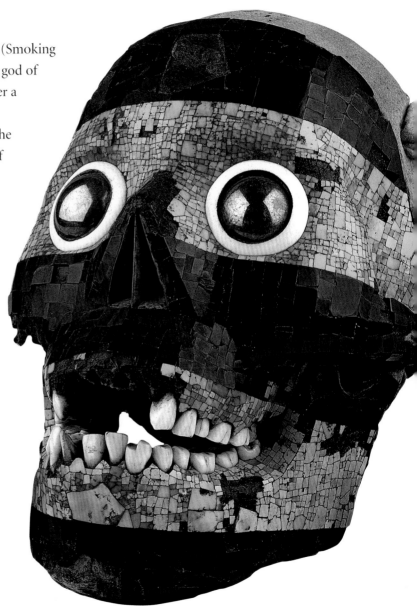

THIS MASK IS believed to represent Tezcatlipoca (Smoking Mirror), one of the Aztec creator gods and also the god of rulers, warriors and sorcerers. The mask is built over a human skull with a movable hinged jaw. Alternate bands of turquoise and lignite mosaic work cover the front of the skull. The eyes are made of two discs of iron pyrites set in rings made of shell. The back of the skull has been cut away and lined with leather.

Turquoise was sent as tribute to the Aztec capital from several provinces of the empire. The turquoise was sent as raw chunks or as cut and polished mosaic tiles decorating objects such as masks, shields, staffs, discs, knives and bracelets. A tribute list issued by the emperor Moctezuma II (reigned 1503–20) states that ten turquoise mosaic masks made by skilled Mixtec artisans were sent each year from a province in Oaxaca.

Aztec/Mixtec, from Mexico, 15th–16th century AD
Ht 19.5 cm
Christy Collection

Granite statue of Ankhwa the ship-builder

THIS STATUE IS an example of so-called 'private' Egyptian sculpture, intimate images made to be placed in the tombs of ordinary people. This type of sculpture developed during the Third Dynasty (*c.* 2686–2613 BC). Here a seated ship-builder is shown holding a woodworking adze, a tool indicative of his trade. An inscription carved on the figure's kilt gives his name, Ankhwa, and his titles. One of these ranks Ankhwa as a royal acquaintance, a status reflected not only in the quality of his statue but also in its material. Granite was quarried at the king's pleasure, so this statue was probably made in a royal workshop.

The style of private sculptures closely follows the conventions set by royal sculpture. It was static, frontally posed, and with idealized features. Before the Fourth Dynasty (*c.* 2613–2494 BC), sculpture 'in the round' is rare, but this example from the Third Dynasty is outstanding.

Possibly from Saqqara, Egypt, 3rd Dynasty, c. 2650 BC
Ht 65.5 cm

Haniwa

THIS TALL POTTERY female figure would have stood with others in a protective circle around the tomb-mound of a powerful Japanese ruler. Her hair is swept up into an elaborate coiffure and she wears a string of beads round her neck.

From the late fourth century AD the leaders of the Yamato state in the Kyoto area established their dominance over other Japanese kingdoms. Their status is apparent in the size and splendour of their tombs – huge mounds known as *kofun* (old mounds). In the tombs a large earth mound covered a stone chamber in which the stone or wood coffin was placed. The mounds were often marked with circles of low-fired pottery cylinders, or representations of animals, objects, and people such as this example. It is thought that this practice in Japan took the place of the ancient Chinese custom of burying servants and goods with the dead ruler.

From Japan, Kofun period, 6th century AD
Ht 55 cm
Gift of Sir A.W. Franks

Jade *cong*

THIS IS A mysterious ritual object known as a *cong*, which were often found in tombs. This one was made of jade about 4500 years ago by the Neolithic Liangzhu culture in the Jiangsu province of China.

These *cong*, essentially a square tube pierced with a central circular hole, are among the most impressive yet most enigmatic of all ancient Chinese jade artefacts. Though they were buried in large numbers – one tomb contained 33, and spectacular examples have been found at all the major Liangzhu sites – their function and meaning remain unknown.

Cong were extremely difficult and time-consuming to produce, as jade cannot be split but must be ground down and worked with a hard abrasive sand. The corners of most *cong* are decorated with what appear to be faces, indicated by eyes and parallel bars, possibly representing spirits or deities. The faces combine elements of a man-like figure and a mysterious beast.

From southern China, c. 2500 BC
Ht 49.5 cm

Folkton drums

THESE MYSTERIOUS objects were made by a Neolithic community in Europe about the same time as the Chinese *cong* on the other page. These so-called 'drums' were found in a child's grave on Folkton Wold. The custom of burying individuals with 'special' grave goods began about 3000 BC. This grave offering is exceptional (the drums are unique) and must indicate something about the status of the child.

The drums are made from local chalk and are elaborately carved, using a technique very like that of chip-carving used by woodworkers. No other objects like them survive, but perhaps equivalent items were made of wood and have not lasted. We do not know how they were used.

The decoration is organized in panels, and stylized human faces look out from two of the drums. The significance of the designs is unknown, though they are very similar to those found on pottery of the Later Neolithic Grooved Ware style.

Found in East Yorkshire, Late Neolithic period, 2600–2000 BC
Ht 8.7 cm (min.)
Gift of Canon W. Greenwell

Papyrus from the Book of the Dead of Nedjmet

ANCIENT EGYPTIAN funerary literature, such as the Book of the Dead, was created to help the deceased pass through the dangers of the Underworld and be reborn. The books consist of a series of magical texts which deal with different areas and events in the afterlife. The texts are often accompanied by illustrations known as vignettes.

This vignette comes from the Book of the Dead of Nedjmet, and shows her and her husband Herihor making offerings to the gods. Herihor features prominently within this papyrus, probably due to his status. He was one of the High Priests of Amun who effectively ruled Upper Egypt from the end of the Twentieth Dynasty (about 1186–1069 BC) until some time in the Twenty-second (about 945–715 BC). He was the first of these priests to adopt royal attributes, such as placing his name in a cartouche, and showing himself with the royal *uraeus* on his brow.

Perhaps from the Royal Cache at Deir el-Bahari, Egypt
21st Dynasty, c. 1070 BC
Gift of King Edward VII

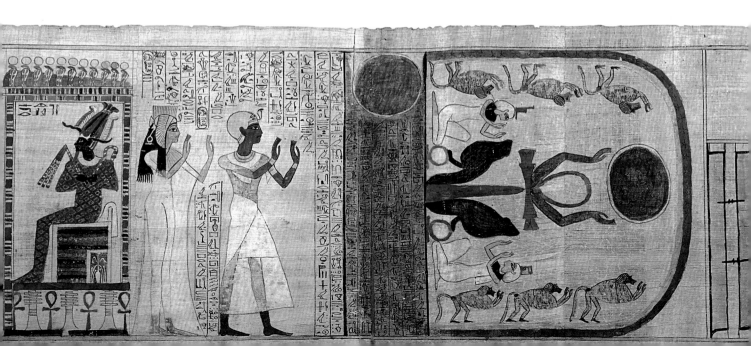

Assistant to a Judge of Hell

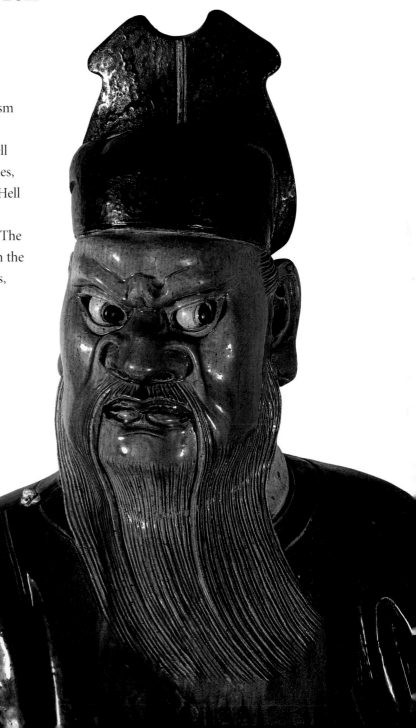

THE IDEA OF HELL came to China with Buddhism during the early first millennium AD. From the late Tang dynasty (AD 618–906) judgement scenes in Hell became more common in Chinese art. In these scenes, the newly deceased appear before the ten Judges of Hell and their assistants to have their virtues and vices assessed and to receive an appropriate punishment. The dead have to account to the Judges for their deeds in the same way as the living had to account to magistrates, their secular counterparts. The Judges' assistants would carry the rolls of documents required to support a case.

This glazed stoneware figure is a fierce-looking Judge's assistant who holds a thick record of sins. The Museum also has a more benign assistant who holds a much slimmer record of good deeds.

Ming dynasty, China, 16th century AD
Ht 137 cm
Given by the Friends of the British Museum and the Art Fund

'Fowling in the marshes', fragment of wall painting from the tomb of Nebamun

THIS SCENE IS one of eleven fragments from a tomb belonging to a 'scribe and counter of grain' named Nebamun. Stylistically the magnificent paintings, which are among the most skilfully executed from ancient Egypt, can be dated to the reign of Thutmose IV (1400–1390 BC) or Amenhotep III (1390–1352 BC).

The paintings are distinguished from other Eighteenth Dynasty examples (about 1550–1295 BC) by the quality of the drawing and composition, and the use of colour. They depict the daily life of Nebamun and his family but their arrangement in the tomb, and much of the imagery used, points to their deeper significance in Nebamun's hopes for rebirth and renewal in the afterlife.

Here Nebamun stands on a small papyrus boat with his wife Hatshepsut behind him and his daughter below. The hieroglyphs below his raised arm describe him as 'taking recreation and seeing what is good in the place of eternity', that is, in the afterlife.

Probably from the northern area of the necropolis, Thebes, Egypt
18th Dynasty, c. 1350 BC
Ht 83 cm
Salt Collection

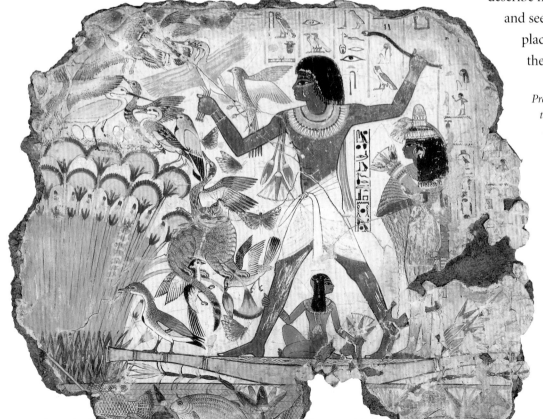

Painted terracotta sarcophagus of Seianti Hanunia Tlesnasa

THIS IS THE sarcophagus of an Etruscan woman named Seianti Hanunia Tlesnasa. The Romans adopted many features of Etruscan culture, and their early sarcophagi and cinerary urns (containers for cremated remains) show strong Etruscan influence.

The deceased is depicted reclining upon a mattress and pillow, holding an open lidded mirror in her left hand and raising her right hand to adjust her cloak. She wears a *chiton* (tunic), a purple-bordered cloak, and jewellery comprising a tiara, earrings, a necklace, bracelets and finger-rings.

Scientific testing of the teeth of the body inside the sarcophagus indicates that she was probably about 50 to 55 years old at the time of her death. The rather youthful portrait is typical of the idealized representation found in the Hellenistic period of Etruscan art, when it was heavily influenced by the international culture of the Greek world.

Poggio Cantarello, near Chiusi, Tuscany, Italy, c. 150–140 BC
L. 183 cm

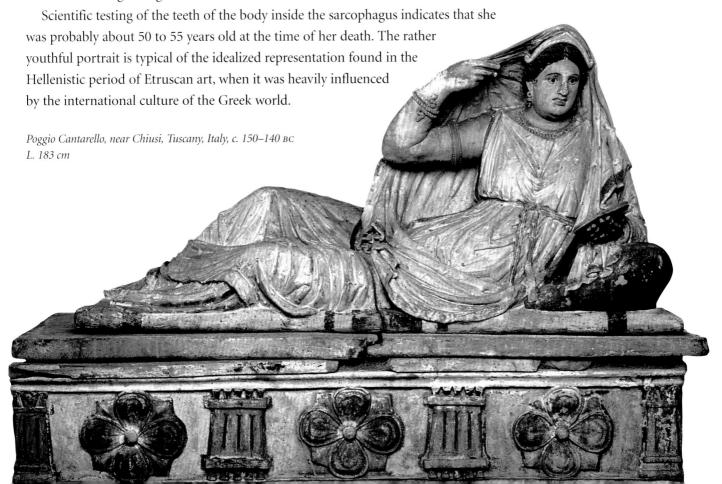

Dhratarastra, Guardian King of the East

THIS VERY LARGE Buddhist painting on hemp cloth from Korea is one of a pair that would have originally been placed inside the entrance of a temple. Buddhism was oppressed during the early Choson period (AD 1392–1910) but gained more respect after the Japanese invasion of Korea in 1592, when Buddhist monks organized armies and fought against the invaders. This painting is from late in the Choson period, when Buddhism became more active.

The four guardians of the north, east, south and west were the defenders of Buddhism. The figure in this painting is playing a lute which is an attribute of Dhratarastra, Guardian King of the East. The huge size of the canvas (3 m high), the dynamic and decorative lines and the combination of mineral colours are typical of Buddhist paintings from Korea.

Probably from Taegu, Kyongsang province, Korea,
Choson dynasty, late 18th–early 19th century AD
Ht 301 cm

Sancai ceramic tomb figure

THIS FIGURE OF a fabulous beast is part of a group reputed to be from the tomb of Liu Tingxun, an important Chinese military commander who died in AD 728. A memorial tablet found with these figures records his skill in military matters and the arts of statesmanship, and that he died at the age of 72.

They are among the tallest known burial figures from the Tang dynasty (AD 618–906). The group comprises two fabulous beasts (one with a human face), two fierce guardian figures usually seen at the entrance to temples, and two officials, one military, one civil. The military official has armour over his green robe and a bird of prey on his hat. It is interesting that all the human heads are unglazed, including that of the fabulous beast, as are the flaming manes of both animals. Otherwise, the figures are completely covered with lead *sancai* (three-colour) glaze.

From northern China, probably Henan province, early 8th century AD
Ht 109 cm (max.)

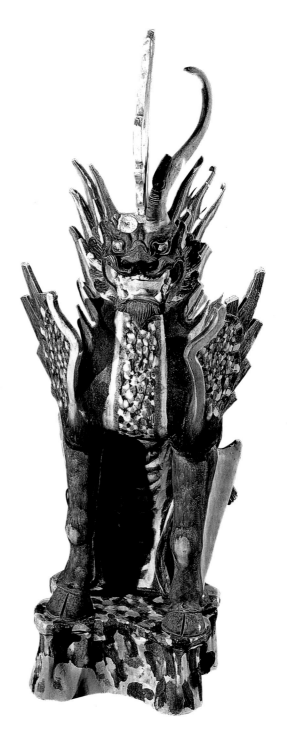

Reliquary of St Eustace

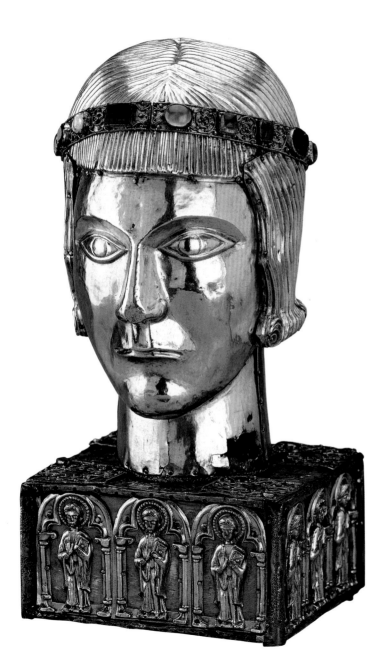

From the ninth century, reliquaries (containers for religious relics) were often made in an idealized form of the relic itself. This 'head' was said to contain fragments of the skull of St Eustace. According to legend, Eustace was a general under the Roman emperor Trajan (reigned AD 98–117) who was converted to Christianity while hunting, after seeing a vision of a stag with a luminous crucifix between its antlers. Some time later, after victory in battle, he refused to join in thanksgiving to the Roman gods, and was burned to death with his wife and sons.

The reliquary, made in Europe in the early thirteenth century, has a sycamore wood core covered with silver plates. When the reliquary was conserved in 1955 a number of relics were found wrapped in textiles which were returned to the Catholic church in Basle.

Basle, Switzerland, c. AD 1210
Ht 32 cm

Mourner's dress

THIS POLYNESIAN DRESS would have been worn by the chief mourner after the death of an important person. He would also have carried a menacing long club edged with shark teeth, and led a procession of mourners through the local area, attacking people, sometimes fatally. This 'reign of terror' could last for up to a month.

The main section of the dress is made from barkcloth, with a feather mantle at the back and feather tassels at the sides. The face mask is made of pearl shell surmounted by tropical bird feathers. Pearl shell also decorates the wooden crescent-shaped breast ornament from which a chest apron of pearl shell slivers is suspended. The barkcloth waist apron is decorated with coconut shell discs.

In 1774 Captain Cook recorded that he had been presented with a complete mourner's outfit; it is thought to be this dress, which was donated to the Museum by Cook.

From the Society Islands, French Polynesia, pre-18th century AD
Ht 214 cm
Collected on the second voyage of Captain James Cook (1772–5)

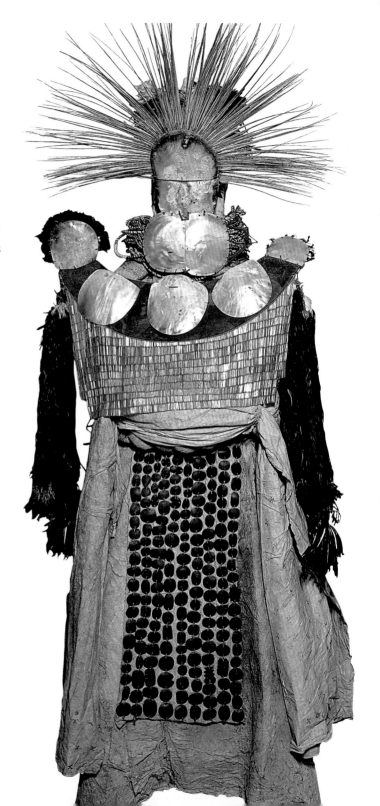

Calcite-alabaster stela

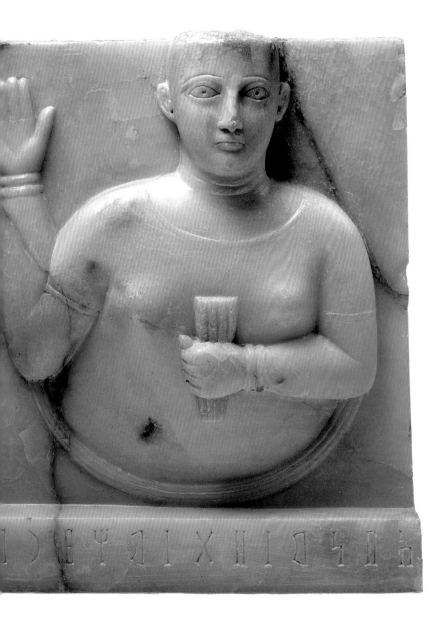

THIS IS THE gravestone of a young woman named Aban. It is an example of a funerary stela known as a *nefesh* ('soul' or 'personality'), important for retaining identity in the next world.

Aban is portrayed in a pose characteristic of these sculptures, facing front with a raised right hand and a stylized sheaf of wheat in her left hand, a symbol of fertility. She wears bracelets on each wrist and would probably originally have had earrings attached to the holes in her ears. The statue finishes at the hairline as the hair was added in plaster, another typical feature of portrait busts from ancient South Arabia.

According to the inscription on the base of the stela, Aban was probably from Qataban in South Arabia. Like its neighbours, Qataban became rich from trade in frankincense and myrrh, two of the most prized materials of the ancient world.

Possibly from Tamna, Qataban, Yemen,
1st century BC–2nd century AD
Ht 30 cm

Marble panel from the grave of Muhammad b. Fatik Ashmuli

THIS PANEL WOULD have been at the head of a four-sided open structure placed around a grave. The ornamental inscription on the outer face is carved in Kufic script, the oldest calligraphic form of Arabic script. It had been in use for over a century by the time of the emergence of Islam, and was used to write down the earliest copies of the Qur'an.

The carving depicts the beginning of the *basmala*: 'in the name of God the Merciful'. This would have introduced verses from the Qur'an, which continued on the exterior surface of the three missing panels. There is another inscription on the other side of the panel which is incised into the stone rather than carved in relief. It also begins with the *basmala*, then gives the name of the deceased, Muhammad b. Fatik Ashmuli, and the date of his death in the month of Jumada II AH 356 (AD 967).

From Cairo, Egypt, 356 AH/AD 967
Ht 45 cm
Purchased with funds from the Brooke Sewell Fund

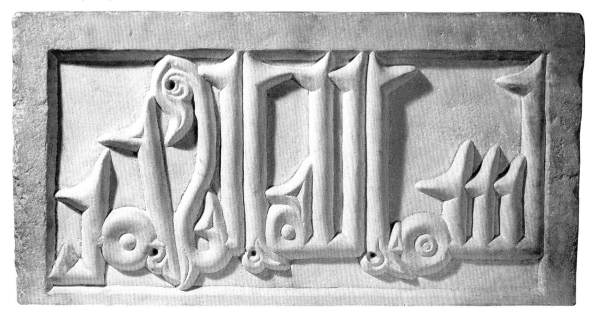

7 Animals

THE OLDEST EXAMPLES of art in the Museum are images of the natural world. These ancient carvings on antler, bone and ivory from the Ice Age (*c.* 40,000–8000 BC) include images of animals such as reindeer and mammoth that shared the world of these early human communities. Objects such as the spear thrower from France in the form of a mammoth suggest that these images were not simply examples of a desire to illustrate the natural world. They show that from the beginning of human 'art', images of the natural world were also used to convey ideas and ideals. These animals were as important to think about as they were essential to hunt, eat or wear. Such examples of Ice Age art were probably not purely decorative but, as in later human cultures, were also symbols associated with stories and myths, perhaps even the physical manifestations of gods and spirits. The tiny rib from Robin Hood Cave is one of the oldest pieces of art to survive from Britain. It is engraved with the image of a horse, now hard to make out, but showing evidence of wear and polish from 10,000 years ago. This little bone fragment must have been much handled, suggesting that the image was far more than just a doodle or a picture of a horse.

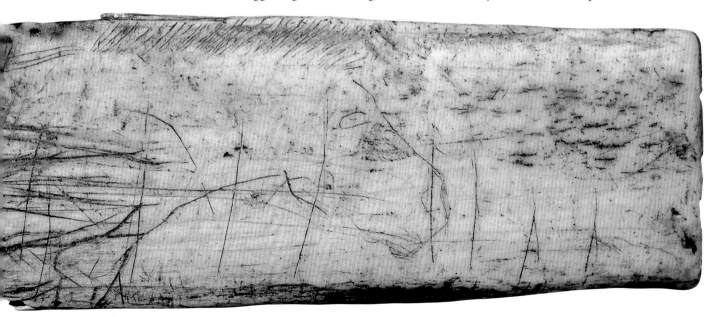

Cresswell horse from Robin Hood Cave

Images such as the Ice Age horse engraving reflect the long history of our relationship with the horse, although at this period horses were not ridden but hunted for food. It can be compared with much later images by European painters such as Stubbs or, as here, Toulouse-Lautrec, but also the many other images of horses from across the world, including the two examples here from Rome and Tang dynasty China. However, other examples can be found in other chapters of this book: riding horses or using them to pull chariots was often the privilege of the richer and higher status members of many societies, and these were also the people who tended to be depicted in art. For example, horses were an integral part of the image of medieval European knights and of the equestrian class in ancient Rome. On the other hand the dog, although the first animal to be domesticated by humans and our companion for over 10,000 years, is much less commonly depicted across world art.

The importance of animals as symbols and in myth is common to many cultures represented in the galleries of the Museum, and their images can be seen on objects ranging from massive sculptures to tiny coins and seals. Small images of scarab

Big Fish Eat Small Fish

beetles were very common in ancient Egypt, where the scarab was associated with rebirth and the daily rising of the sun. Most are only a few centimetres long, but the Museum also has one of the largest known images of a scarab from Egypt. Other objects in this chapter also represent animals from myths and religious stories, such as the famous 'Ram in the Thicket' from the Mesopotamian city of Ur or the animals depicted on ancient North American smoking pipes. The mythical roles played by animals make their images recognizable symbols of individuals, groups or communities. The owl could signify the ancient Greek city of Athens because of its close association with the city's patron goddess Athena. Animals were used as heraldic symbols for European families and rulers, as seen in the small medieval Dunstable Swan. Animal images have also frequently been employed in a wide range of allegories and metaphors, both to glorify and satirize aspects of human society.

Giant sculpture of a scarab beetle

THIS DIORITE SCULPTURE is around one and a half metres long and is one of the largest known representations of a scarab beetle. The scarab is one of the enduring symbols of Ancient Egypt, representing rebirth and associated with the rising sun. As a hieroglyph the scarab has the phonetic value HPR (*kheper*) which as a verb means 'to come into being'. According to one creation myth, the new-born sun was called Khepri and took the form of a man with a scarab head.

This scarab is thought to be from the Ptolemaic period (305–30 BC) but could be earlier. It may once have stood in an Egyptian temple but it was found in Constantinople (modern Istanbul) in Turkey. It may have been taken from Egypt to Constantinople when the city became the capital of the Later Roman empire in AD 330. The sculpture was bought in the nineteenth century by Lord Elgin.

From Constantinople (modern Istanbul), Turkey,
Egyptian, perhaps Ptolemaic period, 332–30 BC
Ht 91.5 cm (max)

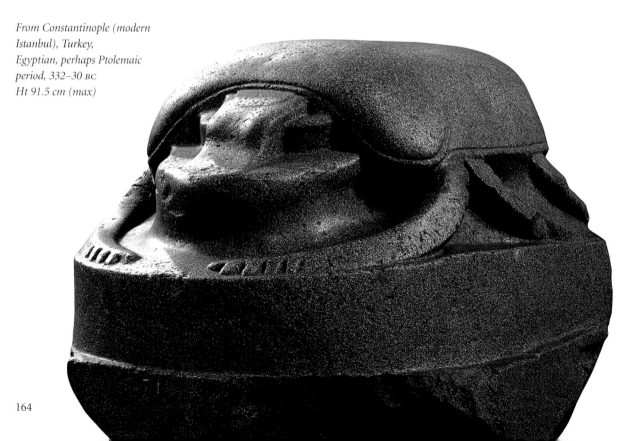

Jade terrapin

THIS LIFE-SIZED terrapin is carved from a single piece of jade and was found in Allahabad, India. It was probably made to be an ornament for the garden of a Mughal palace.

The Mughals were great collectors and sponsors of the arts. Members of the royal family were often taught the arts of painting, seal-engraving, jewellery-making and goldsmithing as well as those of warfare and politics. The interests of the emperors and their training in the arts led them to collect, commission and sometime even design fine examples of both Mughal and foreign artistic skill.

The turtle was found in Allahabad, home to Selim, son of the Mughal emperor Akbar (reigned 1556–1605), later the emperor Jahangir. Selim is known to have patronized jade carvers and was greatly interested in the natural world. The carving of this terrapin is extremely life-like, with particular attention to detail, even on the underside.

From Allahabad, India, 17th century AD
Ht 20 cm
Bequeathed by Lt. Thomas
Wilkinson, through James
Nairne

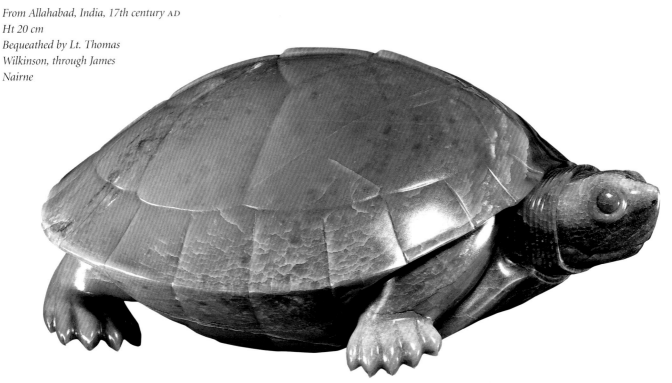

Bronze figure of a seated cat

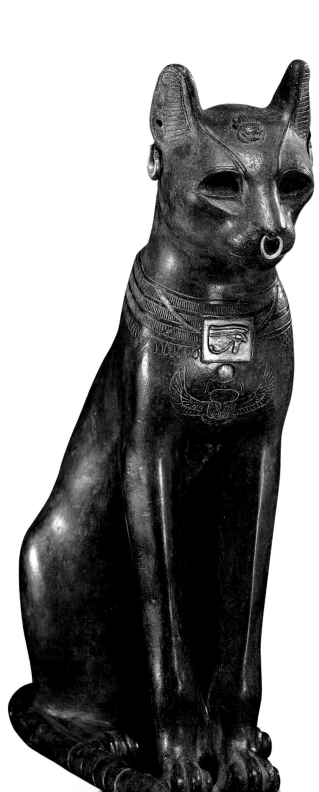

THIS IS A particularly fine example of the many statues of cats found from Egypt. It has gold rings in its ears and nose, a silvered collar round its neck and a silver protective *wedjat* eye amulet.

In Egypt the cat was mostly identified with the goddess Bastet, whose cult centre was at Bubastis in the Nile Delta. Bubastis grew in importance when its rulers became the kings of Egypt, forming the Twenty-second Dynasty, sometimes known as the 'Libyan Dynasty'. The increasing influence of Bastet and the cult of the cat can probably be dated to this period. In the Late Period (661–332 BC) mummified cats were often buried as a sign of devotion to the goddess in special cemeteries, a number of which have been discovered in Egypt.

This sculpture is known as the Gayer-Anderson cat, after its donor to the British Museum.

From Saqqara, Egypt, Late Period, after 600 BC
Ht 42 cm
Gift of Major Robert Grenville Gayer-Anderson

Marble statue of a pair of dogs

THESE MARBLE GREYHOUNDS are among the most charming representations of 'man's best friend' to come down to us from antiquity. They were excavated at a place called 'Dog Mountain' near Civita Lavinia (modern Lanuvio), Italy. Several other marble dogs were also found there: another similar pair of greyhounds, a sphinx with dog's body, and two statues of Actaeon attacked by hounds. The site was once identified with the ruins of a palace of the Roman emperor Antoninus Pius (reigned AD 138–161), who was born in the region. This is no longer accepted, and the sculpture cannot therefore be firmly dated, as previously thought, to his reign.

Found near Civita Lavinia (modern Lanuvio), Lazio, Italy, possibly 2nd century AD
Ht 67 cm
Townley Collection

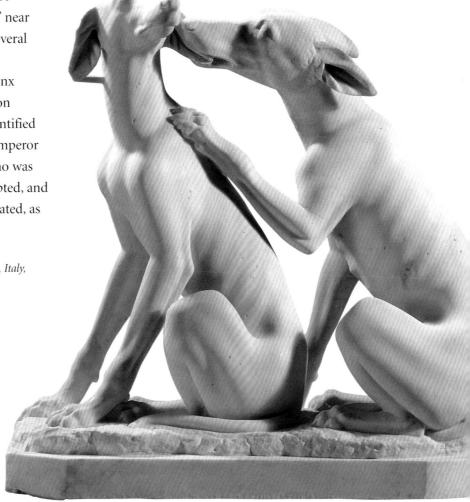

Cornelis Visscher (1629–58), *The Large Cat*

THIS ENGRAVING IS ONE of the most famous prints of a cat. Visscher was a professional engraver of his own and other artists' designs. This was an unusual occupation in seventeenth-century Holland where artists generally adopted the less demanding technique of etching. Contemporaries and later connoisseurs eagerly collected Visscher's work, though they arouse little interest as works of art today.

Visscher has admirably captured the quality of the cat's stiff whiskers and soft fur, with a glossy sheen on the highlights. The cat appears particularly large because it crowds the frame, leaving just the corners for the arched window, the stone bearing Visscher's signature, the silhouetted foliage in front of its nose, and the diagonal lines of engraved shadow above its head. The cheeky mouse, emerging from the safety of the window bars, injects a small element of drama into an otherwise uneventful scene.

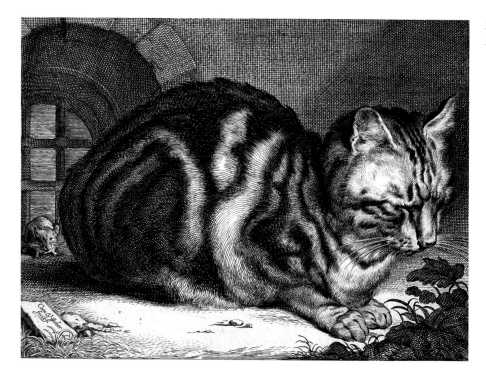

From The Netherlands, AD 1657
Ht 13.9 cm

Sir John Tenniel (1821–1914), *Alice and the Cheshire Cat*

THIS PROOF-WOOD ENGRAVING by the Dalziel Brothers is an illustration to page 91 of the famous children's book *Alice's Adventures in Wonderland* (1865). It shows the meeting between Alice and the Cheshire Cat. The author, Charles Dodgson, who used the pen-name Lewis Carroll, originally provided his own illustrations to the books, but while the type was being set, he was persuaded to employ a more competent draughtsman.

John Tenniel was chosen for the task. Tenniel was already one of Britain's most famous illustrators, having been a satirical cartoonist for *Punch* magazine since 1850. He had also received high praise for his illustrations to Thomas Moore's *Lalla Rookh* (1861). Dodgson provided such specific instructions for Tenniel that their working relationship became strained. The resulting illustrations, however, proved to be an enormous success.

From England, AD 1865
Ht 13.6 cm

Scenes from the legend of Gazi

THIS TYPE OF long scroll-painting was used by itinerant storytellers in rural Bengal as a visual aid to a spoken narration. Storytelling using painted scrolls or panels has a long history in India and is known from at least the second century BC.

This particular scroll was probably made in about AD 1800. Stylistically, the painting belongs to the period before the influence of European artistic conventions.

The 57 pictures of this remarkable scroll-painting may depict the many epic activities of Gazi, a Bengali Islamic *pir* (saint). Gazi had the amazing ability to control the elements of the natural world and his adventures include fighting with demons, overpowering dangerous animals and miraculously causing cattle to give milk. Gazi was also renowned for his power over tigers, so this panel probably depicts Gazi himself.

From Bengal, perhaps the Murshidabad district, India, c. AD 1800
Purchased through the Art Fund

Maruyama Ōkyo (1733–95), tiger screen

THIS SIX-PANEL Japanese folding screen is painted in ink, colour and gold leaf on paper. It depicts tigers crossing a river, a subject inspired by an ancient Chinese legend that if a mother tiger gives birth to three cubs, one will always be a leopard (*hyo*). This scene shows the mother tiger taking her cubs across a river, being careful not to leave the ferocious *hyo* alone with the other cubs.

Maruyama Ōkyo was the most influential Japanese painter of his generation. He was particularly interested in portraying the natural world in a realistic way, and made studies from life wherever possible. Tigers are not native to Japan and at the time this screen was painted there were few, if any, tigers in captivity. Ōkyo, in common with other Japanese artists of the period, is therefore thought to have used house-cats and tiger-skins as the models for his tigers.

From the studio of Maruyama Ōkyo, Kyoto, Japan, c. 1781–2
Ht 153.5 cm
Acquired with the aid of the Art Fund

Stone relief of a lion hunt

SCULPTED STONE RELIEFS illustrating the sporting exploits of the last great Assyrian king, Ashurbanipal (reigned 668–631 BC) were created for his palace at Nineveh (in modern-day northern Iraq). The panels, which probably originally decorated one of his private apartments, depict a lion hunt: the release of the lions, the ensuing chase and the subsequent kill. In ancient Assyria, lion-hunting was considered the sport of kings, symbolic of the monarch's duty to protect and fight for his people. Inscriptions from the reign of Ashurnasirpal II (883–859 BC) claim that he killed a total of 450 lions.

The hunt scenes, full of tension and realism, rank among the finest achievements of Assyrian art. In this scene the king is shown turning round in his chariot to spear a lion that has attacked from the rear. The king is depicted wearing richly embroidered clothes, armlets and bracelets, and the characteristic tall Assyrian crown.

Made in Nineveh, northern Iraq, c. 645 BC

Colossal marble lion from a tomb monument

THIS COLOSSAL LION, carved from a single block of marble, weighs some six tons and is now on display in the Great Court of the Museum. It was originally on the top of a funerary monument at Knidos, set on a headland with a sheer cliff-face that falls around 200 feet into the sea. The monument itself was square with a circular interior chamber and a stepped-pyramid roof. It is a type of funerary monument inspired by the greater tomb of Maussollos, built about 350 BC at Halikarnassos, one of the Seven Wonders of the Ancient World and less than a day's sail from Knidos.

Opinions vary as to when the sculpture was made. One suggestion is that the monument commemorated a naval battle fought between Athens and Sparta off the coast of Knidos in 394 BC. Another dates the Doric architecture of the tomb, and therefore the lion, to about 175 BC.

From Knidos, southwest Asia Minor (modern Turkey), c. 350–200 BC
L. 300 cm
Ht 200 cm

Silver tetradrachm of Athens

In 482 BC an enormous vein of silver was discovered at the Athenian silver mines in Laurium. After much debate, the silver was used to increase the Athenian navy. This improved Athenian fleet defeated the Achaemenid Persians at the Battle of Salamis in 480 BC, a victory that turned the course of the Persian War. The Greeks went on to win the war and secure mainland Greece from Persian invasion.

This tetradrachm (4-drachma piece) may have been minted during the period of the construction of the Athenian fleet, when a large number of coins was issued. The designs on both sides of the coin refer to the patron goddess of Athens, Athena. On the obverse (front) of the coin is the head of Athena, and on the reverse is her sacred bird, the owl. These designs remained unchanged on Athenian coinage for over 300 years, and the 'owls' of Athens became familiar coins throughout the Greek world.

From Athens, Greece, 527–430 BC
Wt 16.71 g
Bequeathed by John Mavrogordato

Head of the horse of Selene

THIS MARBLE HEAD of the horse of Selene, goddess of the Moon, is from the east pediment of the Parthenon temple in Athens. It is perhaps the most famous and best loved of all the Parthenon sculptures.

The horse was originally positioned at the far right of the pediment, jaw hanging over the edge, as Selene's chariot sank beneath the horizon. The sculptor has captured the very essence of a beast at the utmost limits of its physical endurance. A night spent drawing the chariot of the Moon through the sky has left it exhausted and gasping for breath. The skin seems to be stretched over its bones, taut against the great flat plate of the cheekbones. The nostrils are distended, the round, pupil-less eyes bulge with effort, the veins and sinews stand out, and what remains of the ears lie almost flat against the head.

From the east pediment of the Parthenon, Acropolis, Athens, c. 438–432 BC
L. 83.3 cm

Horse engraving on bone

THIS ENGRAVING OF a horse is one of the oldest works of art from Britain. It was made on a piece of rib bone and shows a horse facing right. The line of its mane is shown along the top edge of the rib as a series of diagonal hatched lines. Single vertical lines have been drawn over the horse which might represent spears or fence posts, perhaps used in driving animals to a kill site. Similar more curved diagonal lines cover the opposite side.

There is no reason to doubt that this fine drawing was a genuine find from Robin Hood Cave in Derbyshire. It is very similar to drawings known from French Late Magdalenian sites where such works of art are much more common. It is even possible it was brought to Britain by hunters tracking animals to summer feeding grounds and leaving at the end of the season.

From Robin Hood Cave, Derbyshire, England, about 12,500 years old
L. 7.3 cm
Presented by the Creswell Caves Exploration Committee

Painted clay and wood figure of a horse

THIS FIGURE FORMED part of the furnishings from a tomb at the cemetery site of Astana on the Silk Road in Central Asia, together with other figurines of horses and a camel. Although made from clay and wood, it was based on *sancai*-glazed ceramic examples placed in contemporary tombs in metropolitan China.

The body is painted to indicate that this is a bay-coated horse, and also has petal-shaped pieces of silk attached to it. The wooden legs could be fixed to the floor of a niche in the tomb. The saddle-blanket is shown as magnificently embroidered and remnants of silk indicate where stirrups would have hung.

Documents recovered from these tombs indicate just how important horses were to daily life in the region. The whole network of communications relied largely on horses. Detailed registers were kept of the journeys horses made, penalties prescribed for injuries from neglect or overloading, and enquiries carried out when an animal had died en route.

From Astana, China, Tang dynasty, mid-8th century AD
Ht 60.5 cm
Collected by Sir Marc Aurel Stein
Gift of the Government of India

Henri de Toulouse-Lautrec (1864–1901), *The Jockey*

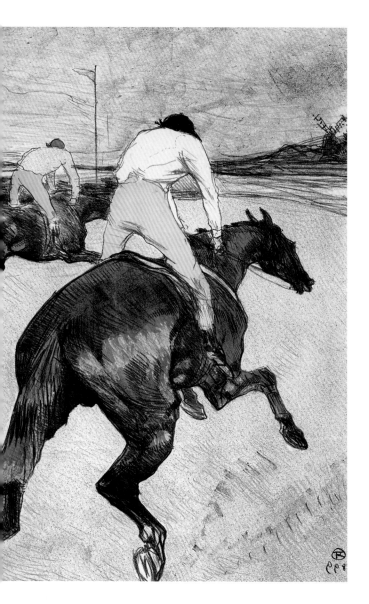

THIS LITHOGRAPH WAS originally intended to be part of a set for a portfolio on a racing theme. Toulouse-Lautrec was suffering acute alcoholic collapse at the time, and this was the only print of the set that was completed. Three further works from the proposed series survive, but only one of these approaches a finished state. *The Jockey* was issued in two editions, first as a monochrome lithograph, and secondly in a colour version.

Although the print is titled *The Jockey*, its focus is the power and pace of the racehorses, with their riders only depicted from behind, with a total lack of expressive detail. Toulouse-Lautrec's facility as a draughtsman is clear, as is his ability to distort and exaggerate in order to create atmosphere and character, shown here by the excessive foreshortening of the horses' necks.

From France, AD 1899
Ht 53 cm
Campbell Dodgson Bequest

Marble statue of a youth on horseback

THIS STATUE PORTRAYS a young Roman dressed as a hero – naked except for his military cloak (*paludamentum*). The youth's arms and three of the horse's legs are sixteenth-century restorations.

Equestrian statues such as this were not common in antiquity, so the subject was clearly a person of some importance. The boy's facial features and hairstyle resemble those of members of the Julio-Claudian dynasty of Roman emperors. When the sculpture first entered the Museum it was identified as a portrait of the emperor Caligula (reigned AD 37–41) in his youth. Later it was thought that the head was earlier than the body. During recent cleaning, however, it was observed that the marble of the head of the youth and the unrestored parts of the horse were the same. This has raised once more the possibility that horse and rider belong together and do indeed represent a Julio-Claudian prince.

Roman, made in Italy, AD 1–50
Ht 205 cm (approx.)

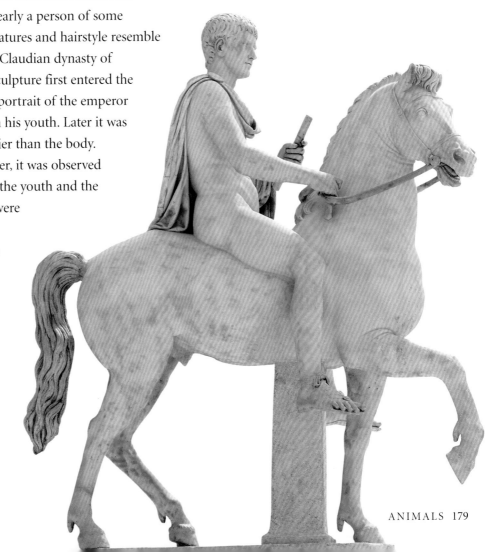

Maria Sibylla Merian (1647–1717), *A Surinam caiman fighting a South American false coral snake*

MARIA SIBYLLA MERIAN spent much of her life in Frankfurt, Nuremberg and Amsterdam specializing in painting plants, animals and insects on vellum. In 1699 she travelled to Surinam, a Dutch colony in South America, where she made extensive notes and sketches, and collected dried plants and animals preserved in alcohol. She returned to Amsterdam in 1701, where in 1705 she published her work on Surinamese insects, the first scientific work produced about the colony.

Merian was an unconventional figure for her time, and few women could have achieved in art and science what she did. For her period, her work is scientifically accurate and she is considered to be one of the founders of entomology, the study of insects.

This watercolour comes from a set of albums by Merian owned by Sir Hans Sloane, whose collections formed the basis for the British Museum.

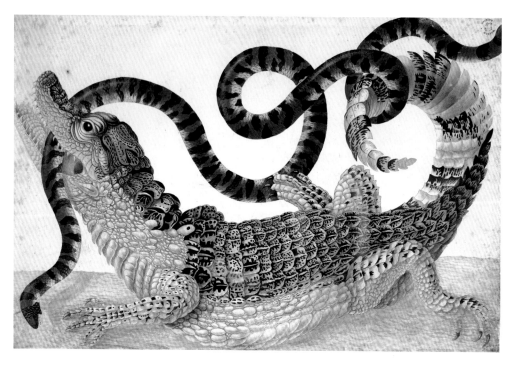

Surinam or Amsterdam,
c.AD 1699–1705
Ht 30.6 cm

Pipe in the form of an otter

EXCAVATIONS IN Ohio have uncovered superbly carved pipes and other exotic trade goods and fine artworks dating from the Hopewell culture (200 BC–AD 100). These pipes are carved in the shapes of different birds and animals, and may have been smoked for purification during rituals, and to strengthen political allegiances.

The pipes were made by native American communities who also constructed large earthworks. When these mounds were studied by European antiquarians, the scale and magnificence of the earthworks were such that it was hard for them to accept that the moundbuilders were local native Americans, but this is now known to be the case.

From Mound City, Ohio, North America
Middle Woodland period, Ohio Hopewell culture, 200 BC–AD 100
L. 11 cm

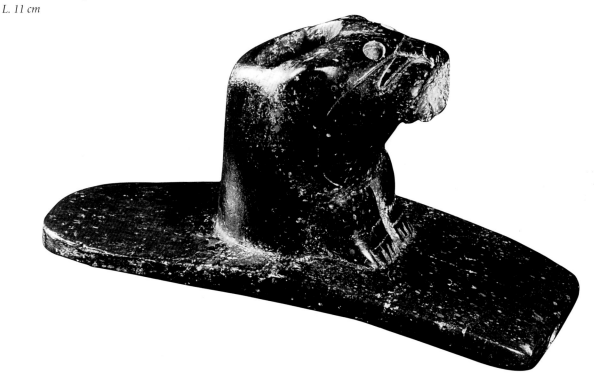

Burghead bull

THIS CARVED SLAB is one of six similar stones, each with a figure of a bull, found together on the site of a major Pictish fortress at Burghead on the north Scottish coast.

The bull is an example of the early Pictish incised style, with lines 'pecked' into the surface. It is shown in a strong and natural pose, with scrolls emphasizing its muscles and joints. Such a degree of naturalism is without equal in early medieval art.

Carved stones like this are the main form of surviving evidence for the Pictish peoples and their culture. The uses and meanings of the carvings are not fully understood.

Most are on free-standing stones and may have been memorial 'headstones', carved with animal portraits and abstract symbols to identify the dead. These boulders however, each carved with a bull, may have been part of a warrior cult of strength and aggression.

From Burghead, Morayshire, Scotland, 7th century AD
Ht 53 cm
Gift of James de Carle Sowerby

Bronze group of a bull and acrobat

THIS SOLID CAST Minoan bronze depicts an acrobat somersaulting over a bull's head to land with both feet on its back. The arms and legs end in stumps; it is not clear whether this was by design or because the bronze did not flow into the extremities of the mould. Minoan bronzes tend to be low in tin, which meant the alloy did not flow well, and also gives a characteristic bubbly surface.

Bull jumping is frequently shown in Minoan art, and probably formed a part of ritual activity. It seems highly unlikely that such leaps could be made, due to the unpredictability of a bull's movements. Perhaps in reality the bulls were restrained or even tamed. It is probable that the Minoans put considerable effort and long experience into the sport, and were able to achieve dramatic effects. Even so, the possibility of some artistic licence should not be discounted.

From Crete, c. 1700–1450 BC
Ht 11.4 cm
Spencer Churchill Collection

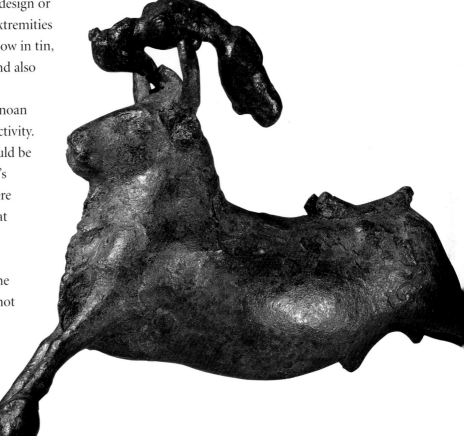

Steel peacock

PEACOCKS WERE symbols of beauty and courtly pleasures throughout the Islamic world. The birds were often allowed to wander around the gardens of noblemen, and models of peacocks ornamented the famous Peacock Throne, taken from India to Iran in 1739.

This fine steel peacock with turquoises for eyes may have decorated the crossbar of an *alam*, a standard carried during religious festivals in Iran. One of the most important of these is Ashura, held in honour of Husayn, the third Shi'i Imam, who was martyred in AD 680. Husayn, his brother Hasan and their father Ali (the fourth caliph and first Shi'i Imam) are depicted in the central medallion on the peacock's tail. The bird is also engraved with stylized inscriptions, princely hunting scenes, human busts and animals in a style typical of the Qajar period (1771–1924) in Iran.

Iran, 19th century AD
Ht 89 cm
Gift of Mr Imre Schwaiger of Calcutta and Simla, through the Art Fund,
in memory of the Imperial Durbar

Dunstable swan jewel

THE DUNSTABLE SWAN jewel is a livery badge, worn as a declaration of allegiance to a noble family or a king. It is made from opaque white enamel fused over gold, and the chain and coronet attached to the swan's neck are also gold.

The emblem of the swan was very popular among medieval nobles eager to demonstrate their descent from the Swan Knight of courtly romance. The most notable English family to use this symbol was that of de Bohun. The swan was adopted by the house of Lancaster when Henry of Lancaster married Mary de Bohun in 1380. When Henry became King Henry IV in 1399, the swan badge became associated with the Prince of Wales. Although descriptions of similarly fine pieces of livery jewellery exist in documents, the Dunstable swan jewel is the only known surviving example of such a badge.

Made in France or England, c. AD 1400
Ht 3.3 cm
Purchased with contribution from the Art Fund, the Pilgrim Trust and the Worshipful Company of Goldsmiths

Hiroshige Utagawa (1797–1858), *Suidō Bridge and Surugadai*

THIS COLOUR WOODBLOCK print is from the series 'One Hundred Famous Views of Edo'. It shows kites in the shape of carp being flown over the samurai district of Surugadai for the Boy's Festival in mid-summer. The leaping carp is a symbol of manly perseverance, and is shown here in exaggerated scale, seeming artificially stuck into the landscape.

'One Hundred Famous Views of Edo' (1856–58) was the final, crowning achievement of Hiroshige's career. Twenty-one of the views included Mount Fuji seen on the distant horizon and three featured the artificial hills constructed as 'mini-Fujis' by members of the Fuji-kō (the Fuji cult). This was a brotherhood that encouraged pilgrimage, rituals and prayers devoted to Fuji, and which by 1825 claimed as many as 70,000 devotees. The mini-Fujis were set in parks and allowed the infirm (or lazy) to engage in a substitute pilgrimage or simply to enjoy them as a kind of theme park.

From Japan, AD 1857
Ht 36 cm
Gift of Henry Bergen

Pieter van der Heyden (1538–72), *Big Fish Eat Little Fish*

ENGRAVER PIETER VAN DER Heyden produced more than 150 prints for the publisher Hieronymus Cock, reproducing the designs of Bosch, Bruegel and other artists. In the foreground of this engraving, a child is instructed by its father: 'See the big fish eat the little fish'. He points to the whale-sized fish stranded on the shore, disgorging smaller fish which in turn have swallowed even smaller ones. The text below the frame states, 'the rich oppress you with their power'.

The inscription 'Hieronijmus Bos inventor', on the lower left, may be misleading. Hieronymus Bosch (about 1450–1516) was

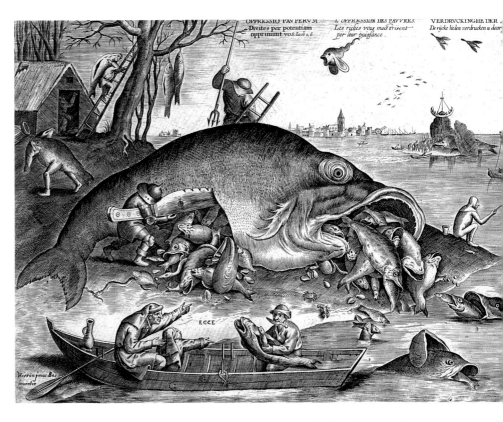

famous for his composite creatures, like the fish with legs depicted here above his name, or the fish flying in the sky. However, this composition is certainly by Bruegel the Elder (1515–69), since the preparatory drawing survives with his signature and the date 1556, although it may depend on a lost prototype by Bosch.

From Flanders, dated AD *1557*
Ht 23 cm

Gilded wooden figure of a goat

THIS FIGURE, also known as 'The Ram in the Thicket', may originally have been part of a small stand. It is an example of the beautifully crafted objects, often worked in precious metals and imported materials, which were owned by the Sumerian-speaking elite of southern Mesopotamia. These objects reflect the well-established trade links, wealth and sophistication of this culture.

When excavated, the figure had been crushed flat and its wooden supporting core had perished. Wax was used to keep the pieces together as it was lifted from the ground, and it was then pressed back into shape. The tree, ram's head and legs are covered in gold leaf, its ears are copper (now green), its twisted horns and the fleece on its shoulders are of lapis lazuli, and its body fleece is made of shell. The base is decorated with a mosaic of shell, red limestone and lapis lazuli.

Excavated at the 'Royal Cemetery', Ur, southern Iraq, c. 2600–2400 BC
Ht 45.7 cm

Mammoth-shaped spear thrower

SPEAR THROWERS CAME into use about 18,000 years ago in Western Europe. The bottom of the spear fits against the hook at the end. Using the thrower to launch the spear sends it with more force, speed and distance than if it was simply thrown by hand.

The hook ends of spear throwers are frequently decorated with an animal. This example is carved from a reindeer antler in the shape of a mammoth. The mammoth's tusks appear on each side of the handle, most of which was broken off in ancient times. It is the only known example which has a hole for an eye (which was probably originally inset with bone or stone). The hook is also unusual because it is an ancient repair. The original hook carved from the antler broke off and was mended by cutting a slot on the back and inserting a bone or antler replacement.

From the rock shelter of Montastruc, Tarn-et-Garonne, France, Late Magdalenian, about 12,500 years old
L. 12.4 cm
Christy Collection

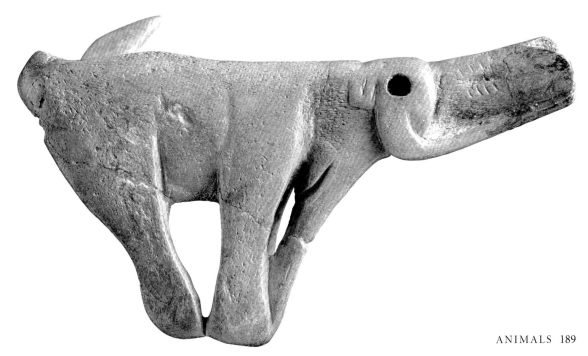

8 The Word

Perhaps the one object that most Museum visitors want to see is not a great work of art or even an Egyptian mummy: it is a fragment of black rock covered with writing, known as the Rosetta Stone. The well-known role of this stone in the understanding of Egyptian hieroglyphs is what makes it such an unmissable exhibit. Other objects throughout the Museum have played similar roles in the rediscovery of lost classics of world literature, others demonstrate the formidable power of words while some remind us there are still ancient scripts that have not yet been deciphered.

Marble panel

A less well known but nonetheless important collection of objects in the Museum contains what is left of one of the greatest libraries of the past, amassed by the Assyrian king Ashurbanipal in what is today northern Iraq. This library was probably larger than the more famous library at Alexandria in Egypt. Excavations in the nineteenth century revealed over 30,000 clay tablets and fragments of tablets that had survived the destruction of the palace which housed the library. Covered with cuneiform writing, the tablets include documents such as administrative records as well as works of science, religion and literature. The first modern translation of one of the great classic poems of world literature, the epic of Gilgamesh, was the work of a nineteenth-century curator at the British Museum called George Smith. This poem included an account of an ancient flood very similar to the story of Noah and the flood in the Old Testament. This was the first time another version of a flood story had been found, and its discovery had a major impact on people's ideas about religion and history. It was so shocking to Smith himself that it was said he ' ... jumped up and rushed about the room in a great state of excitement, and, to the astonishment of those present, began to undress himself.'

Vindolanda tablet

Cuneiform is one of the oldest forms of writing. It was developed in the area of southern Iraq over 2000 years before Ashurbanipal created his library. Examples of the earliest texts can also be found in the Museum. Cuneiform appears to have originated in order to keep administrative records, such as allocations of beer or grain. Other languages and writing systems have different origins, and there are some, such as the script of the Indus Valley civilization, that still remain to be deciphered.

Many of the examples of writing found across the Museum are official texts, including public inscriptions and proclamations on stone (such as the Rosetta Stone), the phrases found on coins and money, or even signatures, such as the *tughra* of an Ottoman sultan. However, there are also more personal communications, such as the delicate letters written on thin slivers of wood from the Roman fort of Vindolanda on Hadrian's Wall. Unfortunately, much of the world's writing has been on perishable materials such as paper, papyrus, silk, bamboo, clay and wood, so little has survived. At Vindolanda, however, due to a rare combination of factors, a mass of letters have been preserved, among them school exercises and even an invitation to a birthday party that took place almost 2000 years ago.

Cuneiform tablet recording food supplies

As the world's first cities developed in southern Mesopotamia around 3400–3000 BC, officials developed a way of recording administrative and economic information. Representations of goods issued as rations or put into store were drawn on pieces of clay using a sharp stick or reed. Circular or crescent-shaped impressions represented numbers. These pictographs became increasingly abstract and the end of the reed was simply pressed into the clay leaving wedge-like lines, or cuneiform (the Latin for wedge is *cuneus*).

This tablet records the allocation of rations. One pictogram represents a human head with a triangular object that looks like a bowl being brought up to the mouth. The triangle shape is the regular symbol for bread, and this combination of pictographs expressed the idea of eating. It was later used to write the Sumerian verb *ku*, 'to eat'.

Probably from southern Iraq
c. 3000 BC
Ht 0.45 cm

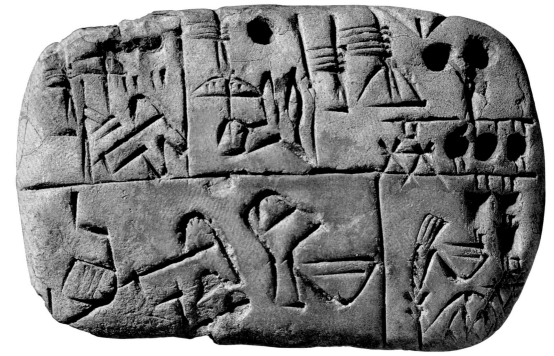

Tughra of Suleyman the Magnificent

THIS CALLIGRAPHIC DEVICE is known as a *tughra* and was the official monogram or signature of the Ottoman sultans. It was developed during the fourteenth century on documents, from which its use spread to seals and coins. The *tughra* was designed at the beginning of a new sultan's reign by the court calligrapher. It is thought to represent the fabulous bird, the *tughri*, the totem of the Oghuz tribe from whom the Ottomans were descended.

During the sixteenth and early seventeenth centuries the Ottomans dominated southeast Europe and the Aegean. The sultans' close identification with their Islamic faith led, after 1517, to their being also entitled the Caliph of Islam. The empire reached its peak under Suleyman I, the Magnificent (reigned 1520–66). He ruled an area extending as far as Persia in the east and Austria in the west. His system of laws regulating land tenure earned him the title of Lawgiver and he was also a great patron of the arts.

From Turkey, AD 1520–66
Ht 34.2 cm
L. 61 cm

Rosetta Stone

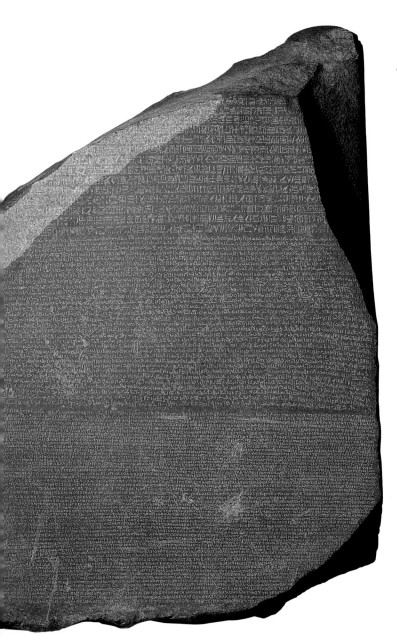

THIS STONE IS inscribed with a decree issued on the anniversary of the coronation of the Egyptian pharaoh Ptolemy V (205–180 BC). The decree is inscribed in hieroglyphic (suitable for a priestly decree), demotic (everyday script), and Greek (the language of the administration).

Napoleon's army discovered the stone in 1799 while digging fortifications near the town of el-Rashid (Rosetta). On Napoleon's defeat, the stone became the property of the British. The importance of this tri-lingual inscription to Egyptology is immense. The knowledge of how to read and write hieroglyphs disappeared soon after the end of the fourth century AD. Some 1400 years later, scholars were able to use the Greek inscription on this stone as the key to decipher them. Thomas Young demonstrated that some of the hieroglyphs represented the name 'Ptolemy'. Jean-François Champollion then realized that hieroglyphs recorded the sound of the Egyptian language, a breakthrough in their decipherment.

Excavated from Fort St Julien, el-Rashid (Rosetta), Egypt, 196 BC
Ht 114 cm (max.)
Gift of H.M. George III

Pillar edict of Emperor Asoka

THIS PILLAR FRAGMENT bears an inscription of Asoka, the last emperor of the Mauryan dynasty (reigned about 265–238 BC). The inscription is in Brahmi, the ancestor of all modern Indian scripts. The technique of writing must have developed in India much earlier, but nothing readable survives, making these edicts important historical records.

The text on this example is not specifically Buddhist, but refers to the emperor's personal and benevolent policy towards all sects and classes, which he calls *dhamma*, a word also used by Buddhists for their religion.

The pillars themselves were highly symbolic and venerated. The best-known Mauryan pillar is at Sarnath, where the Buddha gave his first sermon. Its crowning sculpture of a four-headed lion has been adopted as the symbol of the Republic of India, while the symbol of the *chakra* (wheel) that once surmounted it has been used as the central motif of the Indian flag.

Probably from the Meerut Pillar, Uttar Pradesh, India, c. 238 BC
Ht 33.6 cm

Wooden writing-tablet

THIS WOODEN TABLET is one of number excavated at the site of the Roman fort of Vindolanda in Northumberland. It contains one of the earliest known examples of writing in Latin by a woman. It is an invitation to a birthday party from Claudia Severa to Sulpicia Lepidina, both 'army wives' living on the northern frontier of Roman Britain.

Most of the tablet is written by a scribe: 'Claudia Severa to her Lepidina greetings. On 11 September, sister, for the day of the celebration of my birthday, I give you a warm invitation to make sure that you come to us, to make the day more enjoyable for me by your arrival, if you are present (?). Give my greetings to your Cerialis. My Aelius and my little son send him (?) their greetings.' At the bottom are lines written by Severa herself: 'I shall expect you sister. Farewell, sister my dearest soul, as I hope to prosper, and hail.'

From Vindolanda Roman fort (modern Chesterholm), Northumberland
Roman Britain, c. AD 97–103
L. 22.3 cm

Codex Zouche-Nuttall

THIS IS PART OF one of a small number of Mexican codices (screenfold manuscript books) known to have survived the Spanish Conquest of 1521. Hundreds or even thousands of such books were made, but most were destroyed by Spanish missionaries who considered them to be manifestations of evil.

Mexican manuscripts do not contain written information in word form, but pictures and ideographs (symbols that represent ideas) are used to aid the reader in reciting the contents aloud. This example was produced by scribes of the Mixtec peoples from the region of Oaxaca. It contains two narratives: one side of the document relates the history of important centres in the Mixtec region, while the other, starting at the opposite end, records the genealogy, marriages and political and military feats of the Mixtec ruler, Eight Deer Jaguar-Claw. This ruler is depicted at top centre, next to his calendric name (eight circles and a deer's head).

From Mexico, Mixtec, Late Postclassic period (AD 1200–1521) L. 113.5 cm Ht 19 cm Given by Baroness Zouche of Haryngworth

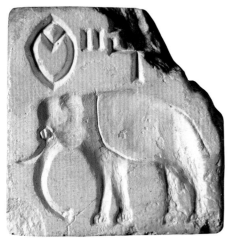

Steatite seals from the Indus Valley

SEALS ARE CHARACTERISTIC of a phase of the Indus civilization when the first towns were developing in the region (around 2500–1900 BC). They come in a variety of forms, the most typical being a square stamp-seal with a perforated knob on the back and a carved design on the front. The most common design is the unicorn, but there are also script-only designs, geometric designs, a few narrative scenes and a wide variety of other animals.

It is not clear how the seals were used, although they were probably associated with trade, as they and their impressions have been found abroad. The inscriptions on the seals are the oldest writing in South Asia. Because there are no bilingual texts and no records longer than 21 characters, Indus writing remains undeciphered and the language uncertain. The seals are useful, however, in reconstructing the economy, art and religion of the region at that time.

From Harappa and Mohenjo-Daro, modern Pakistan, c. 2600–1900 BC
Diam. c. 3 cm
Gift of the Director-General of Archaeology, India

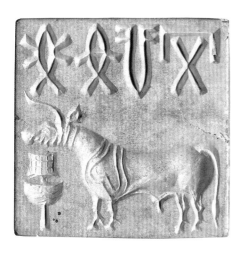

Fenton vase

COLOURED CERAMIC VESSELS such as this 'vase' were a symbol of status and power for the Maya of Mesoamerica. They were used by the elite and are found as offerings in rich burials. The vessels are often decorated with text and images illustrating historical and mythological events, making them an important source of information about Maya society in the Classic period (200 BC–AD 900). The scenes depict scribes, merchants, rulers and other members of society.

This beautiful example was found at a Maya site in the highlands of Guatemala. The painted scene represents the delivery of tribute to a seated lord. Above the basket being presented to him are a series of six hieroglyphs which indicate his name and titles, while the other glyph panels correspond to those of the other figures in the scene. Their jewellery, clothing and spangled turbans adorned with flowers suggest that they are members of the elite.

Maya, from Nebaj, Guatemala, Late Classic period
(AD 600–800)
D. 17.2 cm
Fenton Collection
Purchased with the assistance of the Art Fund

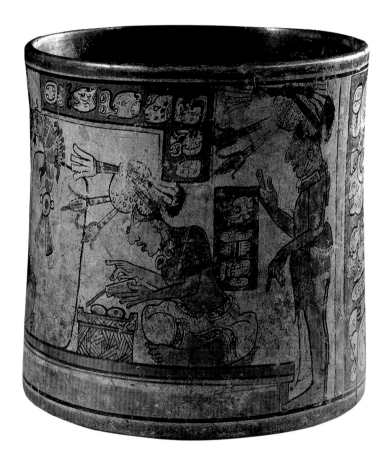

Cyrus cylinder

THIS CLAY CYLINDER is inscribed in Babylonian cuneiform with an account by Cyrus, king of Persia (559–530 BC) of his conquest of Babylon in 539 BC and capture of Nabonidus, the last Babylonian king.

Cyrus also describes measures of relief he brought to the inhabitants of the city, and tells how he returned a number of images of gods, that Nabonidus had collected in Babylon, to their proper temples throughout Mesopotamia and western Iran. At the same time he arranged for the restoration of these temples, and organized the return to their homelands of a number of people who had been held in Babylonia by the Babylonian kings.

This cylinder has sometimes been described as the 'first charter of human rights', but it in fact reflects a long tradition in Mesopotamia where, from as early as the third millennium BC, kings began their reigns with declarations of reforms.

From Babylon, southern Iraq, c. 539–530 BC
L. 22.5 cm

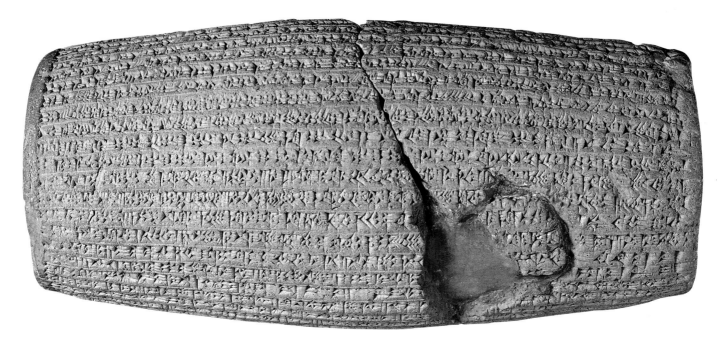

List of the kings of Egypt from the Temple of Ramesses

THE CHRONOLOGY OF the rulers of Egypt is based on many sources: a list compiled by the historian Manetho in the third century BC, dated inscriptions and documents on papyrus, references to identifiable astronomical events, and lists of kings inscribed on papyrus and stone.

This limestone list of Egyptian rulers was excavated from a memorial temple of Ramesses II (reigned 1279–1213 BC). The list tells us as much about Egyptian ideas of history as it does about the chronology of their kings. Names of Ramesses II's ancestors are in cartouches starting at the top right. The cartouches of his own name are repeated many times at the bottom. Originally, there were 76 royal names, though some monarchs whose reigns were controversial have been left out, such as the Hyksos kings from the Levant (ruled 1650–1550 BC), Queen Hatshepsut (reigned 1491–1479 BC) and the pharaoh Akhenaten (about 1390–1352 BC).

From Abydos, Egypt, 19th Dynasty, c. 1250 BC
Ht 13.5 cm
Excavated by W.J. Bankes

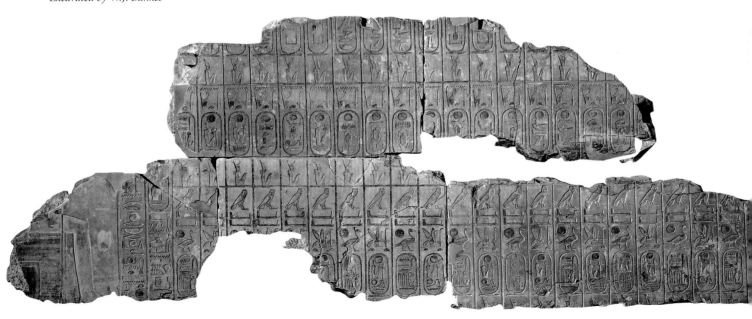

Flood tablet

THIS IS THE most famous cuneiform tablet from Mesopotamia. It is the eleventh tablet of the *Epic of Gilgamesh*, the adventures of a legendary ruler of Uruk. The tablet tells how Gilgamesh met Utnapishtim who, like Noah in the Bible, had been forewarned of a great flood. He built a boat, loaded it with everything he could find and survived the flood while mankind was destroyed. He landed on a mountain called Nimush and released a dove and a swallow but they returned, having failed to find dry land. He later released a raven that did not return, showing that the waters must have receded.

This version of the Biblical flood story was identified in 1872 by George Smith, an assistant in the Museum. On reading the text he '... jumped up and rushed about the room in a great state of excitement, and, to the astonishment of those present, began to undress himself.'

From Nineveh, northern Iraq, 7th century BC
L. 15.2 cm
W. 13.3 cm

Rhind mathematical papyrus

THIS EGYPTIAN PAPYRUS is not a theoretical treatise, but a list of practical mathematical problems encountered in administrative and building works. The text contains 84 problems concerned with numerical operations, practical problem-solving, and geometrical shapes. These include methods of determining the slope of a pyramid, and the multiplication and division of fractions. The majority of literate Egyptians were scribes and they were expected to undertake various tasks that must have demanded some mathematical as well as writing skills.

The papyrus is also important as a historical document, since the copyist noted that he was writing in year 33 of the reign of Apophis, the penultimate king of the Hyksos Fifteenth Dynasty (about 1650–1550 BC) and was copied after an original of the Twelfth Dynasty (about 1985–1795 BC).

The papyrus is named after a Scottish lawyer, A.H. Rhind, who acquired it during a stay in Thebes in the 1850s.

From Thebes, Egypt,
c. 1550 BC
Ht 32 cm

Gold *dinar* of Caliph Abd al-Malik

MANY ISSUES OF early Islamic coinage bore pictures, sometimes even of the caliph himself. Islam bans pictorial representations of humans or animals to discourage idolatry and Muslim clerics grew uneasy about the use of images on coins. In AD 696–7 the Umayyad caliph Abd al-Malik (reigned AD 685–706) reformed the Islamic coinage. All images on coins were replaced with inscriptions. Along with the new design came a new weight standard. The original Byzantine standard of 4.55 g was adjusted to 4.25 g, a weight also known as the *mithqal*.

This *dinar* was minted as part of the first issue of the new design. From this time inscriptions predominate on Islamic coins. The inscriptions, in the angular Kufic script, do not include the name of the caliph or the mint. Instead they state the essence of the Muslim message in Arabic, the Islamic profession of faith, the *shahada*.

Probably minted in Syria, 77 AH/AD 696–7
D. 1.9 cm
Wt 4.25 g
Gift of E.T. Rogers

Great Ming Circulating Treasure Note

AFTER THE MING dynasty seized control of China from the Mongols in 1368, they tried to reinstate bronze coins. There was not sufficient metal for this, however, so paper money, made of mulberry bark, was produced from 1375. Paper money continued to be issued throughout the Ming period, but inflation quickly eroded its value. The effect of inflation was so devastating that paper money was regarded with suspicion for many years. It was not until the 1850s that a Chinese emperor dared to issue paper money again.

The writing along the top of this note translates as: 'Great Ming Circulating Treasure Note'. Below this, the denomination is written in two characters: 'one string'. Beneath the denomination is a picture of a string of 1000 coins, arranged in ten groups of 100 coins. Beneath this are the instructions for use and a threat to punish forgers.

From China, Ming dynasty, first issued AD 1375
Ht 34.1 cm

9 Eating and Drinking

SHARING FOOD AND DRINK has been at the heart of many celebrations across the world, including formal events and religious rituals. It also plays a major role in many of our most common daily activities with our families and friends. What people eat is part of what they are and aspire to be, but it is not just the actual foods and drinks that are important – the wide range of objects and vessels we use to prepare and consume are also integral to being human. Thousands of items throughout the Museum are mute evidence for a global history of food and drink, and it is hardly surprising that many were intended to express the wealth and importance of their owners.

Most of the objects in this chapter were made for special occasions, whether feasts, major celebrations or religious rites and ceremonies. Sharing food and drink between worshipers or with the gods and ancestors is a common feature of many religions. The objects that more than any other visually sum up the Bronze Age in China are the cast bronze vessels of the Shang period, similar to the *gui* in this chapter. These vessels were made in specific shapes for ritual offerings of food and wine. Similarly, the silver vessels of the Water Newton hoard from England may be some of the earliest objects used in Christian worship to have survived from the Roman empire.

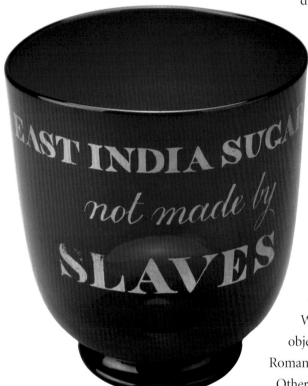

Blue glass sugar bowl

Other objects were made for secular meals and feasts, and examples from different cultures show the many ways that serving food to guests and relations, friends and enemies has been of great social and political importance. This significance is made clear through the often extraordinary objects that were created to enhance these meals, whether to serve the food and drink or to act as complex objects to hold the eye – a feature described

by one expert as 'a technology of enchantment'. Evidence of this can be found in objects as diverse as the great dish from Mildenhall, Blacas ewer, Basse Yutz flagons and medieval French royal cup, though their shapes vary because of the practical functions they performed.

Most of the objects in this chapter are elaborate pieces used by the powerful and wealthy. They are made of exotic materials such as gold or silver; many required long hours of skilled work to produce. Huge objects such as the great dish from Mildenhall have understandably become star objects in the Museum, but the collections also contain many thousands of more mundane examples of bowls and plates, cooking vessels and grinding stones fashioned over the last 10,000 years in all parts of the world. The shapes, colours and decoration of the thousands of pots on display in the Museum vary widely to suit their functions. These everyday items can easily be overlooked in the galleries compared to the extravagant pieces used for great occasions, but these ordinary utensils provide the historical and material evidence for our human history.

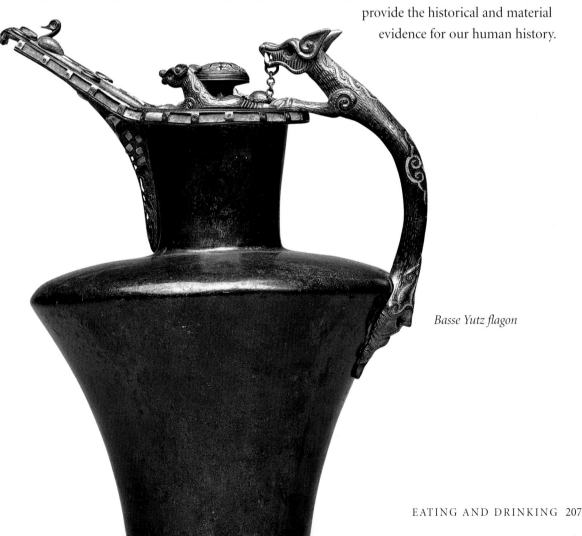

Basse Yutz flagon

Engraved glass ewer by the Cristalleries de Baccarat

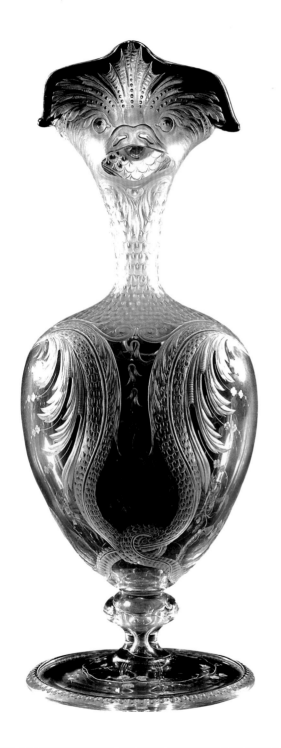

THIS VIRTUOSO EWER was produced by the leading French glassworks, Cristalleries de Baccarat, envied across Europe for the purity of its crystal glass. It was made as a showpiece for the Paris Exposition Universelle of 1878, an event which heralded France's recovery from the Franco-Prussian War (1871). Such exhibition showpieces were created by manufacturers from different countries to highlight their technical and artistic expertise.

The free-blown ewer combines technical virtuosity with a stunningly original design. The spout forms the mouth of a sea monster, while the neck and shoulders are wheel-engraved to suggest the monster's scaly body, ending in entwined tails wreathed with ivy. The idea of creating fantastic creatures in glass comes from early seventeenth-century rock crystal vessels engraved with fantastic ornamentation. Collections of these vessels had been part of the French Royal Collection and displayed in the Louvre for around a hundred years and provided models for Baccarat.

Made by the Cristalleries de Baccarat, Lorraine, France, AD 1878
Ht 31.9 cm

Basse-Yutz flagon

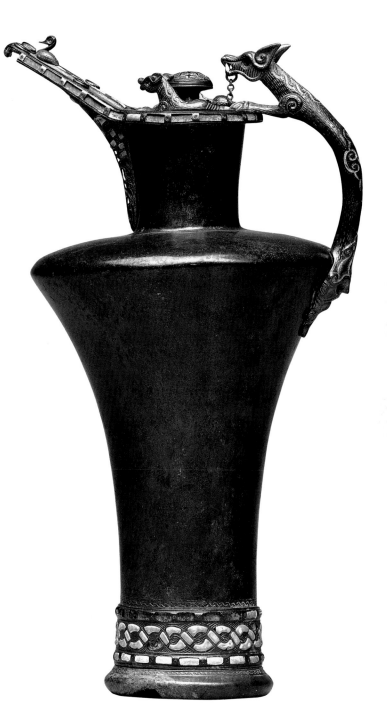

THIS BRONZE FLAGON is one of a pair that is considered one of the finest examples of early La Tène art. They were made in eastern France but copy the shape of Etruscan vessels from northern Italy. Originally used for pouring drinks at feasts, the flagons were probably buried as grave-goods in a rich burial, which also included two large bronze jars made in Etruscan Italy.

The design of the flagons shows a mixture of influences: the dog/wolf handles are an idea from Greek or Etruscan art, but made in a local style, the palmettes under the spouts are a popular Celtic motif originally from Egypt via Greece, the interlace is inlaid with coral from the Mediterranean, and the lid with red enamel probably from Asia Minor. The duck at the end of the spout, however, is a purely native element of the decoration. The flagons would have been used to serve beer, mead or wine at feasts.

From Basse-Yutz, Lorraine, France, c. 400 BC
Ht 39.6 cm

William Hogarth (1697–1764), *Gin Lane*

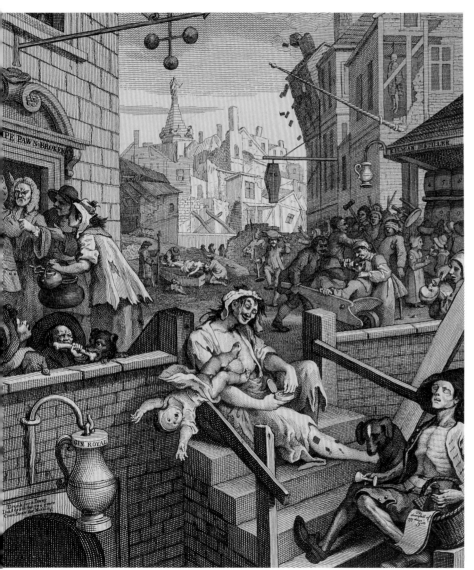

THIS PRINT WAS produced as part of the 1750 campaign against the consumption of gin. Gin was the plague of London in the first half of the eighteenth century. It was said to be responsible for a falling birth rate and rising infant mortality. The campaign led to the Gin Act of 1751 which introduced licensing of retail premises and finally reduced consumption.

Gin Lane is a pair to *Beer Street*, in which healthy working people are shown consuming flagons of beer, the English national brew, in contrast to the emaciated drinkers of liquor of foreign origin that has reduced the population to frenzied drunks. This scene is set in the poverty-stricken area to the north of Covent Garden. Everyone pictured drinks gin, from babies to young charity girls (identifiable by their uniform caps and aprons and the badges on their sleeves) to an old woman confined to a wheelbarrow.

From London, England, 1 February 1751
Ht 38.5 cm

Palmerston gold chocolate cups

CHOCOLATE WAS BROUGHT to Europe by the Spanish after their conquest of the Aztec empire in 1521. It was an enormously expensive luxury, and only the richest in society could afford to drink it. This is the only known pair of chocolate cups made from gold. Most unusually, they are made from melted-down mourning rings, memorial objects that were normally passed down through families and kept as treasured mementoes. Lady Palmerston, however, took several rings that she had inherited to John Chartier, a leading Huguenot goldsmith, who melted them down and made the cups.

Inscriptions on the insides of the handles and base of the cups read: *DULCIA NON MERUIT QUI NON GUSTAVIT AMARA* (he has not deserved sweet unless he has tasted bitter) and *MANIBUS SACRUM* (to the shades of the departed); on the other *Think on yr Friends & Death as the chief* and *MORTVIS LIBAMVR* (let us drink to the dead).

Made in London, AD 1700
Ht 6.4 cm
Acquired with the aid of the National Heritage Memorial Fund, Art Fund and private donations

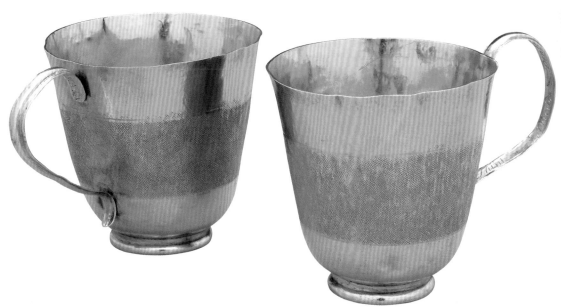

Royal gold cup

THIS SOLID GOLD cup is lavishly decorated
in translucent enamels with scenes relating
to the life and miracles of St Agnes. It
was given to King Charles VI of
France (reigned 1380–1422) by his
uncle Jean duc de Berry
(1340–1416). It is possible that
the Duc originally intended the
cup for his brother Charles V, who was
born on St Agnes' day, 21 January, but who
died before it was completed.

The cup came into the possession of John, Duke
of Bedford (1391–1447), regent in France for the
English king Henry VI (reigned 1422–61), and from
there it passed into the royal collection. Two extra
bands have been inserted in the stem of the cup, the
first of which is decorated with enamelled Tudor roses
dating to the period of Henry VIII (reigned 1509–47).
The second carries an inscription relating to the peace
agreed between England and Spain in 1604.

From Paris, France, c.AD 1370–80
Ht 23.6 cm (with cover)

Ringlemere gold cup

THIS CRUSHED OBJECT is a rare gold cup that was made over 3500 years ago. The gold cup was found at Ringlemere in East Kent in 2001 and has been damaged by modern farming equipment. Subsequent excavation at the findspot has revealed a Bronze Age cemetery nearby. It could be that this cup was last used during a funerary ritual.

Only five similar gold cups are known from mainland Europe, distributed between Brittany, northwest Germany and northern Switzerland. These early gold vessels, dating to about 1700–1500 BC, had rounded bases and all but one have a single handle riveted neatly to their 'S'-profiled bodies.

The Ringlemere cup is testimony to the skills of gold-workers in the later part of the Early Bronze Age. Beautifully crafted from sheet metal, the body is horizontally corrugated, a feature most closely paralleled on the Rillaton gold cup, found on Bodmin Moor, Cornwall, in the early nineteenth century.

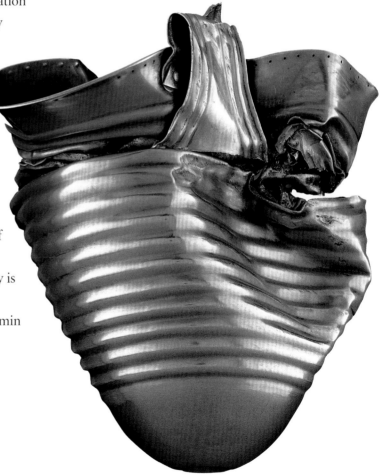

From Ringlemere, Kent, England, c. 1700–1500 BC
Ht 14 cm
Wt 184 g
Acquired under the Treasure Act
Purchased with assistance from the Heritage Lottery Fund, the Art Fund and the British Museum Friends

Bronze *gui*

THIS IMPOSING BRONZE vessel is a *gui*, a Chinese ritual vessel for food offerings used in the Shang and throughout the Zhou period. The inscription inside the *gui* tells that King Wu's brother, Kang Hou (Duke of Kang), and Mei Situ were given territory in Wei (in Henan province) in recognition of their contribution to the Zhou state. The inscription can be dated because it refers to a Shang rebellion and its successful defeat by the Zhou.

During the Shang period (about 1500–1050 BC), bronze vessels bearing cast inscriptions were occasionally made to commemorate particular events. These cast bronze inscriptions served to communicate the political and social achievements of the vessels' owners. In 1050 BC King Wu conquered the Shang dynasty and established the Zhou dynasty. Bronze inscribed vessels became much more common during this period. Today, they are vital historical documents.

From China, 11th century BC
Ht 21.6 cm

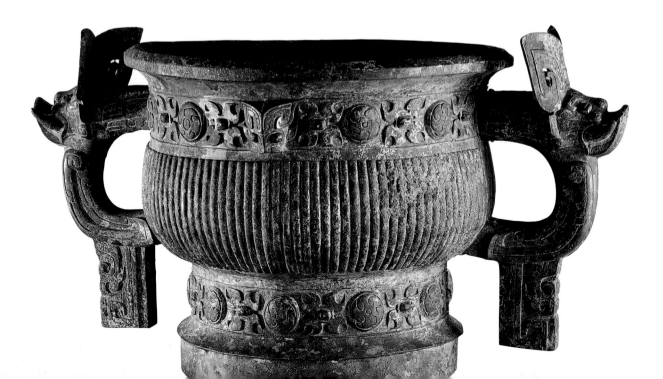

Water Newton treasure

THIS HOARD CONTAINED nine silver vessels, a number of silver votive plaques, and a gold disc. It is thought that they were originally used in Christian worship and are the earliest such vessels yet found from the Roman empire. The form of the handled cup resembles later Christian chalices and many of the objects bear the Chi Rho monogram, a symbol commonly used by early Christians. Two bowls and one plaque have Latin inscriptions, one of which can be translated as 'I, Publianus, honour your sacred shrine, trusting in you, O Lord.' Other inscriptions give the names of female members of the congregation: Amcilla, Innocentia and Viventia.

Individual pieces in the treasure were probably made at different times and in different places, and it is impossible to establish accurately the date at which they were hidden. The treasure may have been hidden in response to specific persecution of Christians or to more general political instability.

From Water Newton, Cambridgeshire, 4th century AD
Ht 12.5 cm (cup)
Treasure Trove

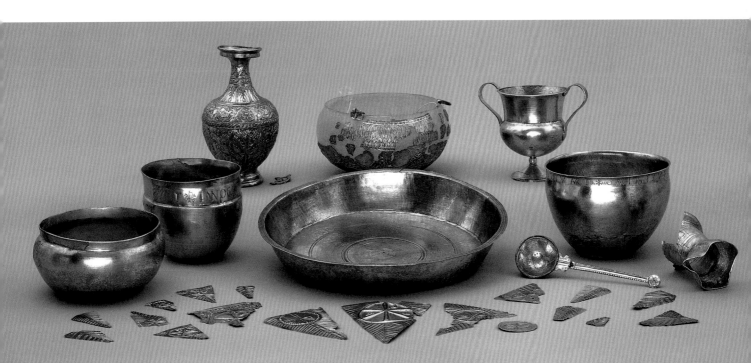

Armada service

THIS IS THE earliest known surviving set of English dining silver. It comprises 26 parcel gilt (partly gilt) dishes, each engraved on the rim with the arms of Sir Christopher Harris of Radford, Devon (about 1553–1625) and his wife, Mary Sydenham. The set is an important and unique survival; functional items of gold and silver of this date were more frequently melted down for their monetary value or made into newer, more fashionable pieces.

At the set is known as the 'Armada service' because of a tradition that it was made from New World silver captured from Spanish treasure ships. There is no proof for this theory, though Sir Christopher Harris did work for Sir Walter Raleigh in Devon and Cornwall as an Admiralty official during the Anglo-Spanish War (1585–1604). In 1592 Harris safeguarded booty from a Spanish ship for Raleigh, an incident that could have given rise to the 'Armada' tradition.

From London, England, AD 1581–1601
D. 12.1 cm (min.)
Purchased with the assistance of the National
Heritage Memorial Fund

White porcelain 'moon jar'

THIS LARGE PORCELAIN jar was made in Korea during the Choson dynasty (AD 1392–1910). The plain white porcelain of the period represents the epitome of austere Confucian taste.

The jar was bought by the British potter Bernard Leach (1887–1979) in Seoul. He was involved with the Japanese *mingei* (folk crafts) movement in the early part of the twentieth century. The group particularly admired the white porcelain of the Choson period for its lack of self-consciousness, and the beauty of its slight imperfections. This jar is an exquisite example of such vessels, showing imperfections in the clay and the glaze, as well as in the bulge around the centre that marks the join between the upper and lower halves of the body.

Leach later gave the jar to fellow potter Lucie Rie (1902–95). A famous photograph of her by Lord Snowdon shows her, dressed in white, seated beside the pot.

From Korea, Choson dynasty, 17th–18th century AD
Ht 47 cm
Purchased with the assistance of the Hahn Kwang-Ho Purchase Fund for Korean Art

Incised lacquer cup

SOPHISTICATED LACQUER vessels have been excavated in China dating from the Shang period (about 1500–1050 BC), and high quality lacquers were produced in large quantities in the Warring States period (475–221 BC). By the Han dynasty (206 BC–AD 220), the lacquer industry was organized under government control and using early processes of mass production.

This cup is the product of that industry. An engraved inscription states that it was made for the emperor in AD 4 at the Western Factory workshop in Shu (now Sichuan province). It goes on to name the craftsmen responsible for each step of the manufacturing process: making the wooden core, lacquering, top-coat lacquering, gilding the ear handles, painting, and final polishing. It also names the inspectors, supervisors and deputies at the workshop. Lacquer requires many coats, with setting time between each, so specialization and assembly line production was well suited to its manufacture.

Made in China, Eastern Han dynasty, dated AD 4, found in Korea
D. 17.7 cm
Gift of P.T. Brooke Sewell

Lycurgus cup

THIS EXTRAORDINARY cup is the only surviving complete example made from dichroic glass, which changes colour when held up to the light. When light is shone through the body of the cup it turns from opaque green to a glowing translucent red. The glass contains tiny amounts of colloidal gold and silver, which give it these unusual optical properties.

The cup is also the only figural example of a vessel known as a 'cage-cup'. First a thick glass blank was blown or cast, then cut and ground away until the figures were left in high relief. Sections of the figures are almost free-standing and connected only by 'bridges' to the surface of the vessel.

The relief depicts an episode from the myth of Lycurgus, a king of the Thracians, who attacked the god Dionysos and one of his female followers. He was punished by being entrapped in the branches of a vine.

Probably made in Rome, 4th century AD
Ht 16.50 cm (with modern metal mounts)
D. 13.20 cm
Purchased with the aid of the Art Fund

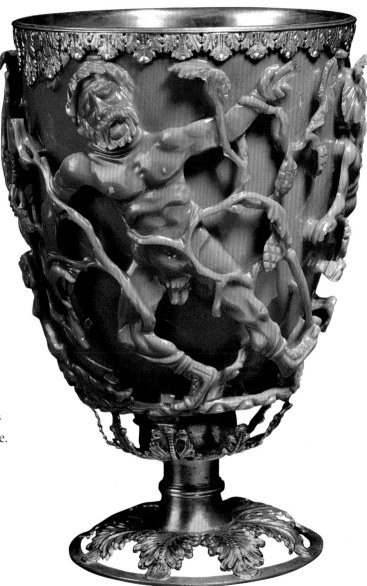

Blacas ewer

THIS EWER IS a masterful example of medieval Islamic inlaid brass. It was made in Mosul, a city that became famous from the twelfth century onwards for its inlaid metalwork. Mosul metalworkers inlaid brass vessels with intricate courtly scenes in silver and copper to create glittering objects that were very popular with the local élite. They were often given as diplomatic gifts to neighbouring rulers.

This ewer is signed by Shujac ibn Manca, one of the best inlayers in the Mosul, and dated Rajab AH 629 (April 1232). The quality of the inlaid decoration is exceptional, and includes medallions portraying scenes of contemporary court life. These include a horseman out hunting with a cheetah seated on the rump of his horse, a lady choosing jewels from a casket held by her maid while admiring her reflection in a mirror, and a wealthy woman in a camel-litter attended by two servants.

From Mosul, northern Iraq, 629 AH/AD 1232
Ht 30.4 cm
Originally in the collection of the Duc de Blacas

Qingbai wine ewer and basin

Qingbai (BLUE-WHITE) and *yingqing* (shadow blue) wares take their name from the blue colour of their glaze, produced at Jingdezhen in southeastern China from the tenth century. Much of the early production imitated northern white wares in shape and decoration, particularly the Ding wares of Hebei province. Different firing processes yielded the very different colour tones.

Qingbai wares are known for the pure, sugary quality of the porcelain body. Another important feature is the way that the glaze pools, which shows incised decoration to great effect. This can be seen in this delicately coloured and intricately carved wine ewer and warming basin.

Two very similar ewer-and-basin sets appear in the late Song painting in the Beijing Palace Museum, *The Night Revels of Han Xizai*, which is a copy of the lost tenth-century original by Gu Hongzhong, one of the most famous paintings in Chinese art history.

From southern China, Song dynasty (11th–12th century AD)
Ht 25.5 cm

Elgin amphora

THIS SPLENDID neck-handled amphora was made during Greece's Geometric period (900–700 BC) and has been restored from fragments excavated in Athens in 1804–6. It was probably used to hold wine at the funerary feast of a wealthy individual and then placed in his tomb, perhaps along with some smaller vases and a bronze *dinos* (cauldron) containing his ashes.

The amphora has elaborate painted geometric decoration which displays remarkable skill and precision. It can be attributed to an artist known as the Dipylon Painter, named after the ancient gate of Athens next to the cemetery where many of his works have been found. He and his workshop specialized in the production of large vessels, especially funerary markers. One of their innovations was the expansion of the web of complex geometric ornament to cover the whole surface of a vase.

From Athens, Greece, c. 750 BC
Ht 67 cm
Acquired with the assistance of the British Museum Friends, the Art Fund, the Caryatid Fund, Alexander Talbot Rice and the Society of Dilettanti

Marlborough ice pail

ICE PAILS, designed to cool a single bottle of wine, were made to be placed on the dining table. They became fashionable at the French court from the 1680s and were used by nobility and wealthy aristocracy throughout Europe.

This ice pail is one of the only surviving English examples made of pure gold. Their large, heavy form, lion masks and ringed handles show the influence of Huguenot goldsmiths. These craftsmen were French Protestants who, after 1685, came to Britain to escape religious persecution, bringing with them new designs and technical knowledge. Combined with spiral gadrooned decoration, a late-seventeenth-century English tradition, the style indicates a date of manufacture in London around 1700.

The ice pails were bequeathed by Sarah, 1st Duchess of Marlborough (1660–1744) to her grandson the Honourable John Spencer (1708–1746). The ice pails remained in the Spencer family at Althorp, Northamptonshire, until their acquisition by the Museum in 1981.

From London, England, c. AD 1700
Ht 26.7 cm
Wt 5.750 kg
Purchased with the aid of the Worshipful Company of
Goldsmiths, the Art Fund, the National Heritage Memorial
Fund, the Pilgrim Trust and funds bequeathed by Mrs
Katherine Goodhart Kitchingman

Lacquer dish

THIS DISH IS one of the earliest known examples of polychrome lacquer carved with a pictorial scene. By the time of its manufacture, the art of carving such scenes was being perfected, and these beautifully executed pieces were often made to imperial order.

The scene shows a famous fourth-century drinking and poetry party at the *lanting* (Orchid Pavilion) in the Chinese province of Zhejiang. The event has been the subject of countless Chinese paintings and poems. In this depiction, the sky is full of clouds and cranes, birds symbolic of immortality. The party arriving in the foreground is accompanied by deer, also associated with immortality, and the Islands of the Immortals rise out of the waves around the border of the dish. The carver has signed his name and the date around the door of the pavilion. On the back is a verse by the Tang dynasty poet, Wang Bo (650–675).

Possibly Gansu province, western China, Ming dynasty,
dated AD 1489
D. 19 cm

Muse casket from the Esquiline treasure

THIS DOMED SILVER CASKET, known as the Muse casket, is part of the Esquiline treasure, a collection of Roman silverware discovered in 1793 at the foot of the Esquiline Hill, Rome.

It was not meant to hold food or drink, but toiletries. The casket is designed to be suspended from chains and is fitted out inside to hold five small silver bottles for perfumes and unguents. Representations on Roman mosaics and wall paintings suggest that caskets of this form were made specifically for use at the baths. The panels around the scalloped body of the casket bear repoussé figures of eight of the nine Muses, who can be distinguished by their costumes and individual attributes. The seated figure on the top of the lid has no attribute and therefore is not the ninth Muse but a substitute in the form of a real woman, associating the owner with the accomplishments of the Muses.

From Rome, 4th century AD
Ht 26.7 cm
Diam. 32.7 cm

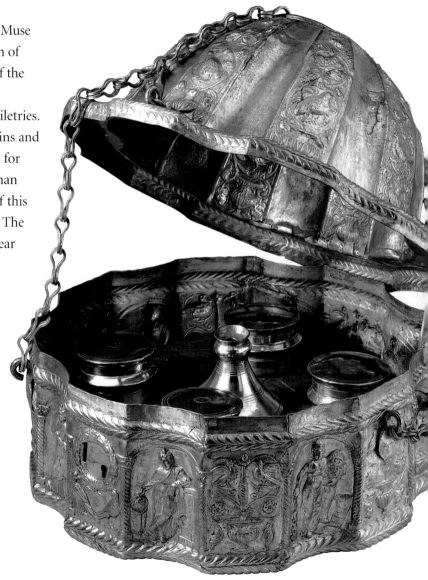

Bronze flesh-hook

THIS BRONZE 'flesh-hook', possibly used to pull chunks of meat out of a cauldron, was found in a bog at Dunaverney, Ireland, in 1829. Recent radiocarbon dating has placed it between 1050 and 900 BC, within the Late Bronze Age – a time of superb bronze-working skills.

Flesh-hooks appear to be a basic utensil for cooking or serving portions of meat. Most, however, are the products of highly skilled metalworking. This flesh-hook is particularly exceptional in having two sets of birds mounted on rotating shanks through the shaft of the instrument. No other Bronze Age artefacts from Ireland or Britain have animal-shaped models. The fact that objects such as this required high levels of skill and had elements of individuality sets them apart. They would have been associated with figures of authority and particular occasions such as communal feasts and could also therefore have acted as a symbol for the whole community.

From Dunaverney, Co. Antrim, Northern Ireland, 1050–900 BC
L. 56.3 cm

Great dish from the Mildenhall treasure

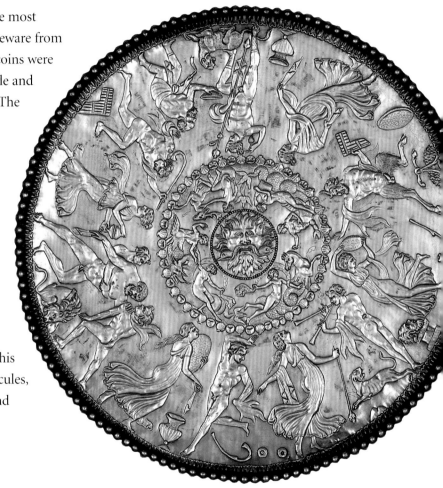

THE MILDENHALL TREASURE is one of the most important collections of late-Roman silver tableware from anywhere in the Roman empire. Although no coins were found to give a reliable date, the tableware's style and decoration is typical of the fourth century AD. The artistic and technical quality of the objects is outstanding, and they probably belonged to someone of considerable wealth and status.

This large platter, known as the 'Great dish', or the 'Neptune' or 'Oceanus dish', is the most famous object from the hoard. It is decorated in low relief and engraved line with designs alluding to the worship and mythology of Bacchus. The central face represents Oceanus, the personification of the oceans. The wide outer frieze features Bacchus presiding over a celebration of music, dancing and drinking in his honour. The participants include the hero Hercules, overcome by the consumption of wine, Pan, and various satyrs and female devotees of Bacchus.

Found in Mildenhall, Suffolk, 4th century AD
D. 60.5 cm
Wt 8256 g
Treasure Trove

10 The Human Form

THE MUSEUM ABOUNDS with images of the human body created at various times and places across history. As the objects on the following pages show, the ways the human body is represented and its ideal form have often differed between cultures and even within a single culture. Michelangelo's famous image of Adam, from the scene showing God creating mankind painted on the ceiling of the Sistine Chapel at the Vatican in Rome, has often been seen in Western art as an idealized image of the masculine body. One of the drawings the artist made as a study for the ceiling is shown in this chapter. This image of Adam, which has inspired many artists since its creation 500 years ago, stands in striking contrast to another way of seeing the human form, represented in the eye idols made in the Middle East some 3000 years earlier.

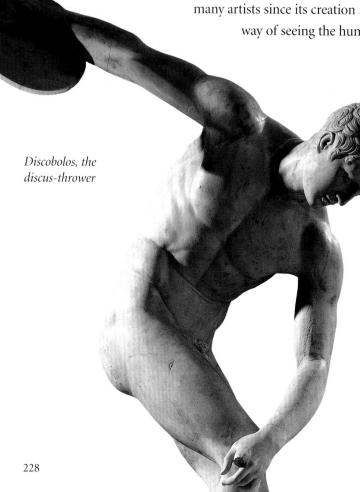

Discobolos, the discus-thrower

The idealized human form is a common element of many of the images of humans, or gods in human form, throughout this book. In this chapter, the Strangford Apollo embodies the ideal of the perfect human body in Greek culture of about 500 BC, stressing symmetry, beauty and athleticism. This can be compared and contrasted with another image of classical bodily perfection made only a few decades later: the famous image of Discobolos. This not only shows how quickly ideas about the ideal human form could change, it also demonstrates how a single vision of perfection, like Michelangelo's Adam, could become a source of inspiration lasting for centuries. The Discobolos may be the most famous sculpture of an athlete ever

created. Not only was this ideal of bodily perfection and athleticism copied from the original Greek bronze by a much later Roman sculptor, who produced the elements of the marble figure we know today, but its image continues to be constantly reproduced in books, posters, stamps, films and other media around the world.

The human images included in this chapter and elsewhere in this book were created for many different purposes, although it may be difficult for us now to understand the exact function of some of them. Michelangelo's drawing is a study for a painting illustrating the act of creation, while the eye idols may have been made as offerings or petitions to a deity. Many of the images were created as portraits, to act as reminders of a particular person. Examples in this chapter include a face on a Roman mummy case from Egypt, Rubens' portrait of a woman and the depiction of a Korean scholar. Most of the portraits across this book, however, are idealized representations, including those that may look like realistic portraits, such as the limestone sculpture of the 18th Dynasty Egyptian couple. Images created for funerary monuments may show what the deceased might have looked like at some point during their life. Equally, as seen in an earlier chapter, images of rulers have rarely been intended as true portraits in the modern sense, but instead aim to show an individual looking as a ruler ought to appear.

Nō mask

Many human images – from masks and statues to drawings and images on objects – have thus been created in order to illustrate the essence of their subject, sometimes using characteristics specific to that person but often emphasizing those which a person is supposed to possess in order to be recognized as the ruler, priest or character in a play or ritual.

Alabaster 'eye idol'

HUNDREDS OF THESE miniature figurines with prominent eyes were excavated from the remains of a monumental building, known as the Eye Temple, in Tell Brak, Syria. Tell Brak is the modern name of a huge Mesopotamian settlement that began as early as 6000 BC and became one of the most important cities in the region during the late prehistoric period. It held a strategic position on a major route from the Tigris Valley to the mines of Anatolia, the Euphrates and the Mediterranean.

The 'eye idol' figurines may represent worshippers and therefore may have been placed as offerings in religious buildings. They can be grouped into several types: single pair of eyes; three, four or six eyes; small 'child' eye figure carved on their front (as on this example); and eyes that have been drilled through. Examples of figurines with drilled eyes have been found at a number of sites of this period across north Mesopotamia.

Mesopotamian, excavated from Tell Brak, northeastern Syria, c. 3500–3300 BC
 Ht 3.5 cm

Michelangelo Buonarotti (1475–1564), *Study for Adam*

THIS BEAUTIFUL DRAWING of a male nude was drawn by Michelanglo when he was planning the figure of Adam to be painted on the ceiling of the Sistine Chapel, Rome. At the lower left is a study for his right hand.

Michelangelo has exploited the qualities of the red chalk to create a warmth of tone as he drew from the life model. He concentrated on the torso and upper legs of his model whose ideal anatomy is indicated by shading, especially on the chest and stomach areas. The figure appears to be as much like a sculpture as a painting, and Michelangelo considered himself primarily a sculptor.

Michelangelo spent 1508–12 decorating the ceiling of the Sistine Chapel. He painted the figure of Adam around 1511 and the pose as painted in the fresco is almost unchanged from this working drawing. Michelangelo would have used a full-size cartoon (preliminary drawing) to transfer the final design to the ceiling itself.

From Italy, c. AD 1510–11
Ht 19.3 cm
Gift of the Art Fund with contributions from Sir Joseph Duveen and Henry Van den Bergh

Peter Paul Rubens (1577–1640), *Isabella Brant*

THIS FAMOUS PORTRAIT drawing is of Rubens' first wife, Isabella Brant (1591–1626). Rubens has used the red chalk to bring out the warm flesh of Isabella's face and ears. Gentle hatching in both red and black chalks suggests the shadows on her face. Long curly strokes of black chalk define her hair which sweeps back over her head and gently down the side of her face. White heightening picks out the light on her forehead, nose and neck.

Both the large scale of the drawing and the stare of the sitter draw us to her. She has a warm smile, the head is beautifully finished and her facial features are highly polished and modelled. Her attractive personality is clear for all to see. Her marriage to Rubens was a successful one, and at her death in 1626 she was much mourned by her husband and family.

From The Netherlands, c. AD 1621
Ht 38.1 cm

Soapstone head

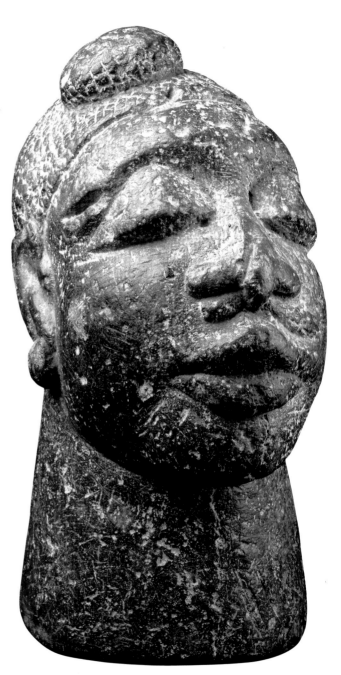

SOAPSTONE CARVINGS ARE rare in sub-Saharan Africa, but they are found in a small area covering parts of the modern states of Guinea, Sierra Leone and Liberia. Most of the sculptures are of human form and some of these are just heads. In Sierra Leone the Mende, who find them while preparing their fields, believe them to be from the previous owners of the land and make offerings to them to increase their harvest.

Pieces from Kissi country, such as this, tend to be different in style. The Kissi worship them in the belief that they represent their ancestors. These sculptures were probably made by the ancestors of the Kissi peoples who inhabited lands currently occupied by the Mende. It is very difficult to date the sculptures with any certainty or to know for what purpose they were originally carved. It seems likely, however, that they are at least several hundred years old.

Kissi, from Sierra Leone, possibly 17th or 18th century AD
Ht 24 cm
Gift of Mrs E.W. Fuller in memory of Captain A.W.F. Fuller
Art Fund

Marble figurine of a woman

THE ISOLATED POSITION of the Cycladic islands in the Aegean Sea meant that Cycladic culture developed traditions that remained unchanged for centuries. An example of this is the characteristic Cycladic marble figurine, produced for hundreds of years.

It is not known why the figurines were made or who they represented. The most common type are the 'folded arm' figurines such as this unusually large example. The form of these figurines is reduced to a few key components; facial features and other details were often originally painted on. The survival of these details on this figurine is remarkable. It is possible to make out almond-shaped eyes, a necklace and two rows of dots around the brow that may indicate a diadem. There is also a clear dotted pattern on the right cheek, which, along with traces of paint elsewhere on the face, shows that it was originally extensively covered with bright, perhaps even garish, patterns.

From the Cyclades, Aegean Sea, Early Bronze Age, c. 2700–2500 BC
Ht 76.5 cm

Nō mask of a young woman

NŌ IS A MUSICAL masked Japanese dance drama. It flourished in the fourteenth and fifteenth centuries and came under the patronage of the Ashikaga shogunate (1333–1568) after Ashikaga Yoshimitsu saw a particular performance in Kyoto in 1374. Its development was highly influenced by Zen Buddhism. It later became formalized and adopted as official entertainment under the Tokugawa shoguns (1600–1868).

A number of standard masks are used in different dramas. A skilfully carved mask will appear to have subtle changes of expression depending on the way the wearer turns his head and the angle at which it is held. This is one of several variations of a young-woman mask based on an original design by the famous fourteenth-century *Nō* actor Zeami Motokiyo. The false eyebrows painted high on the forehead and the blackened teeth were fashionable cosmetic styles for over a thousand years until the late nineteenth century.

From Japan, 18th–19th century AD
Ht 21.2 cm

Statue of a retired townsman

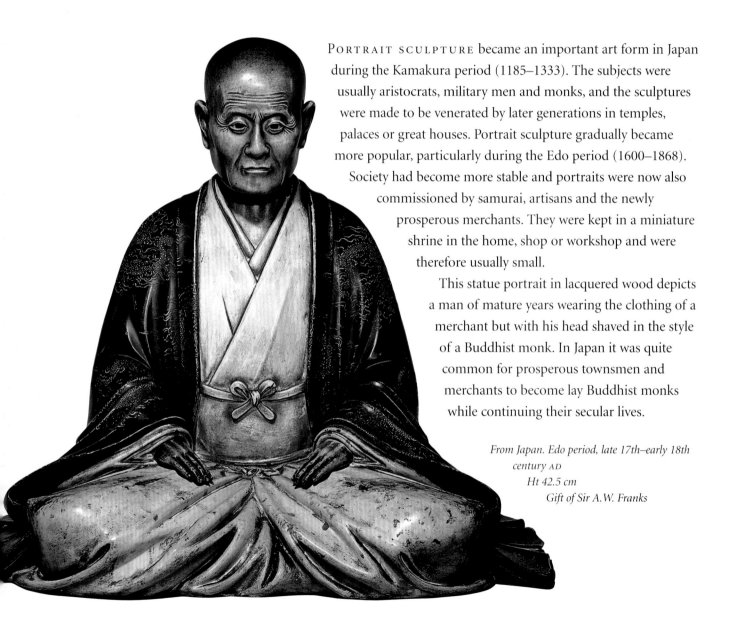

PORTRAIT SCULPTURE became an important art form in Japan during the Kamakura period (1185–1333). The subjects were usually aristocrats, military men and monks, and the sculptures were made to be venerated by later generations in temples, palaces or great houses. Portrait sculpture gradually became more popular, particularly during the Edo period (1600–1868). Society had become more stable and portraits were now also commissioned by samurai, artisans and the newly prosperous merchants. They were kept in a miniature shrine in the home, shop or workshop and were therefore usually small.

This statue portrait in lacquered wood depicts a man of mature years wearing the clothing of a merchant but with his head shaved in the style of a Buddhist monk. In Japan it was quite common for prosperous townsmen and merchants to become lay Buddhist monks while continuing their secular lives.

From Japan. Edo period, late 17th–early 18th century AD
Ht 42.5 cm
Gift of Sir A.W. Franks

Yi Che-gwan (1783–1837) (attributed to), *Portrait of a Confucian scholar*

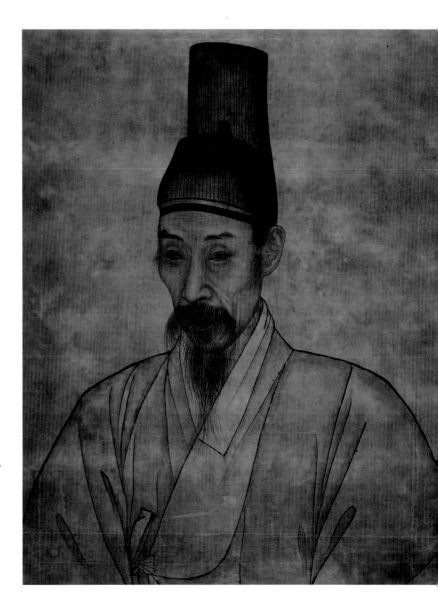

WESTERN PAINTING techniques were introduced to Korea in the eighteenth century through Jesuit missionaries in China. Such influence is apparent in this painting of a Confucian scholar wearing a traditional horse-hair indoor hat *(t'anggon)*, in the details of the face such as the wrinkles and the use of repeated minute lines (hatching) to show shading.

Earlier Korean portraits were more likely to capture a sense of the sitter's 'spirit' than portray an actual physical likeness. However, during the prosperous eighteenth century it became fashionable in portraiture as well as in *chin'gyong* (true-view) painting of real scenes from the Korean landscape.

There is a very similar painting in the National Museum of Korea which suggests that they are of the same man, and both painted by Yi Che-gwan. This portrait appears to be the later of the two, as the sitter seems to have aged.

From Korea, Late Choson dynasty, late 18th–early 19th century AD
Ht 60 cm

Henry Moore (1898–1986),
Seven seated figures before ruined buildings

During the Blitz of World War II (1939–45), many Londoners sought refuge in the Underground, even staying there overnight. The artist Henry Moore witnessed this and began making a series of sketches recording these scenes from the stations and platforms of the 'tube'. As he said: 'the scenes of the shelter world, static figures asleep – reclining figures – remained vivid in my mind, I felt somehow drawn to it all. Here was something I couldn't help doing'.

Moore never drew in the shelters as he felt it would be insensitive. Instead he walked through the platforms and the groups of sheltering people, often spending all night below ground, and made discreet notes to remind himself of the scenes. He then created the drawings in his studio, sketching them on cheap notebooks with pen and ink, crayon and watercolor. This is a leaf from the First Shelter Sketchbook.

From London, England AD 1940–41
L. 18.6cm
Ht 16.2 cm
Bequest of Jane Clark (1977)

Limestone statue of an unnamed nobleman and his wife

THIS PAIR-STATUE depicts a seated husband and wife. There is no inscription on the statue, perhaps indicating it remained unfinished, so the names of the couple are unknown. It is not known where their statue originated, though a number of similar statues have been found in Saqqara. The style of the figures, and their elaborate wigs and pleated robes, are characteristic of sculpture of the later years of the Eighteenth Dynasty, around the reign of Amenhotep III (1390–1352 BC), and the early years of the Nineteenth Dynasty (begins 1295 BC).

Henry Moore (1898–1986), one of the greatest British artists of the twentieth century, was a frequent visitor to the British Museum and once said: '... nine-tenths of my understanding and learning about sculpture came from the British Museum'. He particularly admired this statue, and it was the inspiration for his *King and Queen* (1952–3), now in the Tate Gallery, London.

From Egypt, 18th or 19th Dynasty, c. 1300 BC
Ht 130 cm

Edgar Degas (1834–1917), *Dancers Practising at the Barre*

DEGAS BEGAN STUDYING dancers in the 1870s and they became a principal motif in his work. He frequently visited the back stage and public areas of the Opéra building in Paris where the ballet was performed. He rarely, however, actually made his studies there, preferring instead to draw in his studio from posed models or memory. Although Degas tended to depict scenes from backstage and the wings of the theatre, through his studies, pastels, paintings and sculptures, he created a detailed picture of both the glamour of the performance and the more sordid reality of the dancers' backstage life.

Degas was a magnificent draughtsman. He experimented with media and developed a technique called *peintre à l'essence*, which he used for this drawing on green paper. This is coloured pigment from which the oil has been extracted and which has been thinned with turpentine to enable it to dry quickly.

From France, AD 1876–77
Ht 47.2 cm
Bequeathed by César Mange de Hauke

Tōshūsai Sharaku, *The Actors Nakamura Wadaemon and Nakamura Konozō*

THE ARTIST Tōshūsai Sharaku is only known to have produced works for a brief period of ten months between 1794 and 1795. Very little is known of him before or after this period and his identity is the object of much conjecture among historians of Japanese art.

Sharaku had a special talent for characterizing his subjects by differentiating their facial features. This woodblock print shows a scene from the play 'A Medley of Tales of Revenge' (*Katakiuchi noriai-banashi*) performed at the Kiri Theatre in the fifth month of 1794. The two subjects are strongly contrasted. On the right is Wadaemon in the role of Bodara no Chozaemon, a customer visiting a house of pleasure, with his sharp, angular features. He is pleading with Kanagawaya Gon, the chubby boatman, played by Konozō. The boatman's narrowed eyes and snub nose suggest that he is bent on striking a hard bargain.

From Japan, Edo period, 5th month, AD 1794
Ht 35 cm
Sir Ernest Satow Collection

Discus-thrower (*discobolos*)

THIS MARBLE STATUE is a Roman copy of a bronze original, now lost, attributed to the Greek sculptor Myron (fl. 470–440 BC). It captures the moment before the discus is released and illustrates the classical ideal of *rhythmos*, or harmony and balance.

The original statue was already famous in Roman times, and this is only one of several copies. It was restored in Italy soon after its discovery in 1791 in the villa of the emperor Hadrian, but with a different head set at the wrong angle. The popularity of the sculpture in antiquity was due to its representation of the athletic ideal. Discus-throwing was one of the five sporting events that made up the pentathlon. Pentathletes were much admired for their physical appearance: as no one set of muscles was over-developed, their overall proportions were considered particularly harmonious.

From Hadrian's Villa in Tivoli, Lazio, Italy
Roman copy of a bronze original of the 5th century BC
Ht 170 cm
Townley Collection

Diorite statue, probably of Gudea of Lagash

AROUND 2159 BC the Akkadian state in southern Mesopotamia collapsed and the area reverted to city-states under local rulers. The best known of these is Gudea, ruler of Lagash (in modern Iraq) from around 2120–2100 BC. He was a prolific builder and some of the longest and earliest Sumerian literary texts were written during his reign. It is also recorded that he imported stone from Magan (probably modern Oman) and commissioned numerous statues of himself for dedication in his temples.

Many of these figures have been found at Girsu, near Lagash, most of which are now in the Louvre, Paris. Although this statue of a shaven-headed man with clasped hands does not bear an identifying inscription, it too probably represents Gudea. Despite his wealth, Gudea's rule was limited to the area of his own city, which was soon absorbed into the new empire of Ur (called the Third Dynasty of Ur).

From Mesopotamia, c. 2100 BC
Ht 73.6 cm

Marble statue of a *tirthankara*

THE INDIAN FAITH of Jainism arose at around the same time as Buddhism. Its followers believe in a series of 24 *tirthankaras*. The title *tirthankara* means 'ford-maker' and refers to these individuals making 'fords' that allow their followers to cross over from suffering and pain to happiness and perfect knowledge. They are also called Jinas, or 'conquerors' because they have conquered and controlled their desires and attained a state of inner enlightenment.

This figure can be identified as a Jina due to the *srivatsa* mark on his chest. Only two Jinas are depicted with distinct physical characteristics: the first, Rishabhanatha, has long loose hair and the twenty-third, Parshvanatha, has a canopy of snakes over his head. Other Jinas are identifiable by symbols or emblems. Artists did not always include these signs, however, and often, as with this example, it is impossible to identify which particular Jina is represented.

From western India, AD 1150–1200
Ht 68.5 cm
Gift in memory of Sir Alfred Lyall

Bronze head

THIS HEAD WAS once part of a full-length statue. It depicts a man of middle age, with a thick beard, slightly thinning hair and a severe expression, enhanced by a deeply wrinkled brow. His hair is bound by a ribbon, signifying he is a poet. Once thought to represent the poet Homer, this has now been identified as a 'portrait' of the Athenian dramatist Sophokles, made long after his death.

During the Hellenistic period (323–31 BC) these imaginary portraits representing earlier historical figures became popular. Sophokles lived during the fifth century BC, but most surviving portraits of him are Roman copies or versions of Hellenistic creations. Such statues adorned the libraries of the Hellenistic kingdoms. The Romans continued the practice, often reducing the full-length portrait to a more compact bust or herm (a head on a pillar), sometimes inscribed with the name of the subject.

Acquired in Constantinople (modern Istanbul), Turkey
Hellenistic Greek, 2nd century BC
Ht 29.5 cm
Arundel Collection

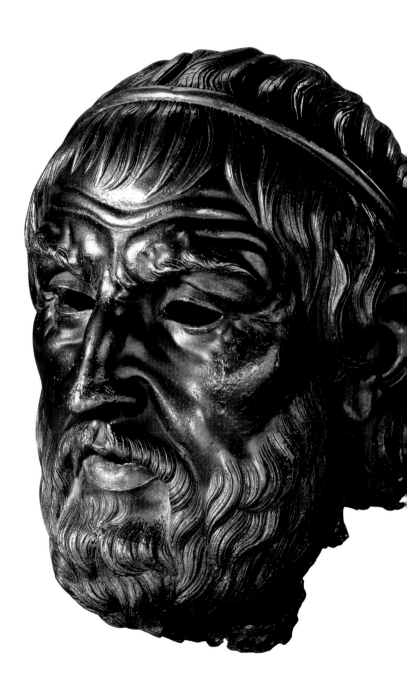

Mummy portrait of Artemidorus

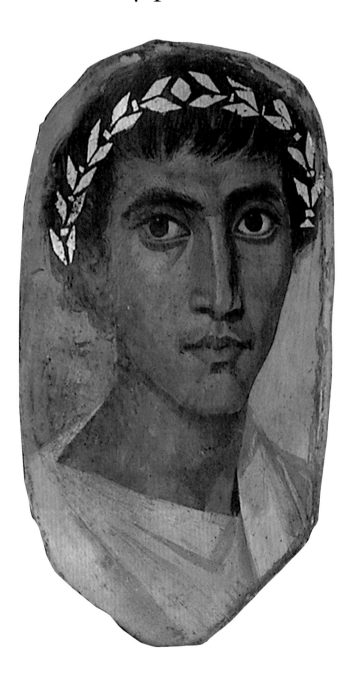

THIS MUMMY IS a reflection of three great influences on Egyptian culture: native Pharaonic traditions, Greece, and Rome.

The mummy case is decorated with a falcon-collar and a series of traditional Egyptian funerary scenes applied in gold leaf. The identity of the dead man is preserved in a Greek inscription across the breast: 'Farewell, Artemidorus'. A portrait panel, characteristic of Roman art, has been inserted at the head of the case. It is painted in encaustic, a mixture of pigment and beeswax with a hardening agent such as resin or egg.

Interior scans of the mummy show damage to the head but no signs of healing. While the damage may have resulted from rough treatment during mummification, it is possible that the injuries were the cause of death. Artemidorus was probably between 18 and 21 when he died, which is in keeping with the age suggested by his portrait.

From Hawara, Egypt, c. AD 100–120
Ht 171 cm
Gift of H. Martyn Kennard

Bronze model of a human head

THIS IS ONE of three small bronze models of men's faces that decorated a wooden bucket (probably to contain alcoholic drink) found in a Late Iron Age cremation burial. The grave probably belonged to someone of great importance and wealth, perhaps even a king or queen. It also contained two bronze jugs, a bronze pan, two Roman silver cups, five Roman wine amphorae and many pots.

The head, a rare picture of a prehistoric Briton, shows a mature man with his hair combed back, and clean-shaven except for a well-groomed moustache. Such images are very unusual as during this period people were almost never depicted in sculpture or in decoration on objects. The Iron Age La Tène artistic style was usually abstract and rarely used images of people, animals or plants. Towards the very end of the Iron Age, men were sometimes depicted on coins or, as here, as decoration on wooden buckets.

From Welwyn, Hertfordshire, England,
Iron Age, c. 50–20 BC
L. 4 cm
Gift of Mrs A.G. Neall

Pablo Picasso (1881–1973), preparatory study for *Les Demoiselles d'Avignon*

THIS STUDY BY Picasso in bodycolour and watercolour was one of many leading up to his famous painting, *Les Demoiselles d'Avignon* (Museum of Modern Art, New York). *Les Demoiselles d'Avignon* was the most difficult and revolutionary work of Picasso's career, and it profoundly disconcerted even his supporters when first exhibited in 1916.

The composition as a whole was conceived as a brothel scene with the more explicit title of *Le Bordel d'Avignon* provided by the artist himself, referring to a street in Barcelona. Originally it contained both male and female figures but in the form in which Picasso left the painting in the summer of 1907 there were just five women. This drawing relates to the second figure from the left. The simplified oval of the head, particularly in the study on the right of the sheet, reflects the influence of ancient Iberian sculpture which Picasso saw at the Louvre from the spring of 1906 onwards.

c. AD 1906–7
Ht 62.6 cm
Acquired with the assistance of the Art Fund

Strangford Apollo

THIS MARBLE STATUE depicts a youth standing in the conventional pose of a *kouros*. *Kouroi* are stone male figures dating from the Archaic period of Greek art (about 600–480 BC). The characteristic pose is based on symmetry: the left and right sides mirror each other, and the legs are positioned so as to divide the bodyweight equally between front and back.

The mouth is invariably fixed in a smile, probably a symbolic expression of the *arete* (excellence) of the person represented. It was thought that all *kouroi* represented the god Apollo, but though this may be true of some, others were simply grave markers. The *kouros* was not intended as a realistic portrait of the deceased, but an idealized representation of youthful beauty and athleticism; values and virtues to which the dead laid claim.

The figure is known as the Strangford Apollo after a previous owner, the sixth Viscount Strangford.

Said to be from the island of Anáfi, Cyclades, Aegean Sea, c. 500–490 BC
Ht 101 cm
Strangford Collection

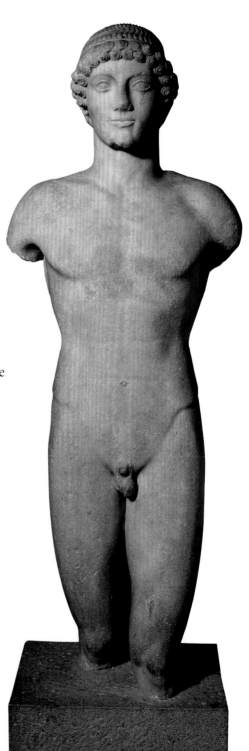

11 The Power of Objects

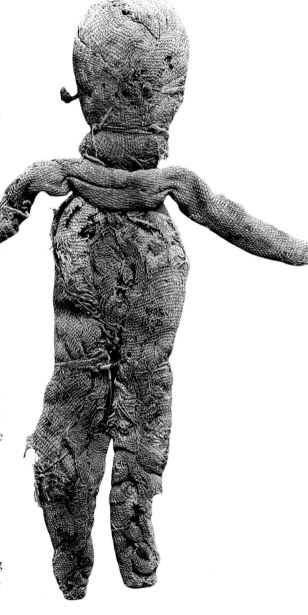

THROUGHOUT THE PAGES of this book are images of just 250 of over six million objects, drawings and prints that are looked after by the British Museum. Our selection includes objects that are extremely well known to visitors, such as the Rosetta Stone, mummy cases from Egypt and the Sutton Hoo helmet, possibly the most iconic object from Britain's early history. Yet our selection has also deliberately included a wide range of other objects, some huge, others very small, which show the wide range of the collection and reveal aspects of the Museum that may surprise even regular visitors. Relatively few people are aware that the Museum continues to collect modern contemporary objects, such as the *Throne of Weapons*, badges from recent elections and political campaigns, works of art from the Middle East and examples of twenty-first-century Japanese crafts as well as *manga* comics. This is because the Museum is as much about understanding the present as it is about helping people to understand the past. To fulfil both these functions, the Museum needs constantly to add new items that can create fresh and different perspectives from which visitors can connect the past with the present. In this sense, museums are always looking to the future.

Objects are deliberately included in this book that may not immediately be associated with the concept of 'masterpieces'. Is a rag doll from Roman Egypt a 'masterpiece' comparable to a watercolour by the artist Turner? Other pieces may stand out for the great skill involved in their making, or their immediate visual impact and

Roman rag doll from Egypt

'beauty', but may be known only to a small number of specialists. This is why the notion of 'a masterpiece' may perhaps strike some as odd, considering the British Museum is not an art museum or gallery despite containing many wonderful works of art. Certainly, many visitors come to the Museum to be inspired by the works of art they see here, but this is just one of the many functions of the Museum. Another is to offer a place where people can explore the history of the world, or specific cultures and geographic areas, through the objects those societies have created which tell us about all aspects of their lives. In this sense, the rare survival of a Roman rag doll may not be a particularly beautiful or well-made object, but it does make a powerful connection between us and the everyday lives of thousands of people in the Roman world 2000 years ago.

The British Museum exists because of the power of objects, be they celebrated works of art or broken sherds of ancient pots or the waste left over from making Ice Age stone tools. The power of things – as evidence of past lives and witnesses to some of the great events and processes in human history – is what draws over 10,000 researchers and scholars annually from around the world to visit the Museum to study the objects and works of art housed here. This is also why these objects continue to act as a powerful inspiration for creative artists, writers and designers, whatever their chosen medium, just as they have for over 250 years. The British artist Henry Moore first visited the British

Hokusai's 'Under the Wave'

Museum in the 1920s, and the Egyptian, Greek and African sculptures he saw then had a striking influence on the sculpture he went on to make, which has in its turn influenced modern artists around the world.

This power, especially when visitors can see an object close up, or touch an object from one of the Museum's handling tables, is also why millions come to the Museum, see its objects on loans and tours in other parts of the world, and explore the collections online via the website (www.britishmuseum.org). The power of things to help us understand our world is why the British Museum was founded, over 250 years ago, as the first public museum in the world. An Act of Parliament called for the Museum and its collections to 'be preserved and maintained not only for the Inspection and Entertainment of the learned and curious, but for the use and benefit of the Publick'.

Bark shield

THIS BARK SHIELD is a poignant object that was witness to the first meeting between native Australians and Captain Cook and his crew at Botany Bay, near what is today the city of Sydney in Australia.

The shield has been identified, reasonably convincingly, as having been collected in 1770 on Captain Cook's first voyage in HMS *Endeavour* (1768–71). It is the only Australian artefact in the Museum from the voyages.

When Cook's landing party came ashore at Botany Bay, it was opposed by two men of the Eora tribe. Cook and his officers fired small shot at the men's legs and one man ran and retrieved a shield from his camp for protection. The landing party forced their way on shore and the men retreated, leaving the shield behind. Records made at the time strongly support that this is the shield dropped at this first encounter.

Made in New South Wales, Australia, before AD 1770
Almost certainly collected on the first voyage of Captain James Cook
L.97 cm

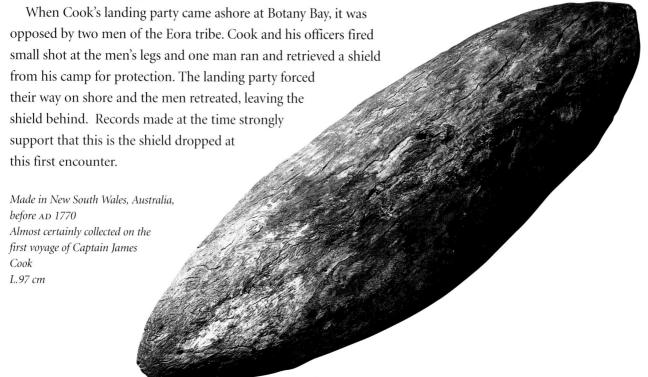

John White, *Portrait of a member of the Secotan or the Pomeioc tribe*

THIS WATERCOLOUR PORTRAIT is one of the first images of a native North American to be made by a northern European artist. It was made by John White, who in 1585 accompanied the English expedition to colonize Roanoke, Virginia. He was employed as draughtsman-surveyor and his duties included making visual records of anything unknown in England, including plants, animals, birds and the native Americans, especially their costumes, weapons and ceremonies.

This is a portrait of a member of one of the two Algonquian tribes, the Secotan and the Pomeioc, who lived in what is now Virginia and North Carolina. White's inscription tells us the purpose of this body decoration and costume: 'The manner of their attire and painting them selves when they goe to their generall huntings, or at theire solemne feasts'.

From North America, c. AD 1585–93
Ht 27.4 cm

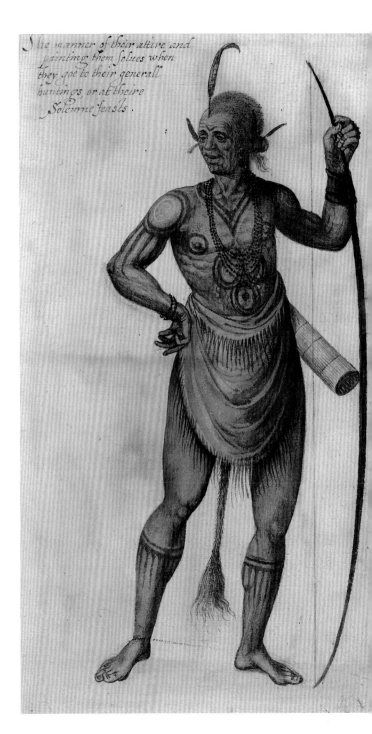

The manner of their attire and painting them selues when they goe to their generall huntings or at theire Solemne feasts.

Royal Game of Ur

THIS IS ONE of the oldest surviving board games in the world. The game is one of several with a similar layout found by Leonard Woolley in the Royal Cemetery at Ur. The wood had decayed but the inlay of shell, red limestone and lapis lazuli survived in position so that the original shape could be restored.

According to references in ancient documents, two players competed to race their pieces from one end of the board to another. The gaming pieces for this particular board do not survive. However, some sets of gaming pieces of inlaid shale and shell were excavated at Ur with their boards. The boards appear to have been hollow with the pieces stored inside. Dice, either stick dice or tetrahedral in shape, were also found.

Examples of this 'Game of Twenty Squares' date from about 3000 BC to the first millennium AD and are found widely from the eastern Mediterranean and Egypt to India.

From Ur, southern Iraq, c. 2600–2400 BC
Ht 2.4 cm
W. 11 cm
L. 30.1 cm

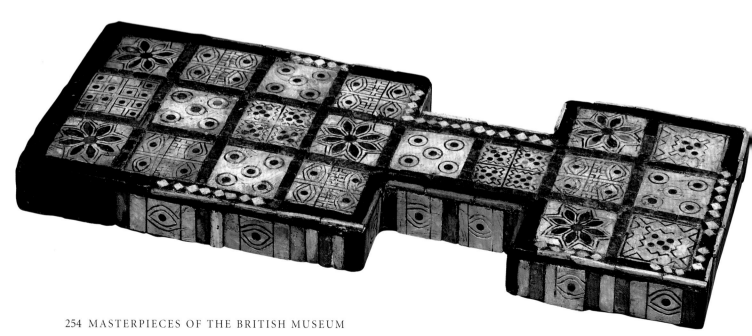

Rag doll

IN THE ANCIENT world dolls were usually made of rags, wood, bone or fired clay. Relatively few have survived because of the perishable nature of their materials. This doll survived as a result of the very dry conditions in parts of Egypt.

It is made of made of coarse linen stuffed with rags and pieces of papyrus. The arms are made from a long roll of linen attached at the back. Coloured wool, now faded, was applied to parts of the face and body. A blue glass bead attached to the head, perhaps a hair ornament, suggests the doll was female.

Dolls ranged from simple home-made playthings such as this example, to miniature works of art, with finely worked features and jointed bodies. As well as dolls, children had a wide range of toys and playthings, such as toy animals, soldiers, doll's houses with miniature furniture, spinning tops, hoops and marbles.

Roman, made in Egypt, 1st–5th century AD
Ht 19 cm
Gift of the Egypt Exploration Fund

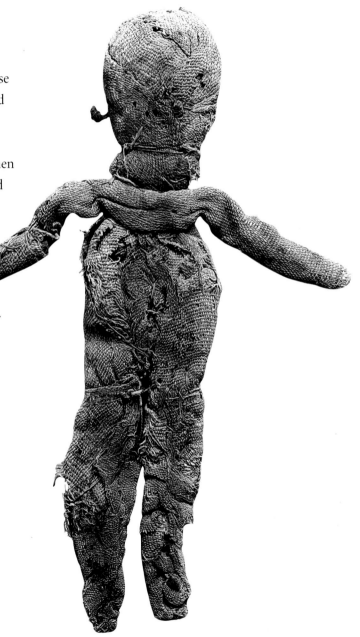

Raffles gamelan

A GAMELAN IS a set of instruments that traditionally accompany puppet shows, dance dramas, feasts and ceremonies in Indonesia. During shadow puppet plays, the orchestra highlights the moments of drama and provides the music that fits the personality of characters on stage. There are various kinds of gamelan, the main differences being the number and type of instruments that make up each orchestra and the tonal system used. An orchestra may contain a few instruments or more than thirty.

Sir Stamford Raffles, former Lieutenant-Governor of Java and founder of Singapore, brought this gamelan to Britain. The frames for the instruments are unique: the instruments are carved to represent peacocks, dragons, deer and other animals.

From Java, Indonesia, 19th century AD
L. 100 cm
Collected by Sir Stamford Raffles
Bequeathed by Revd Raffles Flint

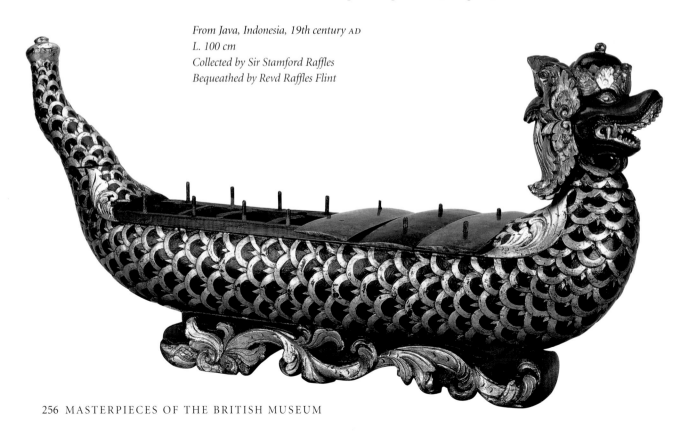

Citole

A CITOLE IS the medieval equivalent of a guitar. This example is both a unique survival of its type and an outstanding example of medieval secular art. It was highly prized in its day and continued to be highly regarded throughout its history.

The back, sides and neck are all carved from a single piece of wood and date from the late thirteenth or early fourteenth century. Several alterations have been made to the citole, including attempts to convert it to a violin.

The citole is carved with trees, forest creatures and hunting scenes. A silver plate has been added, engraved with the arms of Elizabeth I, Queen of England (1558–1603) and her favourite and lover, Robert Dudley, Earl of Leicester. The gittern was used to accompany love ballads in the medieval period; this, and the hunting decoration, probably appealed to Elizabeth and Leicester, for both were passionate hunters.

Made in England, c. AD 1280–1330
L. 61 cm
Purchased with the assistance of the Art Fund
and the Pilgrim Trust

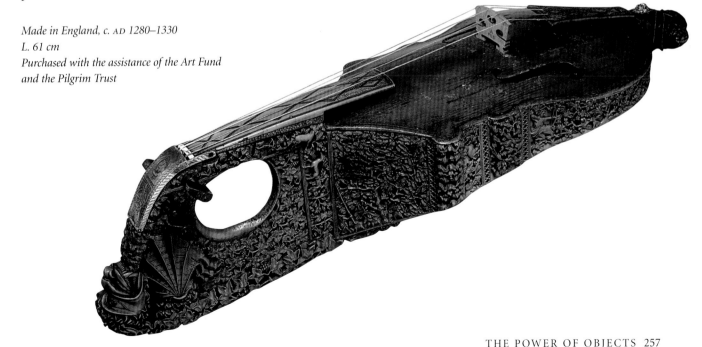

1,000,000 mark note

BANKNOTES FOR HUGE sums of money sound like a dream come true, but in reality they are often a symptom of economic nightmare. After World War I (1914–18), Germany faced crippling demands for reparation payments, and suffered severe economic depression. The early 1920s saw disastrous inflation, with ever-increasing issues of banknotes for denominations of up to a hundred billion marks. Soaring price rises meant that these apparently vast sums of money could buy less and less.

Ordinary people found their savings and incomes reduced to nothing. Wages were collected in sacks, and shopkeepers used tea chests instead of tills to store their notes. In 1923, the year this one million mark note was issued by the Reichsbank, it was reported that the price of a ham sandwich had gone up from 14,000 marks to 24,000 marks in one day and the price of a loaf of bread rose to 400 billion marks.

From Germany, AD 1923
Ht 8 cm
Chartered Institute of Bankers Collection

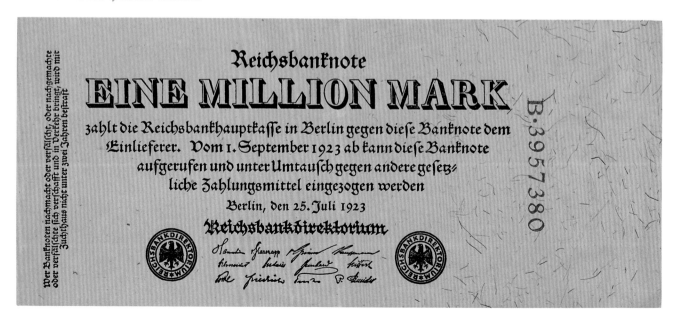

Gold *croesid* coin

IT IS THOUGHT that the first coins were issued in Lydia (modern Turkey) in around 650–600 BC. One of the kings of Lydia, Croesus (reigned about 560–547 BC), was renowned for his wealth. The expression 'as rich as Croesus' is still used today to mean fabulously rich. His capital Sardis (in modern Turkey) was on the River Pactolus and the river may in part have been responsible for his legendary wealth. Electrum, an alloy of gold and silver, occurs naturally in the sands of the river bed and was extracted from the river in antiquity. This was the metal from which the earliest coins were made.

Because of his legendary wealth, the earliest coins to be issued in gold have often been attributed to Croesus. Ancient writers mention a gold coin called a *croesid*, and it may well be this coin to which they refer.

Lydia, modern Turkey, c. 550 BC
D. 2 cm
Wt 8.003 g

Astronomical compendium

An ASTRONOMICAL compendium is a collection of small mathematical instruments in a single box. It provided the user with a multitude of options in a handy format, but was also an expensive item, clearly meant to show off the owner's wealth. This elaborate example was made by James Kynvyn for Robert Devereux, second earl of Essex (1567–1601), whose arms, crest and motto are engraved on the inside of the cover.

The compendium consists of a nocturnal (for finding the time at night from the orientation of the stars), a latitude list, a magnetic compass, a list of ports and harbours, a perpetual calendar and a lunar indicator. The compendium could be used for timekeeping as well as for establishing high tide at particular ports and for calendrical calculations. At some point the nocturnal was incorrectly restored, so unfortunately this part of the compendium is now useless.

From London, England, AD 1593
D. 5.9 cm

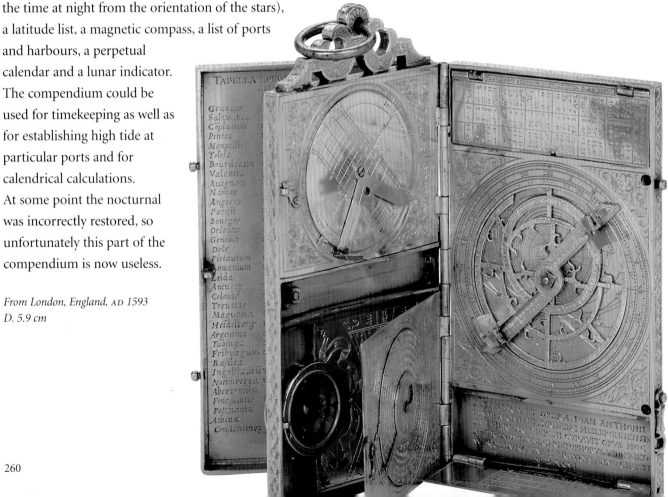

Table clock by Thomas Tompion

THIS YEAR-GOING, spring-driven table clock was made by Thomas Tompion for William III (reigned 1689–1702). It is a spectacular work by Britain's most celebrated clockmaker. The case is made of ebony veneer decorated with applied silver and gilt-brass mounts.

The dial shows hours and minutes but also has a sector aperture at the top which displays the days of the week, each with a personification of the day's ruling planet. The year duration is achieved by using six-wheel gear trains which are driven by relatively large barrels and fusees. The clock has a verge escapement controlled by a short pendulum. It strikes the hours in passing and has a pull-quarter repeat system (that is, it strikes the last hour and quarter on pulling a cord at the side of the case). A silver plaque on the dial is inscribed *T Tompion Londini Fecit* (Thomas Tompion of London made it).

Made in London, England, c. AD 1690
Ht 71 cm
Purchased with the assistance of the National Heritage Memorial Fund and the Art Fund

Samuel Palmer (1805–81), *A Cornfield by Moonlight with the Evening Star*

PALMER BEGAN HIS career as an artist at an early age and first exhibited at the Royal Academy at the age of fourteen. In 1824 he met William Blake whose influence helped to confirm his visionary approach to art. Palmer retreated into rural isolation in the village of Shoreham in Kent. Here he gathered around him a group of artists who were influenced by Blake, such as Edward Calvert (1799–1883) and George Richmond (1809–96), who called themselves the 'Ancients'.

Palmer produced his most distinctive work while living in Shoreham, and this striking watercolour with bodycolour and pen and ink is one of his finest from that period. Palmer's technique was as unconventional as his vision and the paint used on this picture has been mixed with various varnishes and pastes to alter its thickness and sheen.

From England, c. AD 1830
Ht 19.7 cm
Purchased with the assistance of the National Heritage Memorial Fund, Henry Moore Foundation, British Museum Publications, British Museum Friends and Sir Duncan Oppenheim

Katsushika Hokusai (1760–1849), *Under the Wave, off Kanagawa (Kanagawa oki nami-ura)*

THIS IS PERHAPS the single most famous of Hokusai's colour woodblock prints, indeed possibly the most famous of all Japanese prints. The graceful snow-clad Mount Fuji stands in the background of the print, its white cap contrasting against the deep blue of the horizon. It is however, reduced to a tiny hillock compared with the towering strength of the wave which threatens to engulf the struggling boats. Such clever, playful manipulation of composition is a feature on many of Hokusai's works.

The print belongs to the series 'Thirty-six views of Mount Fuji', the first to exploit the new, cheaply available, chemical Berlin blue pigment. Hokusai's series was so commercially successful that the publisher, Nishimuraya Eijudō, extended it with another ten prints, printed this time with black instead of blue outlines. Though highly valued today, several thousand impressions were taken from the cherry-wood printing blocks, literally as many as the publisher could sell.

From Japan, Edo period, c. AD 1829–33
Ht 25.9 cm
Bequeathed by Charles Shannon, RA

Jade *bi*

IN BOTH EUROPE and China, the past played a powerful role in inspiring art and the imagination in the eighteenth century. This can be seen in both the ancient object and the watercolour on the opposite page.

This jade *bi* (ring or disc) dates to the Shang dynasty (about 1500–1050 BC). Engraved on the *bi*, however, is a poem written by the Qianlong emperor (reigned AD 1736–95). The emperor's inscription says that his poetic imagination was stirred by the subtle and exquisite shape of the *bi*, and the quality of the jade from which it was made. The Qianlong emperor was a great collector of antiquities and managed to acquire many famous old paintings, bronzes, porcelains and jades for the imperial collection. The emperor not only wanted to possess these things, he wanted to put his seal on them, or to write a poem or comment on them.

From China, Shang dynasty (about 1500–1050 BC)
D. 15 cm

J.M.W. Turner (1775–1851),
Tintern Abbey, the transept

THE IMAGES ON this page and the next were made at almost the same time in different parts of Europe by two famous painters. This watercolour of Tintern Abbey is by Turner. In the late eighteenth century the effects of the Industrial Revolution on the landscape, and a fashion for the medieval or 'Gothick', led to a new appreciation of the British countryside. Tourists sought out picturesque ruins and romantic landscapes.

Turner visited the ruins of the twelfth-century abbey in Monmouthshire, which he visited in 1792, and again in 1793. Visitors were as much impressed by the way that nature had reclaimed the monument as by the scale and grandeur of the buildings, and Turner's blue-green washes over the far wall blend stone and leaf together. The figures of the tourist party and the gardener may have been added by another artist working in collaboration with Turner, a common method of production at the time.

From England, c. AD 1795
Ht 34.5cm
R.W. Lloyd Bequest

Francisco José de Goya y Lucientes (1746–1828), *El sueño de la razon produce monstruos*

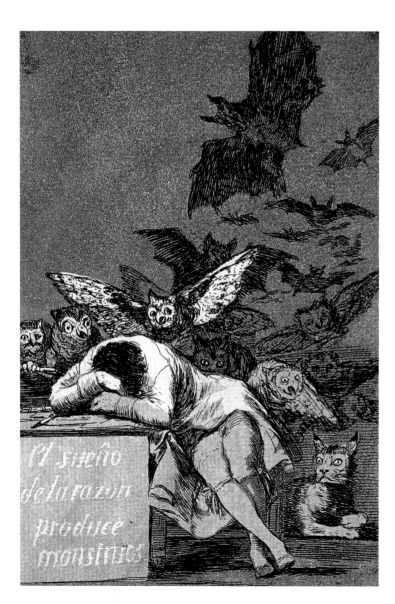

FRANCISCO JOSÉ DE Goya y Lucientes was a court artist to the Spanish royal family, but also a portraitist and satirist. In 1799 he produced a series of 80 satirical etchings known as *Los Caprichos* (The Fantasies). The series held up the vices and follies of contemporary Spanish society for ridicule.

This print, *The Sleep of Reason Produces Monsters*, acts as a chapter heading for the second part of the series, set in a nightmarish realm where witches and demons conceal the social satire. It shows the artist asleep at a worktable covered in papers and drawing instruments. Night creatures loom out of the darkness and an owl offers him a crayon holder. A drawing for this print from 1797 was captioned: 'The Author Dreaming. His one intention is to banish harmful beliefs commonly held and with this work of *Caprichos* to perpetuate the solid testimony of truth.'

From Spain, first published AD 1799
Ht 21.4 cm

William Blake (1757–1827), *Albion Rose*

THIS COLOUR PRINTED etching with hand-drawn additions in ink and watercolour was made three years before Goya's *The Sleep of Reason* and a year after Turner's watercolour of *Tintern Abbey*. It depicts the figure of Albion, a personification of Britain. Blake often portrayed Albion as an elderly man, exhausted or in fetters, destroyed by war, social injustice, false morality and capitalism. This image of Albion was printed in 1796 and reflects how Blake was inspired by the political changes created by the American War of Independence (1776–81) and the French Revolution (1789).

Here Albion as shown as a joyful and vigorous young man freeing himself from the shackles of materialism. In Blake's world view, Albion could still be saved by the triumph of individual liberty, imagination and spirituality over social, political and religious oppression.

From England, c. AD 1796
Ht 26.5 cm

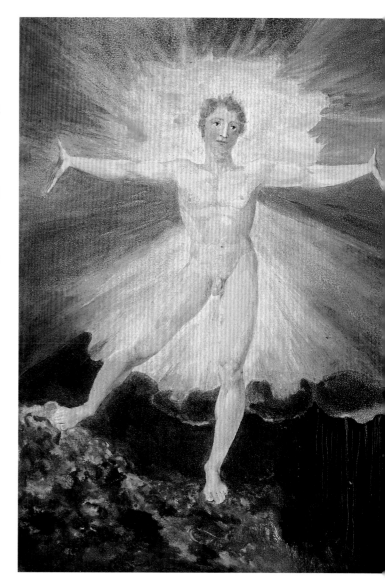

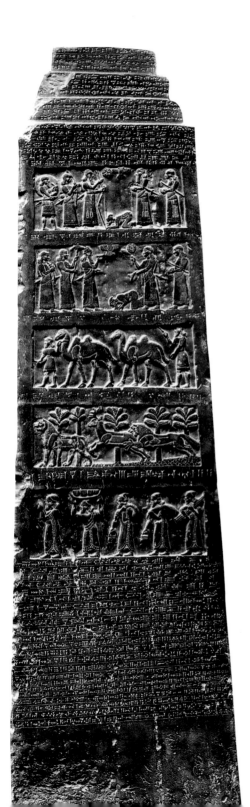

Black obelisk of Shalmaneser III

THIS BLACK LIMESTONE obelisk was found at the site of Kalhu, the ancient Assyrian capital. It was erected as a public monument in 825 BC at a time of civil war. The relief sculptures glorify the achievements of King Shalmaneser III (reigned 858-824 BC) and his chief minister.

There are five scenes of tribute. The second register from the top includes the earliest surviving picture of an Israelite: the Biblical Jehu, king of Israel, who brought or sent his tribute in around 841 BC. The caption above the scene, written in Assyrian cuneiform, can be translated:

The tribute of Jehu, son of Omri: I received from him silver, gold, a golden bowl, a golden vase with pointed bottom, golden tumblers, golden buckets, tin, a staff for a king [and] *spears.*

From Nimrud (ancient Kalhu), northern Iraq,
Neo-Assyrian, 858–824 BC
Excavated by A. H. Layard
Ht 197 cm

Standard of Ur

THIS OBJECT WAS excavated from one of the largest graves in the Royal Cemetery at Ur in Mesopotamia. When found, the original wooden frame had decayed and the panels were crushed and broken. As a result, the present restoration is only a best guess as to how it actually appeared. Its original function is not known, but suggestions include a standard, and the sound-box of a musical instrument.

The long panels, covered with mosaic of shell, red limestone and lapis lazuli, are known as 'War' and 'Peace'. 'War' shows one of the earliest representations of a Sumerian army. Chariots pulled by donkeys trample enemies; infantry with cloaks carry spears; enemy soldiers are killed with axes and others are paraded naked and presented to the king. 'Peace' depicts animals, fish and other goods brought in procession to a banquet. Seated figures wearing woollen fleeces or fringed skirts drink to the accompaniment of a musician playing a lyre.

From Ur, southern Iraq, c. 2600–2400 BC
Ht 21.59 cm
Excavated by C.L. Woolley

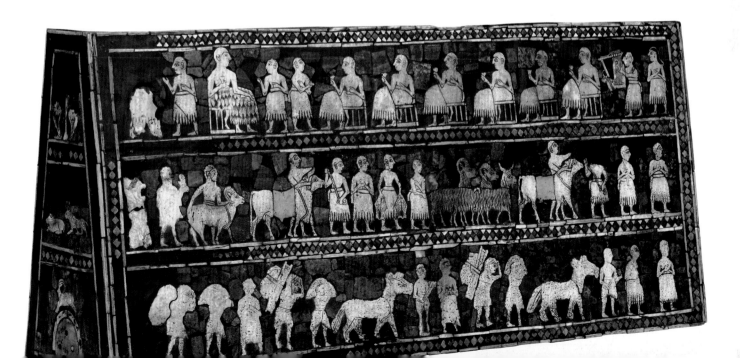

Portland vase

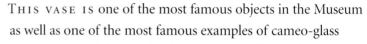

THIS VASE IS one of the most famous objects in the Museum as well as one of the most famous examples of cameo-glass vessel from antiquity. To make such vessels requires great skill and technical ability. This example was made by dipping the partially blown blue glass into molten white glass. The two were then blown together into the final form. After cooling, the white layer was cut away to form the design. The cutting was probably performed by a skilled gem-cutter.

The scenes decorating the vase are much debated, but seem to relate to the themes of love and marriage. The bottom of the vase probably originally ended in a point but was broken in antiquity and mended with a cameo-glass disc, showing a pensive King Priam of Troy. This has been displayed separately since 1845.

It is not known exactly where and when the vase was found. In 1778 it was purchased by Sir William Hamilton, British Ambassador at the Court of Naples.

Perhaps from Rome, Italy, c. AD 5–25
Ht 24 cm
Purchased with the aid of a bequest from James Rose Vallentin

Pegasus vase

THIS VASE IS made of jasper ware, a type of unglazed stoneware that can be stained with colour before firing. Josiah Wedgwood (1730–95) perfected the technique by 1775, after a number of experiments.

Wedgwood made a number of examples of the Pegasus vase in jasper ware and in black basalt. With sharp relief decoration set against the smooth body surface, the vase is a masterpiece of the potter's art, and Wedgwood took great pride in presenting it to the British Museum in 1786.

The decoration of the vase was modelled for Wedgwood by the artist John Flaxman junior (1755–1826). Flaxman adapted a variety of classical sources: the figures in the main scene are based on an engraving of a Greek vase of the fourth century BC, while the Medusa heads at the base of the handles are taken from an engraving of an antique sandal.

Made in the Etruria factory, Staffordshire, England, AD 1786
Ht 46.4 cm
Gift of Josiah Wedgwood

Casket depicting the Adoration of the Magi

THIS GILDED CASKET was made in France in around AD 1200 and shows a scene from the New Testament on the front of the casket depicting the journey of the Magi to Bethlehem and their Adoration of the infant Jesus. The sides each have the image of an unidentified saint while the back is decorated with squares containing floral motifs. The casket may have been made as a reliquary to contain relics from the shrine of the Magi at Cologne, Germany, which was an important pilgrimage site in medieval Europe.

The casket is made of a wooden core decorated with champlevé-enamelled copper sheets. Champlevé enamelling is a technique that uses individual cells cut into the metal base to build up a design. Each cell is then filled with enamel. Examples of this technique dating from the late twelfth to early fourteenth century are known as Limoges enamels, after the town in south-west France which became an early centre for fine enamel work.

From Limoges, France, c. AD 1200
Ht 18.5 cm
Bernal Collection

Geometric *krater* painted with a couple and a ship with oarsmen

THIS *KRATER* (wine-mixing bowl) is decorated with a scene of a couple standing beside a ship. The scene clearly seems to portray a leave-taking and has been interpreted as a mythological scene, possibly Theseus taking Ariadne from Crete, or Paris abducting Helen from Sparta. The woman, with shoulder-length hair, is wearing a long skirt and holding what is probably a wreath. She is being held at her left wrist by a man who looks back at her while stepping towards the rear of the ship, perhaps to board it via the two gangplanks. The ship has a long prow and is the first known representation of a vessel manned by two tiers of oarsmen.

Said to be from the region of Thebes, Boeotia, Greece
c. 735–720 BC
Ht 30 cm

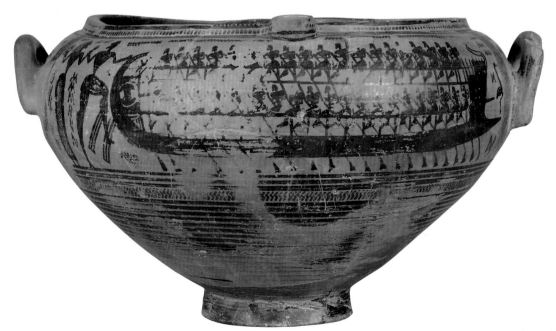

Rock crystal skull

LARGE QUARTZ CRYSTAL skulls such as this began to
surface in public and private collections during the
second half of the nineteenth century. Some of
them have been attributed to the work of Aztec,
Mixtec or even Maya stone workers. Others
are said to be examples of post-Conquest
Mexican art for use in churches, perhaps as
bases for crucifixes.

This skull was said to have come from
Mexico, brought to Europe by a Spanish
officer before the French occupation
(1862–7). The Museum's Department of
Scientific Research has concluded however
that the quartz crystal is likely to have come
from Brazil, a relatively recent source of
crystal. Moreover, it bears traces of the use of a
jeweller's wheel, which was unknown in the
Americas before the arrival of the Europeans.
These traces and the high polish of its surface also
indicate that it was carved using traditional
European techniques.

Probably European, 19th century AD
Ht 25 cm

'Seal of God' from Dr John Dee's magic set

THE BRITISH MUSEUM has a number of objects associated with the Elizabethan mathematician, astrologer and magician John Dee (1527–1608/9). Dee was one of the most learned men of his time, but later in life he became interested in psychic phenomena. He worked with a medium, who would see visions in 'shew-stones', polished translucent or reflective objects which Dee used as tools for his occult research.

Dee's 'magic set' included a mirror, made of highly polished obsidian (volcanic glass), that was used by Dee as a 'shew-stone'. Four wax discs are recorded as having supported the legs of Dee's 'table of practice'. A larger disc, shown here, the 'Seal of God' (*Sigillum Dei*) was used to support one of Dee's 'shew-stones'. All the wax discs are engraved with magical names, symbols and signs. Another disc, made of gold, is engraved with the Vision of Four Castles, experienced during one of Dee's 'experiments' at Krakow in 1584.

England, 15th–16th century AD
Mirror: Aztec, 15th–16th century AD
D. 23 cm (large wax disc)
Gold disc: Gift of the Art Fund

Piranesi vase

THIS VASE WAS restored by the celebrated Italian architect and engraver Giovanni Battista Piranesi (1720–78). Piranesi, better known for his architectural views of ancient and modern Rome aimed at the Grand Tour market, later took up the lucrative business of the restoration and sale of antiquities. In 1769 he acquired a number of ancient fragments found at a site on the grounds of the villa of the Roman Emperor Hadrian at Tivoli near Rome. He restored these fragments and incorporated them into highly decorative classical pastiches.

Although Piranesi described this vase as a fine work of the time of Hadrian (reigned AD 117–138), only small sections of it are ancient. These are: two of the bull's heads on the base, sections of the lion's legs and parts of the relief depicting satyrs picking grapes. The rest of the vase is entirely of Piranesi's own making.

From Tivoli, Italy, 18th century, incorporating Roman fragments (2nd century AD)
Ht 272 cm

Colossal marble foot

THIS COLOSSAL RIGHT foot originally belonged to a statue several times larger than life-size. In antiquity this scale was only used for images of gods and emperors. Although the statue from which the foot came was Roman, the sandal is an elaborate Greek type first seen in the fourth century BC. It is therefore likely that the foot belonged to the statue of a senior Olympian god, probably represented seated, as a standing figure would have been more than five metres tall.

Limbs of colossal statues, particularly feet, were acquired as curiosities by eighteenth-century collectors. This foot was originally owned by Sir William Hamilton (1730–1803), British Ambassador to Naples, who presented his collection of Greek and Roman artefacts to the Museum in 1784. A list of donations to the Museum dated 31 January 1784 refers to it as 'A Colossal Foot of an Apollo in Marble'.

From Naples, Italy, 1st–2nd century AD
L. 88.9 cm

Swimming reindeer carved from the tip of a mammoth tusk

THIS CARVING IN the form of two reindeer is one of the most beautiful pieces of Stone Age art ever found. The reindeer are depicted with their noses up and antlers back, apparently in the act of swimming. This choice of pose might have been suggested by the tapering shape of the mammoth tusk.

The animals are perfectly modelled from all angles. The front figure is a female and has a smaller body and antlers. Her delicately shaded fur is depicted using feathered strokes to represent the reindeers' distinctive autumn coat. The larger, male, figure is not shaded but the strength of his body is indicated by the bold, sweeping lines of the carving. On both animals the antlers are laid along their backs and their legs are folded underneath them, with the exception of the back left leg of the male which originally extended behind.

From the rockshelter of Montastruc, Tarn et Garonne, France
Late Magdalenian, c. 12,500 years old
L. 20.7 cm
Christy Collection

Stone handaxe

THIS SMALL HANDAXE is one of the most beautiful in the British Museum. It is made from quartz with attractive amethyst banding, a difficult material from which to make tools because it is extremely hard. The toolmaker would have had to hit with considerable force and accuracy to remove flakes. Such a high degree of difficulty makes the thin, symmetrical shape of this piece a masterpiece of the toolmakers' art.

After roughing out the basic form of this handaxe, the maker went on to refine its shape, straighten its edges and thin it down. This added little to its usefulness: a simple, sharp quartz flake would have worked as well. It suggests that the skill invested in producing such beautiful and sometimes very large handaxes may have had other purposes. Perhaps some pieces were status symbols or had ritual significance.

From Bed IV, Olduvai Gorge, Tanzania
Lower Palaeolithic, c. 800,000 years old
L. 13.6 cm
W. 7.7 cm
D. 4.1 cm

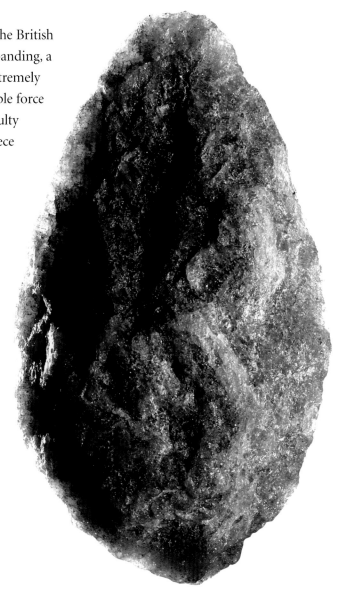

Further Reading

BRITISH MUSEUM
Online Resources
britishmuseum.org

The British Museum: 250 Years, Marjorie Caygill, 2005
The British Museum: A History, David M. Wilson, 2002
The British Museum A-Z Companion, Marjorie Caygill, 2007
The British Museum Reading Room, Marjorie Caygill, 2000
Building the British Museum, Marjorie Caygill & Christopher Date, 1999
The Collections of the British Museum, ed. David M. Wilson, 2007
Explore the British Museum: A Family Souvenir Guide, Richard Woff, 2007
The Great Court and the British Museum, Robert Anderson, 2005
The Story of the British Museum, Marjorie Caygill, 2002
Treasures of the British Museum, Marjorie Caygill, 2009
The Art of Small Things, John Mack, 2007
Behind the Scenes at the British Museum, ed. Andrew Burnett & John Reeve, 2001
Christian Art, Rowena Loverance, 2007
Flowers, ed. Marjorie Caygill, 2006
Little Book of Treasures, 2006
The Museum of the Mind, John Mack, 2003
Visitor's Guide, John Reeve, 2008
Winter: A British Museum Companion, ed. Marjorie Caygill, 2004
World Religions: British Museum Visitor's Guide, John Reeve, 2008

AFRICA
Africa: Arts and Cultures, ed. John Mack, 2005
African Art in Detail, Chris Spring, 2009
African Designs, Rebecca Jewell, 2006
African Textiles, John Picton & John Mack, 1999
The Art of Benin, Nigel Barley, 2010
Bronze Head from Ife, Edithe Platte, 2010
The Kingdom of Kush, Derek A. Welsby, 2001
Medieval Kingdoms of Nubia, Derek A. Welsby, 2001
Silk in Africa, Christopher Spring & Julie Hudson, 2002

AMERICAS
Central & South America
Ancient American Art in Detail, Colin McEwan, 2009
Aztec and Maya Myths, Karl Taube, 2002
Alfred Maudslay and the Maya: A Biography, Ian Graham, 2002
Fiesta: Days of the Dead and other Mexican Festivals, Chloë Sayer, 2009
Inca Myths, Gary Urton, 1999
Nasca: Eighth Wonder of the World?, Anthony F. Aveni, 2000
Textiles from the Andes, Penny Dransart & Helen Wolfe, 2011
Textiles from Guatemala, Ann Hecht, 2001
Textiles from Mexico, Chloë Sayer, 2002
Turquoise Mosaics from Mexico, C. McEwan et al., 2006
Unknown Amazon, ed. C. McEwan, C. Barreto & E. Neves, 2001

North America
The American Scene: Prints from Hopper to Pollock, Stephen Coppel with Jerzy Kierkuc-Bielinski, 2008
A New World: England's first view of America, Kim Sloan, 2007
North American Indian Designs, Eva Wilson, 2000
Ritual and Honour, Max Carocci, 2011

ANCIENT EGYPT
Ancient Egypt: Art, Architecture and History, Francesco Tiradritti, 2007
The British Museum Book of Ancient Egypt, ed. A.J. Spencer, 2007
The British Museum Dictionary of Ancient Egypt, Ian Shaw & Paul Nicholson, 2008
The Ancient Egyptian Book of the Dead, trans. Raymond O. Faulkner, Reissue 2010
Ancient Egyptian Designs, Eva Wilson, 2008
An Ancient Egyptian Herbal, Lise Manniche, 2006
Ancient Egyptian Medicine, John F. Nunn, 2006
Ancient Egyptian Religion, Stephen Quirke, 1992
The Art of Ancient Egypt, Gay Robins, 2008
The Cat in Ancient Egypt, Jaromir Malek, 2006
Concise Introduction: Ancient Egypt, T.G.H. James, 2005
Death and the Afterlife in Ancient Egypt, John Taylor, 2001
Egypt, Vivian Davies & Renée Friedman, 1999
Egypt after the Pharaohs, Alan K. Bowman, 1996
Egypt from Alexander to the Copts: An Archaeological and Historical Guide, ed. Roger S. Bagnall & Dominic W. Rathbone, 2004
Egyptian Mummies, John H. Taylor, 2010
Egyptian Myths, George Hart, 2008
Eternal Egypt: Masterworks of Ancient Art from the British Museum, Edna R. Russmann, 2001
Food Fit for Pharaohs: An Ancient Egyptian Cookbook, Michelle Berriedale-Johnson, 2008
The Gayer-Anderson Cat, Neal Spencer, 2007
Journey through the afterlife, John H. Taylor, 2011
Little Book of Mummies, 2004
Magic in Ancient Egypt, Geraldine Pinch, 2006
Masterpieces of Ancient Egypt, Nigel Studwick, (paperback) 2012
Monuments of Ancient Egypt, Jeremy Stafford-Deitsch, 2001
Mummy: The Inside Story, John H. Taylor, new edn. 2011
The Painted Tomb-Chapel of Nebamun, Richard Parkinson, 2008
The Rosetta Stone, Richard Parkinson, 2005
Spells for Eternity: The ancient Egyptian Book of the Dead, John H. Taylor, 2010
Sudan: Ancient Treasures, ed. Derek A. Welsby & Julie R. Anderson, 2004
The Tale of Peter Rabbit, hieroglyph edn, 2007
Voices from Ancient Egypt: An Anthology of Middle Kingdom Writings, R.B. Parkinson, 2004
Women in Ancient Egypt, Gay Robins, 2008
Women in the Ancient World, Jenifer Neils, 2011
Write Your Own Egyptian Hieroglyphs, Angela McDonald, 2007

ANCIENT GREECE & ROME
The British Museum Book of Greek and Roman Art, Lucilla Burn, 2005
The Classical Cookbook, Andrew

Dalby & Sally Grainger, new edn. 2012

Classical Love Poetry, ed. & trans. Jonathan Williams & Clive Cheesman, 2007

Masterpieces of Classical Art, Dyfri Williams, 2009

The Portland Vase, Susan Walker, 2004

Sex or Symbol? Erotic Images of Greece and Rome, Catherine Johns, 2005

Women in the Ancient World, Jenifer Neils, 2011

Greek World

The Ancient Olympic Games, Judith Swaddling, new edn. 2011

Concise Introduction: Ancient Greece, Jenifer Neils, 2008

The Discobolus, Ian Jenkins, 2012

The Elgin Marbles, Brian Cook, 2008

Etruscan Civilization: A Cultural History, Sybille Haynes, 2005

Etruscan Myths, Larissa Bonfante & Judith Swaddling, 2006

The Etruscans: Art, Architecture and History, Federica Borrelli & Maria Cristina Targia, 2004

Greek Architecture and its Sculpture, Ian Jenkins, 2006

Greek Designs, Sue Bird, 2003

Greek Myths, Lucilla Burn, 2004

Greek Vases, Dyfri Williams, 1999

How the Olympics Came to Be, Helen East & Mehrdokht Amini, 2011

The Lion of Knidos, Ian Jenkins, 2008

Minoans, J. Lesley Fitton, 2002

The Mycenaeans, Louise Schofield, 2007

The Parthenon Frieze, Ian Jenkins, 2008

The Parthenon Sculptures, Ian Jenkins, 2007

Power Games, David Stuttard, 2011

Roman World

31 BC: Antony, Cleopatra and the Fall of Egypt, David Stuttard & Sam Moorhead, 2012

AD 410: The Year that Shook Rome, Sam Moorhead & David Stuttard, 2010

Ancient Rome: Art, Architecture and History, Ada Gabucci, 2007

Ancient Mosaics, Roger Ling, 1998

Concise Introduction: Ancient Rome, Nancy H. Ramage & Andrew Ramage, 2008

Mummy Portraits from Roman Egypt, Paul Roberts, 2008

Roman Myths, Jane F. Gardner, 2008

The Warren Cup, Dyfri Williams, 2006

ANCIENT NEAR EAST

Afghanistan: Crossroads of the Ancient World, Fredrik Hiebert & Pierre Cambon, 2011

Ancient Persia, John Curtis, 2006

Art and Empire: Treasures from Assyria in the British Museum, ed. J.E. Curtis & J.E. Reade, 2006

Assyrian Palace Sculptures, Paul Collins, 2008

Assyrian Sculpture, Julian Reade, 2006

Babylon: City of Wonders, Irving Finkel & Michael Seymour, 2008

Babylon: Myth and Reality, ed. Irving Finkel & Michael Seymour, 2008

The Bible in the British Museum, T.C. Mitchell, 2008

The British Museum Dictionary of the Ancient Near East, ed. Piotr Bienkowski & Alan Millard, 2000

Canaanites, Jonathan Tubb, 2005

Forgotten Empire: The World of Ancient Persia, ed. John E. Curtis & Nigel Tallis, 2006

From Egypt to Babylon: The International Age 1500–500 BC, Paul Collins, 2008

Gods, Demons and Symbols of Ancient Mesopotamia: An Illustrated Dictionary, Jeremy Black & Anthony Green, 2008

Mesopotamia, Julian Reade, 2008

Mesopotamian Myths, Henrietta McCall, 2008

Persian Love Poetry, Vesta Sarkhosh Curtis & Sheila R. Canby, 2007

Persian Myths, Vesta Sarkhosh Curtis, 2006

The Persian Empire: A History, Lindsay Allen, 2005

Phoenicians, Glenn Markoe, 2002

The Queen of the Night, Dominique Collon, 2005

Shah 'Abbas and the Remaking of Iran, ed. Sheila R. Canby, 2009

Shah 'Abbas and the Treasures of Imperial Iran, Sheila R. Canby, 2009

ASIA
China

The British Museum Book of Chinese Art, ed. Jessica Rawson, 2007

The Art of Calligraphy in Modern China, Gordon S. Barrass, 2002

Blue & White: Chinese Porcelain around the World, John Carswell, 2007

Chinese (Reading the Past), Oliver Moore, 2000

Chinese Art in Detail, Carol Michaelson & Jane Portal, 2006

Chinese Calligraphy: Standard Script for Beginners, Qu Lei Lei, 2005

Chinese Ceramics: Highlights of the Sir Percival David Collection, Regina Krahl & Jessica Harrison-Hall, 2009

Chinese Love Poetry, ed. Jane Portal, 2006

Chinese Myths, Anne Birrell, 2000

Chinese Pottery and Porcelain, Shelagh Vainker, 2005

The First Emperor, ed. Jane Portal, 2007

First Masterpiece of Chinese Painting: The Admonitions Scroll, Shane McCausland, 2003

Ming Ceramics in the British Museum, Jessica Harrison-Hall, 2001

Modern Chinese ink paintings, Clarissa von Spee, 2012

Pocket Timeline of China, Jessica Harrison-Hall, 2007

The Printed Image in China, Clarissa von Spee, 2009

The Terracotta Warriors, Jane Portal, 2007

Japan

Japanese Art: Masterpieces in the British Museum, Lawrence Smith, Victor Harris & Timothy Clark, 1990

100 Views of Mount Fuji, Timothy Clark, 2001

Crafting Beauty in Modern Japan, ed. Nicole Rousmaniere, 2007

Cutting Edge: Japanese Swords in the British Museum, Victor Harris, 2004

Floating World: Japan in the Edo period, John Reeve, 2006

Haiku, ed. David Cobb, 2005

Haiku Animals, Mavis Pilbeam, 2010

Hokusai's Great Wave, Timothy Clark, 2011

Japanese Art in Detail, John Reeve, 2006

A Japanese Menagerie: Animal Pictures by Kawanabe Kyosai, Rosina Buckland, Timothy Clark & Shigeru Oikawa, 2006

Japanese Prints: Ukiyo-e in Edo, 1700–1900, Ellis Tinios, 2010

Shinto: The Sacred Art of Ancient Japan, ed. Victor Harris, 2001

Shunga: Erotic Art in Japan, Rosina Buckland, 2010

Korea

Korea: Art and Archaeology, Jane Portal, 2000

South & Southeast Asia

Amaravati: Buddhist Sculpture from the Great Stupa, Robert Knox, 1992

Bengali Myths, T. Richard Blurton, 2006

The Buddha, Delia Pemberton, 2007

Burma: Art and Archaeology, ed. Alexandra Green & T. Richard Blurton, 2002

Hindu Art, T. Richard Blurton, 2002

Hindu Myths, A.L. Dallapiccola, 2007

Hindu Visions of the Sacred, A.L. Dallapiccola, 2004

Indian Art in Detail, A.L. Dallapiccola, 2007

Indian Love Poetry, A.L. Dallapiccola, 2006

Rajput Painting, Roda Ahluwalia, 2008

South Indian Paintings, A.L. Dallapiccola, 2010

Vietnam Behind the Lines: Images from the War 1965–75, Jessica Harrison-Hall, 2002

Visions from the Golden Land: Burma and the Art of Lacquer, Ralph Isaacs & T. Richard Blurton, 2000

BRITAIN & EUROPE
Prehistoric Europe

Britain and the Celtic Iron Age, Simon James & Valery Rigby, 1997

Celtic Art, Ian Stead, 2003

Celtic Myths, Miranda Green, 2003

Lindow Man, Jody Joy, 2009

Little Book of Celts, 2004

The Swimming Reindeer, Jill Cook, 2010

Roman Britain

Roman Britain, T.W. Potter, 2003

Roman Britain, Ralph Jackson & Richard Hobbs, 2010

The Hoxne Treasure, Roger Bland & Catherine Johns, 1994

Life and Letters on the Roman Frontier: Vindolanda and its People, Alan K. Bowman, 2008

Medieval Europe

Anglo-Saxon Art, Leslie Webster, 2012

Byzantium, Rowena Loverance, 2008

Chronicles of the Vikings: Records, Memorials and Myths, R.I. Page, 2002

English Tilers, Elizabeth Eames, 2004

Icons, Robin Cormack, 2007

The Lewis Chessmen, James Robinson, 2005

Masons and Sculptors, Nicola Coldstream, 2004

Masterpieces of Medieval Art, James Robinson, (paperback) 2012

The Medieval Cookbook, Maggie Black, new edn. 2006

The Medieval Garden, Sylvia Landsberg, 2005

Medieval Goldsmiths, John Cherry, 2011

Medieval Love Poetry, ed. John Cherry, 2005

Scribes and Illuminators, Christopher de Hamel, 2006

The Sutton Hoo Helmet, Sonja Marzinzik, 2007

The Sutton Hoo Ship Burial, Angela Care Evans, 2008

Treasures of Heaven, Martina Bagnoli, 2011

Renaissance & Later Europe

Angels and Ducats: Shakespeare's Money and Medals, Barrie Cook, 2012

William Blake, Bethan Stevens, 2005

Britain, Lindsay Stainton, 2005

Christ, Rowena Loverance, 2004

Dürer, Giulia Bartrum, 2007

Albrecht Dürer and his Legacy, Giulia Bartrum, 2002

Edward Burne-Jones: The Hidden Humourist, John Christian, 2011

Ferdinand Columbus: Renaissance Collector, Mark P. McDonald, 2005

Fra Angelico to Leonardo, Hugo Chapman & Marzia Faietti, 2010

German Romantic prints and drawings, ed. Giulia Bartrum, 2011

Hogarth, Tim Clayton, 2007

Italian Renaissance Drawings, Hugo Chapman, 2010

Looking at Prints, Drawings and Watercolours: A Guide to Technical Terms, Paul Goldman, 2006

Master Drawings of the Italian Renaissance, Claire Van Cleave, 2007

Medicine Man, Ken Arnold & Danielle Olsen, 2003

Michelangelo, Hugo Chapman, 2006

Michelangelo Drawings: Closer to the Master, Hugo Chapman, 2006

Mrs Delany: Her life and her flowers, Ruth Hayden, 2006

Objects of Virtue: Art in Renaissance Italy, Luke Syson & Dora Thornton, 2004

Samuel Palmer: Vision and Landscape, W. Vaughan et al., 2006

Prints and Printmaking, Antony Griffiths, 2004

Shakespeare: staging the world, Jonathan Bate & Dora Thornton, 2012

Shakespeare's Britain, Jonathan Bate & Dora Thornton with Becky Allen, 2012

Toulouse-Lautrec, Jennifer Ramkalawon, 2007

Modern Europe

Decorative Arts 1850–1950, Judy Rudoe, 1994

Antony Gormley Drawing, Anna Moszynska, 2002

Eric Gill, Ruth Cribb & Joe Cribb, 2011

Grayon Perry: Tomb of the Unknown Craftsman, Grayson Perry, 2011

Italian Prints 1875–1975, Martin Hopkinson, 2007

London, Sheila O'Connell, 2005

Modern Scandinavian Prints, Frances Carey, 1997

The Print in Germany, Frances Carey & Antony Griffiths, 1984

ISLAMIC WORLD

The Art of Hajj, Venetia Porter, 2011

Hajj: journey to the heart of Islam, Muhammed A. S. Abdel Haleem & Hugh Kennedy, 2011

Islamic Art, Barbara Brend, 2007

Islamic Art in Detail, Sheila R. Canby, 2006

Islamic Designs, Eva Wilson, 2007

Islamic Metalwork, Rachel Ward, 2000

Islamic Tiles, Venetia Porter, 2005

Iznik Pottery, John Carswell, 2006

Mughal Miniatures, J.M. Rogers, 2006

The Golden Age of Persian Art 1501–1722, Sheila R. Canby, 2008

Persian Love Poetry, Vesta Sarkhosh Curtis & Sheila R. Canby, 2007

Persian Painting, Sheila R. Canby, 2004

Pocket Timeline of Islamic Civilizations, Nicholas Badcott, 2009

Shah 'Abbas and the Remaking of Iran, ed. Sheila R. Canby, 2009

Shah 'Abbas and the Treasures of Imperial Iran, Sheila R. Canby, 2009

PACIFIC WORLD

Baskets & Belonging, Lissant Bolton, 2011

Hoa Hakananai'a, Jo Anne Van Tilburg, 2004

Out of Australia, Stephen Coppel & Wally Caruana

Pacific Art in Detail, Jenny Newell, 2011

Pacific Designs, Rebecca Jewell, 2004

Pacific Encounters: Art and Divinity in Polynesia 1760–1860, Steven Hooper, 2006

ANIMALS

Birds, ed. Mavis Pilbeam, 2008

The British Museum Book of Cats, Juliet Clutton-Brock, 2006

The Cat in Ancient Egypt, Jaromir Malek, 2006

Cats, ed. Delia Pemberton, 2006

Cattle: History, Myth, Art, Catherine Johns, 2011

Dogs: History, Myth, Art, Catherine Johns, 2008

Elephants, ed. Sarah Longair, 2008

The horse: from Arabia to Royal Ascot, John Curtis & Nigel Tallis, 2012

Horses: History, Myth, Art, Catherine Johns, 2006
Little Book of Cats, 2008

CONSERVATION & SCIENCE

Earthly Remains: The History and Science of Preserved Human Bodies, Andrew T. Chamberlain & Michael Parker Pearson, 2004
Making Faces: Using Forensic and Archaeological Evidence, John Prag & Richard Neave, 1999
Porcelain Repair and Restoration: A Handbook, Nigel Williams, rev. L. Hogan & M. Bruce-Mitford, 2002
Radiocarbon Dating, Sheridan Bowman, 1990
Science and the Past, ed. Sheridan Bowman, 1991

GLASS

5000 Years of Glass, ed. Hugh Tait, 2000
Glass: a short history, David Whitehouse, 2012
The Portland Vase, Susan Walker, 2004

JEWELLERY

7000 Years of Jewellery, ed. Hugh Tait, 2008
Gold, Susan La Niece, 2009
Jewellery in the Age of Queen Victoria, Charlotte Gere & Judy Rudoe, 2010
Silver, Philippa Merriman, 2009

MONEY & MEDALS

Angels and Ducats: Shakespeare's Money and Medals, Barrie Cook, 2012
Badges, Philip Attwood, 2004
Money: A History, ed. Catherine Eagleton & Jonathan Williams, 2007

MYTHS

Aztec and Maya Myths, Karl Taube, 2002
Bengali Myths, T. Richard Blurton, 2007
Celtic Myths, Miranda Green, 2003
Chinese Myths, Anne Birrell, 2000
Egyptian Myths, George Hart, 2008
Etruscan Myths, Larissa Bonfante & Judith Swaddling, 2006
Greek Myths, Lucilla Burn, 2006
Hindu Myths, A.L. Dallapiccola, 2007
Inca Myths, Gary Urton, 1999
Mesopotamian Myths, Henrietta McCall, 2008
Persian Myths, Vesta Sarkhosh Curtis, 2006
Roman Myths, Jane F. Gardner, 2008
The Story of Bacchus, Andrew Dalby, 2005
The Story of Venus, Andrew Dalby, 2005
World of Myths: Vol. 1, Marina Warner, 2005
World of Myths: Vol. 2, Felipe Fernández-Armesto, 2004

POTTERY

10,000 Years of Pottery, Emmanuel Cooper, Reissue 2010
The Art of Worcester Porcelain, Aileen Dawson, 2007
Blue & White: Chinese Porcelain around the World, John Carswell, 2007
Chinese Ceramics: Highlights of the Sir Percival David Collection, Regina Krahl & Jessica Harrison-Hall, 2009
Chinese Pottery and Porcelain, Shelagh Vainker, 2005
English and Irish Delftware 1570–1840, Aileen Dawson, 2010
French Porcelain, Aileen Dawson, 2000
Greek Vases, Dyfri Williams, 1999
Islamic Tiles, Venetia Porter, 2005
Iznik Pottery, John Carswell, 2006
Ming Ceramics in the British Museum, Jessica Harrison-Hall, 2001

SCULPTURE

Assyrian Palace Sculptures, Paul Collins, 2008
Assyrian Sculpture, Julian Reade, 2007
The Elgin Marbles, Brian Cook, 2008
Greek Architecture and its Sculpture, Ian Jenkins, 2006
The Parthenon Frieze, Ian Jenkins, 2008
The Parthenon Sculptures, Ian Jenkins, 2007

TEXTILES

5000 Years of Textiles, ed. Jennifer Harris, 2006
Chinese Silk: A Cultural History, Shelagh Vainker, 2004
Embroiderers, Kay Staniland, 2006
Embroidery from Afghanistan, Sheila Paine, 2006
Embroidery from India and Pakistan, Sheila Paine, 2006
Embroidery from Palestine, Shelagh Weir, 2006
Indigo, Jenny Balfour-Paul, 1998
Miao Textiles from China, Gina Corrigan, 2006
Nomadic Felts, Stephanie Bunn, 2010
Printed and Dyed Textiles from Africa, John Gillow, 2001
Silk in Africa, Christopher Spring & Julie Hudson, 2002
Textiles from the Andes, Penny Dransart & Helen Wolfe, 2011
Textiles from the Balkans, Diane Weller, 2010
Textiles from Guatemala, Ann Hecht, 2001
Textiles from Mexico, Chloë Sayer, 2002
Thai Textiles, Susan Conway, 2001
World Textiles: A Sourcebook, Chloë Sayer et al, 2011

TIME

Clocks, David Thompson, 2008
Watches, David Thompson, 2008

WRITING

Reading the Past series
Arabic Calligraphy: Naskh Script for Beginners, Mustafa Ja'far, 2008
The British Museum Book of Egyptian Hieroglyphs, Neal Spencer & Claire Thorne, 2003
Chinese Calligraphy: Standard Script for Beginners, Qu Lei Lei, 2007
How to Read Egyptian Hieroglyphs: A step-by-step guide to teach yourself, Mark Collier & Bill Manley, 2006
Write Your Own Egyptian Hieroglyphs, Angela McDonald, 2007

British Museum Registration Numbers

Index